D1118406

PHILADELPHIA'S
TREASURES
IN BRONZE AND STONE

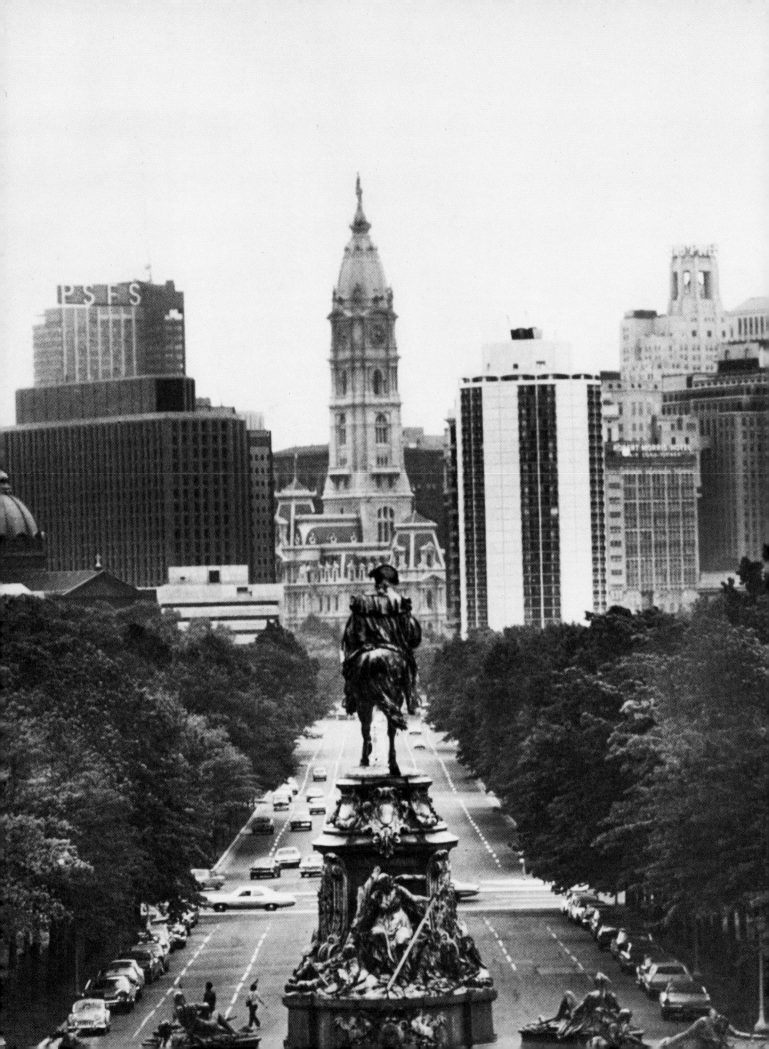

PHILADELPHIA'S TREASURES
IN BRONZE AND STONE

Fairmount Park Art Association

WALKER PUBLISHING COMPANY, INC.
NEW YORK

FAIRMOUNT PARK ART ASSOCIATION

TRUSTEES

C. Clark Zantzinger, Jr., President
Theodore T. Newbold, Vice President
Henry W. Sawyer III, Vice President
H. Gates Lloyd III, Treasurer
William G. Foulke
Joseph T. Fraser, Jr.
J. Welles Henderson
Mrs. Orville Horwitz
Frederick H. Levis
Charles E. Mather III
G. Holmes Perkins
David Pincus
Philip Price
H. Radclyffe Roberts
David W. Scully
Evan H. Turner
William P. Wood

Eileen H. Wilson, Executive Secretary

The photographs in this book originally appeared in
Sculpture of a City, published in 1974 by Walker Publishing
Company for the Fairmount Park Art Association.

FRONT COVER: William Penn atop City Hall
by Alexander Milne Calder. Photograph by Bernie Cleff.

BACK COVER: Sculptural detail of Washington Monument
by Rudolf Siemering. Photograph by George Krause.

Copyright © 1976 by Fairmount Park Art Association

All rights reserved.
No part of this book may be reproduced
or transmitted in any form or by any means, electric or mechanical,
including photocopying, recording, or by any information storage
and retrieval system, without permission
in writing from the Publisher.

First published in the United States of America in 1976
by the Walker Publishing Company, Inc.

Published simultaneously in Canada
by Fitzhenry & Whiteside, Limited, Toronto.

ISBN: 0-8027-7100-9

Library of Congress Catalog Card Number: 75-36536

Printed in the United States of America.
10 9 8 7 6 5 4 3 2 1

CONTENTS

PREFACE

No other city in the United States, and few in the world, can boast of so rich and varied a heritage of outdoor public sculpture as Philadelphia. Works by three generations of Calders, by Remington, Rush (the earliest American sculptor of note), Houdon, Saint-Gaudens, Barye, Rodin, French, Moore, Lipchitz, Manship, Epstein, Nevelson, and many others grace the fountains and squares of Center City, the drive along Schuylkill River, historic Laurel Hill Cemetery, and Fairmount Park (largest and oldest city park in the United States).

Philadelphia's Treasures in Bronze and Stone presents a magnificent selection of photographs from the critically acclaimed *Sculpture of a City.* John Canaday, noted art critic for *The New York Times,* has called them "some of the finest photographs I've ever seen." The photographers of the talented "Philadelphia School" have succeeded in introducing motion, texture, and deep feeling in their record of what has been called "frozen poetry." These photographs, combined with authoritative and informative commentaries,

create a book which is itself a treasure.

The book is a unique record of what *can* be done, indeed, *has* been done to beautify a major American city. The Fairmount Park Art Association was formed over one hundred years ago by a group of citizens dedicated to the improvement of the city. The Association has done more than any other similar organization in this country to acquire and publicly display major works of sculpture. This private endeavor has been supplemented by Philadelphia's statute requiring that one percent of the cost of any new public building be used for works or art.

Also an invaluable guide for a walking tour of Philadelphia in this bicentennial year, the book is divided into sections corresponding to geographic areas of the city. An easy-to-follow map precedes each section.

Many Philadelphians are familiar with their city's sculptural riches—and perhaps assume, incorrectly, that other cities are equally blessed. It is hoped that this book will enlighten them, as well as the visitor, about Philadelphia's treasures.

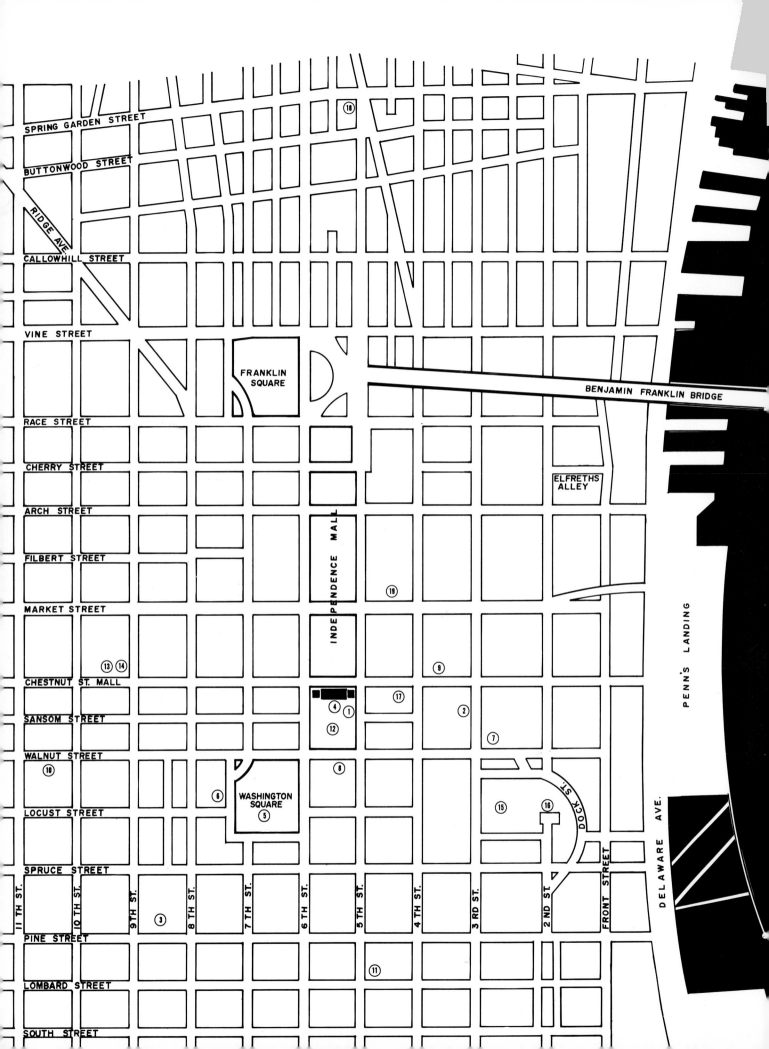

THE OLD CITY: Independence Hall

After William Penn founded his "Greene Countrie Towne" on the Delaware River in 1681, it was not long before Philadelphia became a complex city of teeming wharves, busy commercial buildings, and workers' houses. Inland, prosperous merchants' houses sprang up. The founders of Society Hill established the first hospital, the first library, and the first philosophical society in the country. Almost a century after Penn's landing, the Liberty Bell proclaimed freedom in Independence Hall courtyard. The first Continental Congress met in 1774. Washington, Jefferson, Adams, Madison, Monroe, and Benjamin Franklin walked the streets of the old city, met in its public halls, and forged the dream of democracy into the Constitution of the United States.

Most of the sculpture in this section of the city was created as architectural decoration, but there is portraiture as well and a remarkable collection of twentieth-century works. America's first sculptors were Europeans seeking commissions in a new world. They carved likenesses of our statesmen and our new symbolic eagles, Minervas, and Virtues. The first native sculptor, William Rush, a ship-carver by trade, was to record vividly many of the men who made our history.

A walk through the old city evokes the eighteenth century—its homes, institutions, markets, and taverns. Reproduced on the following pages are its masterpieces of sculpture.

Map drawing by Hugh J. McCauley A.I.A.

Thomas Jefferson c. 1787
by Jean Antoine Houdon (1741–1828)
Plaster, height 29″
American Philosophical Society,
104 South 5th Street

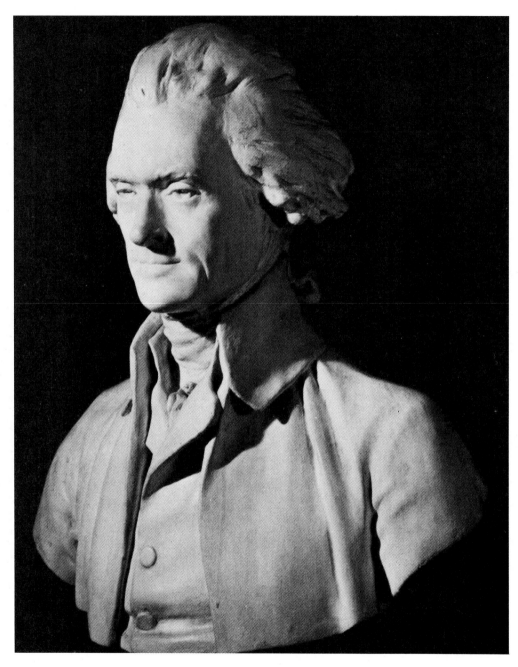

In the shadow of Independence Hall stands this bust of the
author of the Declaration of Independence. While Minister
to France, Jefferson became interested in the work of Houdon
and was responsible for the State of Virginia's commissioning
the great French sculptor to carve a full length figure of Washington.
While at work on that sculpture, Houdon did this bust of
Jefferson—one of the finest likenesses of our third President.

Eagle 1797
by Clodius F. Legrand and Sons
Mahogany, height 96″
First Bank of the United States,
Third Street between Chestnut and Walnut

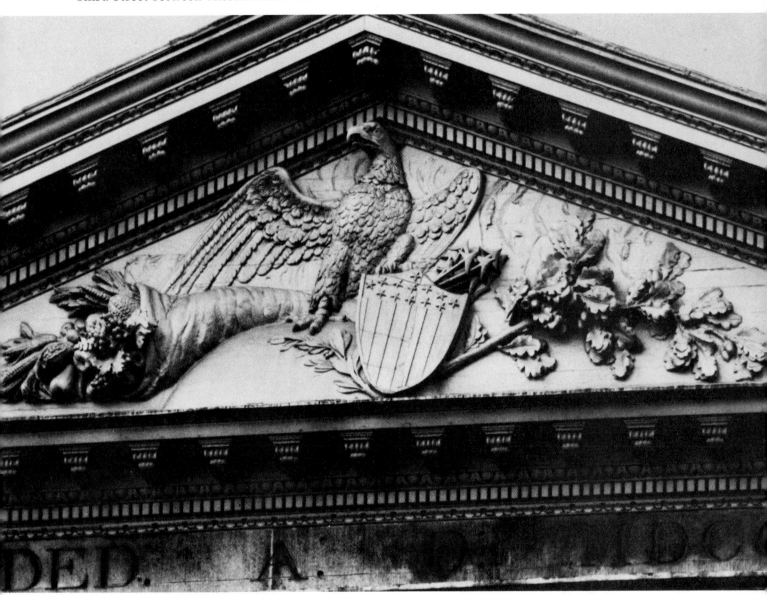

The oldest bank building in the United States was elaborately
conceived to commemorate the founding of the new nation
and to symbolize its high hopes. Appropriately, a cornucopia
and an oak branch appear on the sides of the eagle in the
pediment, and in the center there is a shield carrying thirteen
stars and stripes. During recent restoration work by the Department
of the Interior, it was discovered that these carvings are of mahogany,
not stone. It is not known if this choice was for reasons of
economy, but it is certain that this pediment is
an outstanding example of 18th-century wood carving.

William Penn 1774
by John Bacon, the elder (1740–99)
Lead, painted black; height 72″ (marble base 42″)
Pennsylvania Hospital Yard,
800 block of Pine Street

George Washington 1814
by William Rush (1756–1833)
Painted pine, height 73″ (base 9″)
Second Bank of the United States,
420 Chestnut Street

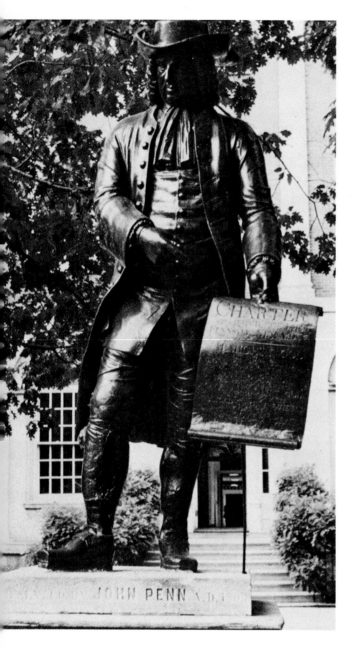

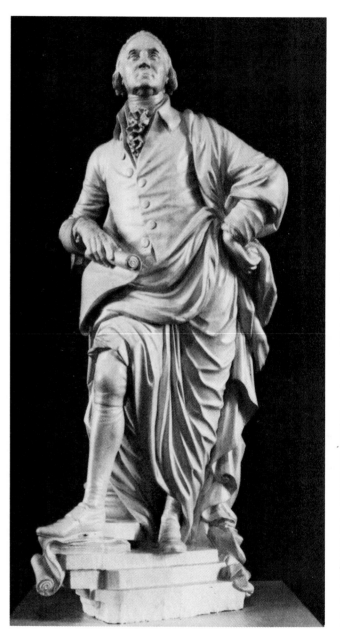

Designed to be placed atop an English country house, this impressive statue was much admired by Benjamin Franklin. It disappeared for a time, but was found by John Penn, grandson of the Founder, in a London shop. He presented the statue to the Pennsylvania Hospital, and it arrived in Philadelphia in 1804. Years later it provided inspiration for Alexander Milne Calder when he sculpted his colossal "Billy Penn" for Philadelphia's City Hall.

One of the truest likenesses of our first President, this statue stands in the recently restored Second Bank of the United States, now a portrait gallery of prominent Colonial and Revolutionary figures. A superb example of public sculpture, it attests to the great skill of its self-taught carver—William Rush, the Father of American Sculpture. Executed in well-seasoned wood, no more than 3″ thick, it is hollow, thus allowing air to circulate and prevent rot.

George Washington
by Jean Antoine Houdon (1741–1828)
Bronze on granite base,
height 79½"
Washington Square,
Walnut Street between 6th and 7th

Nicholas Biddle
Attributed to Luigi Persico
(1791–1860)
Plaster, height 21⅜"
American Philosophical Society
104 South 5th Street

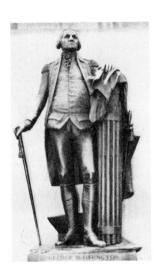 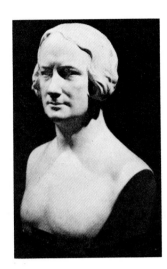

The original marble of Washington was done c. 1790 and is in the Virginia State House, Richmond. This fine bronze version, the only one cast, was made in 1922. The bust of the well-known American financier Nicholas Biddle (1786–1844) is considered to be a remarkable likeness.

Lion 1838
by Henry Fiorelli and Battin
Marble, height 42"
Merchants' Exchange,
Walnut, Third, and Dock Streets

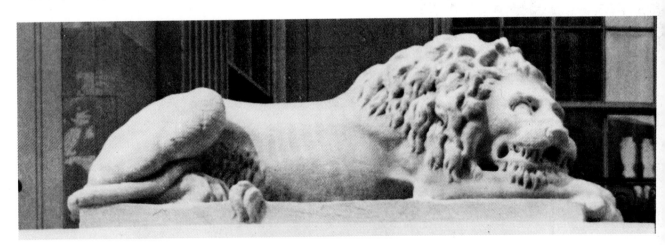

This docile-looking lion is one of a pair that rest on the steps of William Strickland's Merchants' Exchange. It was assumed for years that the lions were imported from Italy, but old records show that they were carved in Philadelphia.

For many years this 600-pound statue of William Penn stood over the doorway of the old Penn Mutual building—gazing at the Merchants' Exchange and the First Bank of the United States. It now stands in the lobby of Penn Mutual's second home. This likeness of the founder of Philadelphia was both a landmark and an advertisement for the insurance firm.

William Penn 1851
by Henry D. Headman
Cast iron, height 75"
Penn Mutual Life Insurance Building,
530 Walnut Street

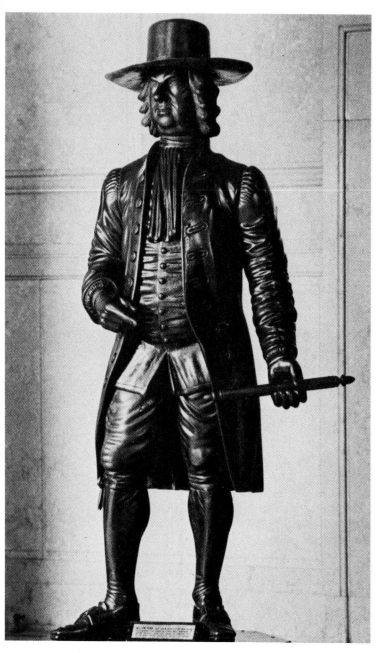

Navigator c. 1875
by Samuel H. Sailor
(dates unknown)
Painted wood, height 66¾″
Philadelphia Maritime Museum
321 Chestnut Street

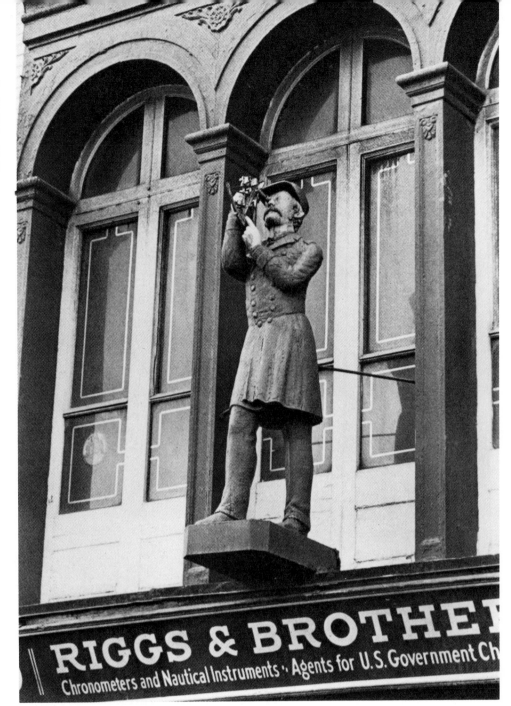

Though no longer standing on a base over the door of the Riggs Brothers store, the *Navigator* is at home in the Maritime Museum, where he was recently placed. There was a great demand for ship carvers in the port cities of the Colonies, and these craftsmen were often called upon to do carvings that advertised shop wares. Samuel Sailor's *Navigator*, captured in the act of sighting through his sextant, is an especially fine example of trade signs.

Dr. Samuel D. Gross 1897
by Alexander Stirling Calder (1870–1945)
Bronze, height 111″ (granite base 120″)
Thomas Jefferson University, 11th and Walnut Streets

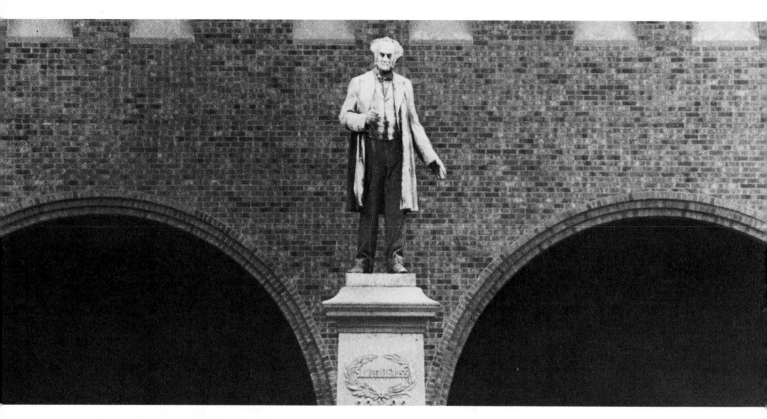

Thomas Eakins's controversial painting *The Gross Clinic* provided the inspiration for this magnificent statue of one of Philadelphia's most famous surgeons. Sculpted with the same uncompromising realism that characterizes the painting, the statue shows the surgeon with a scalpel in hand. The skill of the sculptor, Alexander Stirling Calder, second in the dynasty of renowned Philadelphia sculptors, is seen in this superb work done in his youth.

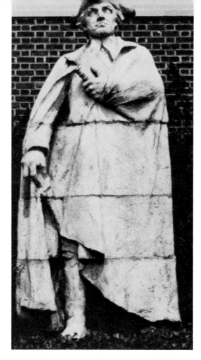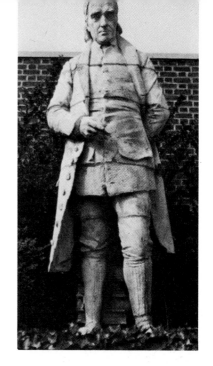

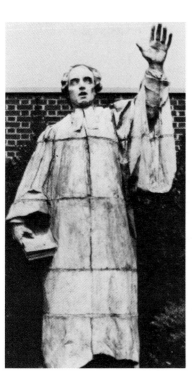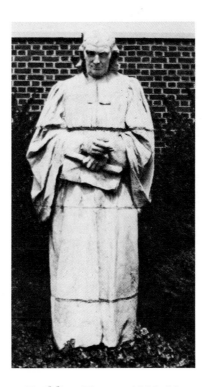

Witherspoon Building Figures 1898–99
by Alexander Stirling Calder (1870–1945)
Cast stone, heights 108″
Presbyterian Historical Society, 425 Lombard Street

These six giant figures—Presbyterian Divines—were originally architectural ornamentation on the seventh story of the Walnut Street facade of the Witherspoon Building. They were executed by young Alexander Stirling Calder, whose father had recently finished the vast program of decorating City Hall. Considered a threat to the safety of pedestrians on the sidewalk below, they were removed from the building in 1967. Today, these figures stand in the garden of the Presbyterian Historical Society.

Commodore John Barry 1907
by Samuel Murray (1870–1941)
Bronze, height 114″ (granite base 138″)
Independence Square, Walnut Street side

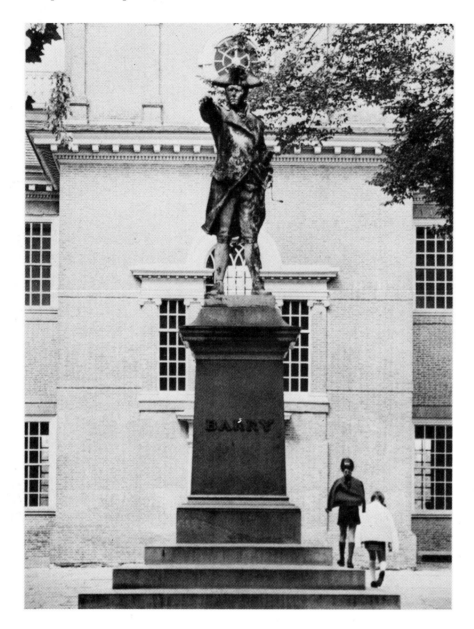

Commodore Barry, Father of the United States Navy, wel-
comes the visitor to this historic area. Murray, the sculptor,
was a member of the Society of the Friendly Sons of St. Patrick.
This affiliation undoubtedly was a deciding factor in his being
commissioned by the society to execute a statue honoring the
Irish-born John Barry. A gift to the city, it was dedicated on St.
Patrick's Day, 1907. This powerful representation of the Com-
modore is an impressive reminder of the Irish contribution to
the making of America.

Facade, N. W. Ayer Building 1929
by J. Wallace Kelly (1894–) and Raphael
Sabatini, (1898–), sculptors;
Ralph Bencker, architect
Washington Square

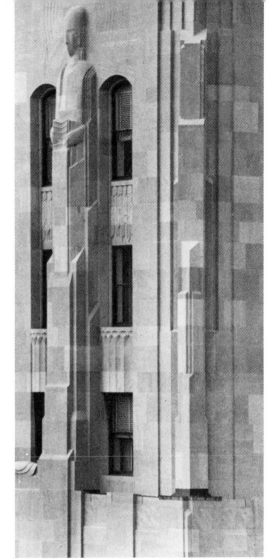

This Art Deco office building is one of
Philadelphia's finest examples of the
integration of figurative sculpture
with architecture. The figure on the
facade is one of eight which cap the
building. Appropriately, each sym-
bolizes basic principles of the adver-
tising business—N. W. Ayer & Son
was Philadelphia's best-known ad-
vertising agency when the figures
were sculpted in 1929. Of signifi-
cance is the fact that they were
carved in situ, the sculptors working
on scaffolds, fourteen floors above
street level.
Below is the proud emblem over
the entrance doors of the building.

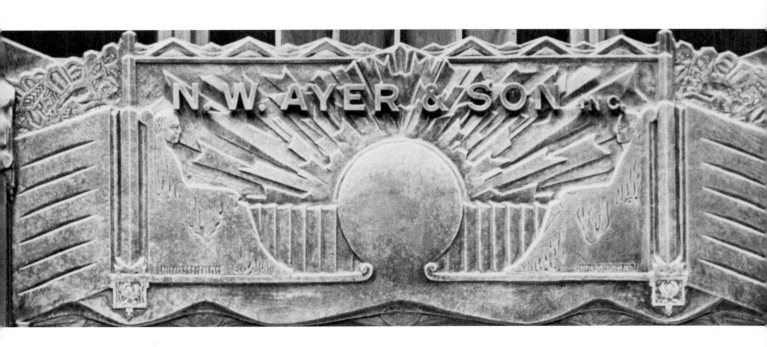

Doors, N. W. Ayer Building 1929
by J. Wallace Kelly (1894–) and Raphael Sabatini (1898–)
Bronze
Washington Square, on 7th Street

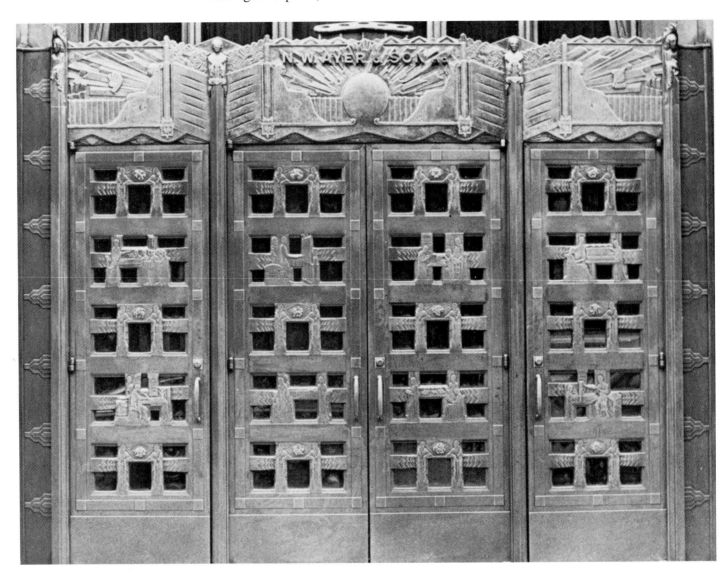

These imposing bronze doors are masterpieces of Art
Deco. The motifs that make up their decoration express
the fundamental goals and purposes of the advertising
industry in the 1920s. N. W. Ayer & Son—through their
architect and sculptors—created a building that
illustrates an optimistic era.

Facade Panels
Federal Building (Post Office)
by Edmond Amateis and
Donald De Lue (1900–) sculptors;
Harry Sternfeld, architect
Granite
9th and Chestnut Streets

The top and middle panels depict the indefatigable postman—one in the North, the other in the South. The bottom panel portrays Justice, flanked by an eagle of massive proportions and awesome force, with no equal in American sculpture.

The sculptors' strong narrative talent is seen in these panels. Amateis' postmen are rendered with crude strength, while DeLue's Justice is solemn and highly stylized.

The Post Office Building is one of the finest examples of the federal style of the 1930s, as are Philadelphia's Thirtieth Street Post Office and Federal Reserve Bank.

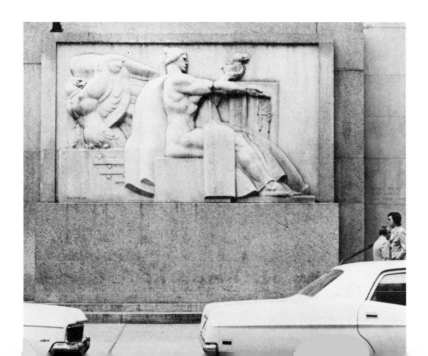

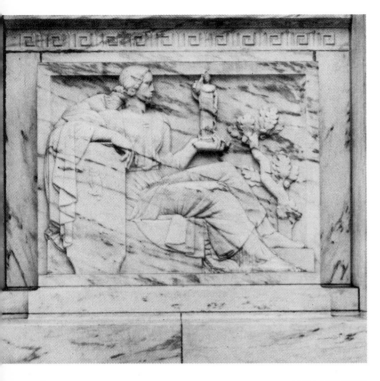

Facade Panel
Federal Reserve Bank
by Alfred Bottiau (d. c. 1968), sculptor;
Paul Cret, architect
Marble
Chestnut Street, between 9th and 10th

This seated woman, symbolizing the
Federal Reserve System, holds a figure of
Athena Parthenos in her hand, invoking
the goddess's wisdom, a national concern
in the midst of the Depression.

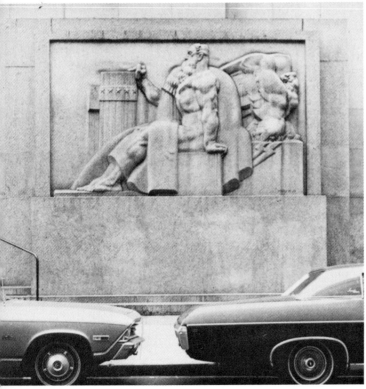

Facade Panel
Federal Building (Post Office)
by Donald De Lue (1900–), sculptor;
Harry Sternfeld, architect
Granite
9th and Chestnut Streets

This panel is the companion of the one
at the bottom of page 19. It depicts
Moses the Lawgiver with the
appropriate sternness, but he is
transplanted to the American scene.
Flanking him are the stars and bars and
an American eagle similar to the one
that accompanies Justice in the
companion panel. The muscular and
plastic rendering of these figures is akin
to that found in the works of the
American regionalist painters—
Thomas Hart Benton, for example.

Floating Figure 1927
by Gaston Lachaise (1886–1935)
Bronze, height 51¾″, length 96″ (marble base 96″)
Courtyard, 3rd Street, off Locust Street

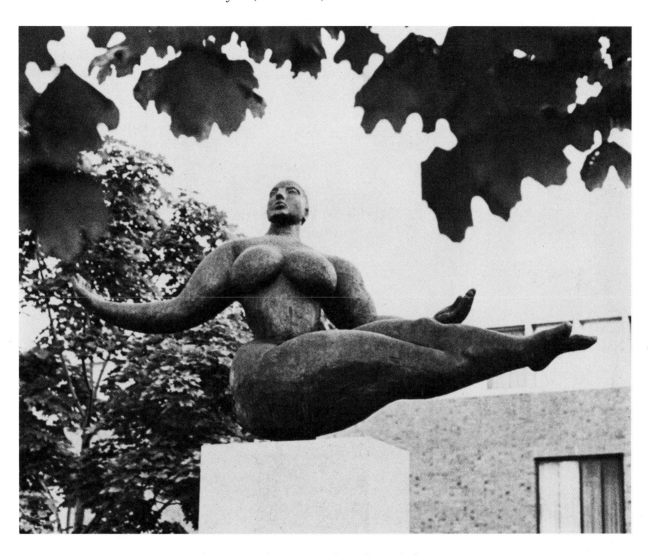

This second casting of Lachaise's famous
and controversial *Floating Woman*
arrived in Philadelphia in 1963. It was
acquired for the Society Hill Town House
development. The 1927 first casting is in
the Museum of Modern Art, New York.
The model for this work was the
sculptor's wife. A superb example of
Lachaise's highly original style, this
sculpture is a rapturous glorification of
the human form.

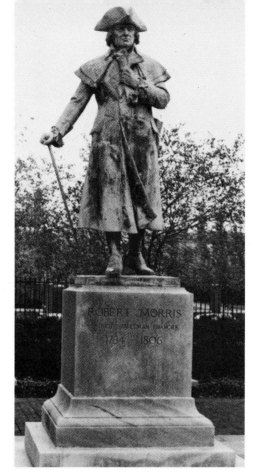

Robert Morris 1923
by Paul W. Bartlett (1865–1925)
Bronze, height 114″
(limestone base)
Second Bank of the United States,
400 block of Library Street

Known as the Financier of the American Revolution, Robert Morris is appropriately represented "struggling through the snow to raise funds for Washington's troops at Valley Forge. The manuscript protruding from his pocket represents the subscription list which he obtained. It amounted to $1,400,000, a sum which enabled the Americans to gain the victory at Yorktown."

The sculptor, Leonard Baskin, has described himself as a "moral realist." He has written: "The forging of works of art is one of man's remaining semblances to divinity." Not shown in this photograph is *The Future*, the final piece in this sculptural trilogy. A winged birdlike creature, ominous in feeling, it represents the future.

Old Man, Young Man 1966
by Leonard Baskin (1922–)
Bronze: *Old Man*, height 76¾″,
self-standing; *Young Man*,
height 75″, self-standing
Society Hill Towers,
3rd and Locust Streets

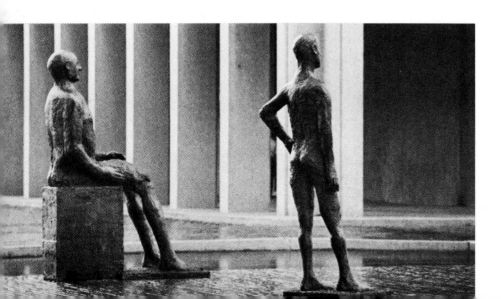

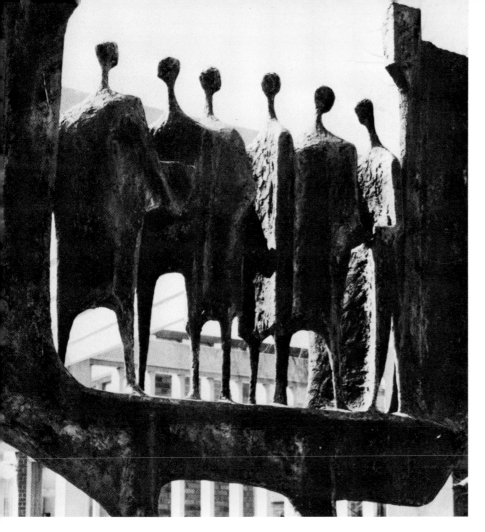

Merchants Bartering 1968
by Gerd Utescher (1912–)
Fiberglass with plastic resin,
bronze patina, 58″
(concrete base 48″)
Fifth Street Wholesale
Distributors Association,
5th and Spring Garden Streets

These stylized figures form a
mass of unforgettable auster-
ity. The sculptor, Gerd
Utescher, who was educated
in Germany, later found his
way to Philadelphia, where he
now teaches.

Perhaps the archaeological artifacts of ancient
civilizations on the sculptor's native island of
Sardinia provided inspiration for this "sand-
cast" sculptural mural. The endless array of
provocative shapes challenges the imagination
while delighting the eye.

**Dedicated to the
American Secretary** 1970
by Constantino Nivola (1911–)
Concrete and sand, height 126″;
fourteen panels, each 36″ wide;
total width 504″
Continental Building,
4th and Market Streets

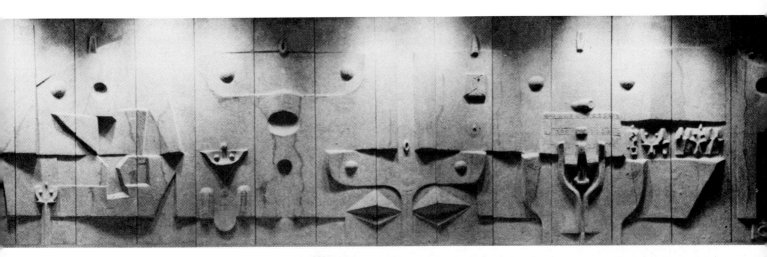

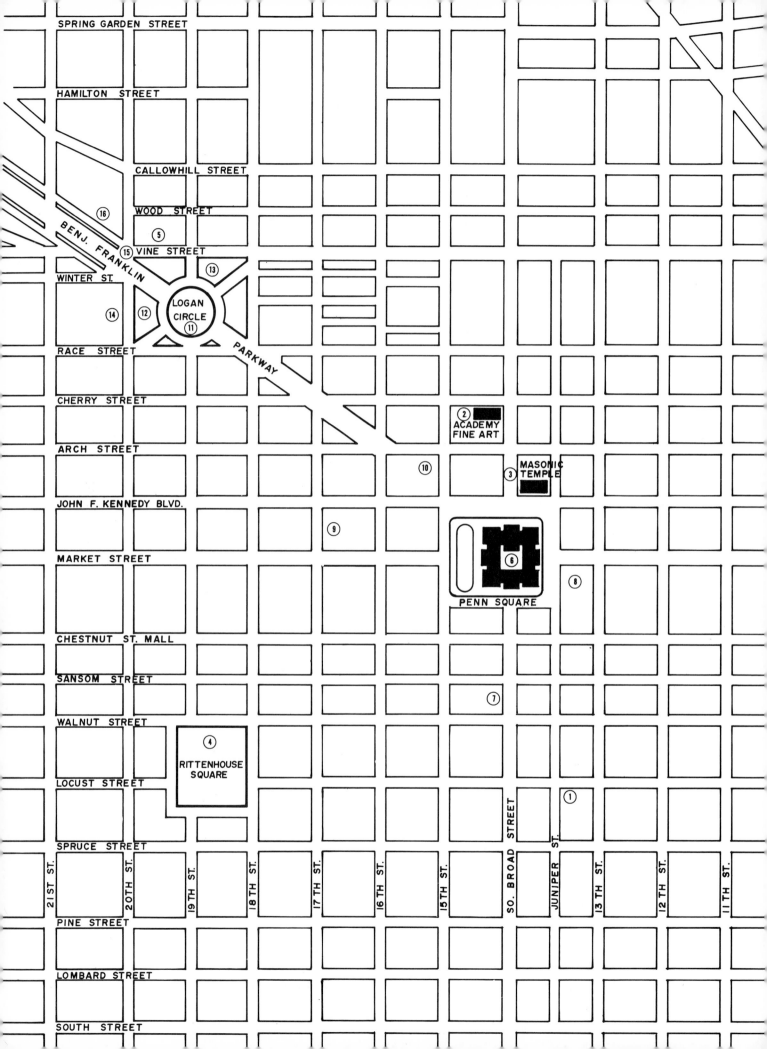

CENTER CITY:
City Hall

Penn's original plan was a logical gridiron of streets numbered from east to west, and named for trees from north to south. Most Philadelphians can still recite "Chestnut, Walnut, Spruce, and Pine." The early city plan provided for five squares. The central one, called Centre Square, housed the municipal waterworks and was a lovely park ornamented with William Rush's fountain of a nymph. Today it is City Hall courtyard, surrounded by the municipal building covered with Alexander Milne Calder's sculpture. The city blocks from Locust on the south to Cherry Street on the north contain one of the greatest collections of nineteenth-century buildings anywhere in the United States: the Academy of Music, the Union League, the Pantheon-like Girard Bank, Wanamaker's Department Store, City Hall, Masonic Hall, and the Pennsylvania Academy of the Fine Arts. Nearby are the Library Company and the Pennsylvania Historical Society on Locust Street, both custodians of important sculpture collections. City Hall, with its famous architectural sculpture, serves as a backdrop for other works—Civil War equestrian generals on the north, on the east President McKinley and the merchant John Wanamaker facing his famous store. Penn Center to the northwest is an outdoor garden displaying twentieth-century masterpieces by Henry Moore, Alexander Calder, and Seymour Lipton. Soon to be added by the Fairmount Park Art Association to the plaza of the Municipal Services Building is a monumental work by Jacques Lipchitz. On North Broad Street at Cherry stands the oldest art school in the United States, with a distinguished collection of sculpture and painting, and to the southwest of City Hall is Rittenhouse Square, with its great Bayre lion and the smaller Billy goat that Philadelphia children love.

Three generations of Calders have enhanced Philadelphia's streets—the City Hall sculpture with the colossal statue of Penn on top by Alexander Milne Calder; the Swann Memorial Fountain at Logan Circle by his son, Alexander Stirling Calder; and the IBM building stabile by Alexander Calder, Stirling's son. The grand boulevard Philadelphians call the Parkway is the wide diagonal running northwest from center square to Logal Circle and beyond. It is an avenue of museums and libraries that contain great collections as well as important sculpture.

⑫ **Aero Memorial**
③ **Beauty, Faith, Hope, Wisdom, Charity**
④ **Billy**
⑥ **City Hall**
⑮ **Civil War Soldiers and Sailors Memorial**
② **Comedy and Tragedy**
④ **Duck Girl**
⑧ **Eagle**
③ **Virtue, Faith, Hope, Charity**
①⑤⑭ **Franklin, Benjamin**
② **Freedman**
⑤ **Fust, Johann**
⑯ **Great Mother**
⑤ **Gutenberg, Johann**
② **Hero**
② **Jones, John Paul**
② **Justice and Wisdom**

⑨ **Leviathan**
④ **Lion Crushing a Serpent**
⑥ **McKinley, William**
① **Minerva**
⑥ **Penn, William**
② **Peri**
② **Plaques, Decorative**
② **Prodigal Son**
⑥ **Reynolds, Gen. John Fulton**
② **Rush, William, Self-Portrait**
⑬ **Shakespeare Memorial**
⑦ **Spirit of '61**
⑪ **Swann Fountain**
⑨ **Three Disks, One Lacking**
⑩ **Three-Way Piece Number 1: Points**
⑤⑥ **Washington, George**
② **Wright, Joseph**

Map drawing by Hugh J. McCauley A.I.A.

Benjamin Franklin c.1791
by Francesco Lazzarini (d.1808)
Marble, height 98″
Library Company of Philadelphia
1314 Locust Street

This Carrara marble statue of Dr. Franklin stood for generations in a niche above the main entrance to the Library Company. Though appropriately placed—Franklin founded the library in 1731—it has suffered because of constant exposure to the elements. Fortunately it now stands safely inside the library's new building. Franklin's erudition is conveyed by the pillar of books upon which his right arm rests. Originally, there was a scepter, pointing downward, in his hand—symbolic of Franklin's dislike of monarchies.

26

Justice and Wisdom c.1824
by William Rush (1756–1833)
Painted pine, height 96″
Pennsylvania Academy of the Fine Arts,
Broad and Cherry Streets

These elaborate figures originally stood on a triumphal arch
in front of Independence Hall. This grand display was ar-
ranged as part of the jubilant welcome for Lafayette when he
returned to the United States. The great French supporter of
the Revolution was greeted by a parade as he approached
Philadelphia and led, with fitting pomp, to Independence
Hall by way of the great arch. Later, the statues were re-
moved to the Fairmount Waterworks.

Minerva as the Patroness of American Liberty 1792
by Giuseppe Ceracchi (1751–1802)
Terra cotta, bronze patina, height 66″
Library Company of Philadelphia
1314 Locust Street

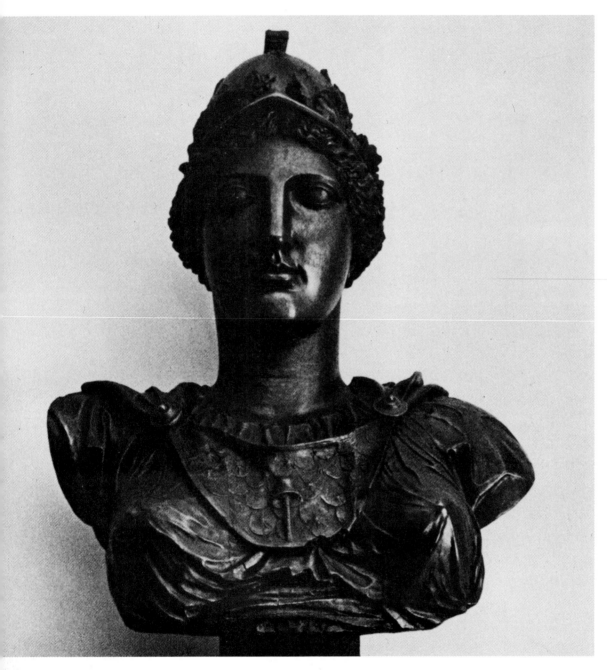

This imposing bust was executed by Ceracchi in the
hope of impressing Congress so that he would receive
a commission to do an equestrian statue of
Washington. Congress was impressed, so much so
that *Minerva* was placed behind the speaker's chair in
Congress Hall. When Congress moved to Washington,
the bust was presented to the Library Company,
where it has commanded attention to this day.

Comedy

Comedy and Tragedy 1808
by William Rush (1756–1833)
Pine: *Comedy*, height 90½″ (base 13½″);
Tragedy, height 90″ (base 11½″)
Pennsylvania Academy of Fine Arts,
Broad and Cherry Streets

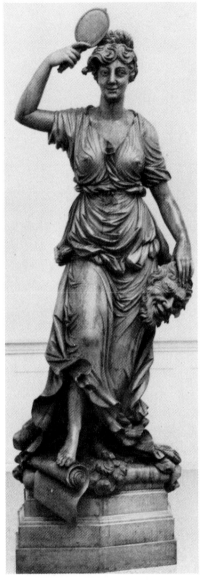

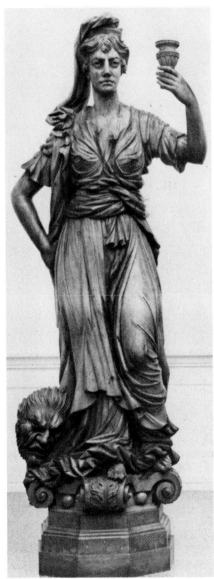

These statues were the first architectural carvings done
by multitalented William Rush. They originally stood in
niches in front of the Chestnut Street Theatre. Luckily,
they were saved when a fire destroyed the theater some
years later. *Comedy* and *Tragedy* are considered out-
standing examples of early American sculpture. At the
time of their completion, a Philadelphia newspaper
noted: "... the genius of the artist is truly portrayed; he
has done himself honor and added to that of his country."

Tragedy

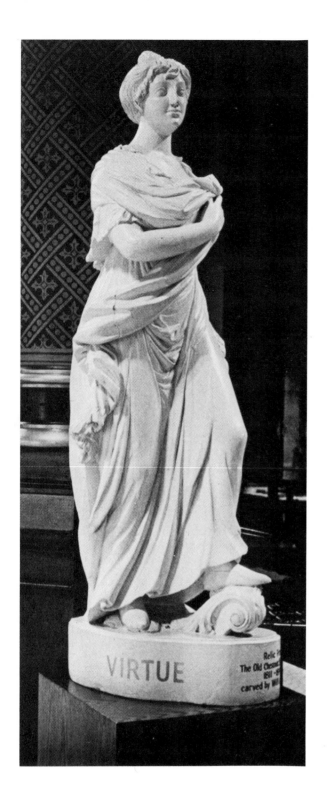

Virtue c.1811
Faith, Hope, Charity c.1811
by William Rush (1756–1833)
Painted pine: *Virtue*, height 70½″ (base 25″);
Faith, height 26½″, length 58½″; *Hope*, height
26½″, length 60½″; *Charity*, height 36½″,
length 69½″
Grand Lodge of Free and Accepted Masons of
Pennsylvania, 1 North Broad Street

The lovely representation of Virtue is
one of Rush's early works. It is believed
to have been intended as a ship's
figurehead—Rush began as a carver of
figureheads. Its design was probably al-
tered to suit the purposes of the Ma-
sons. Happily, Virtue is in a perfect
state of preservation, as are Faith,
Hope, and Charity. These works, care-
fully executed in intricate detail, are
superb examples of their creator's
genius.

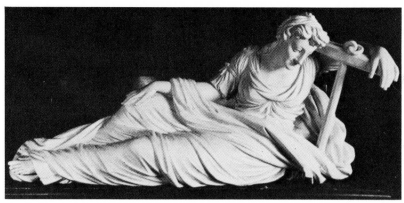

Hope

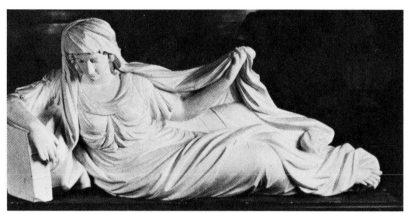

Faith

John Paul Jones 1780
by Jeane Antoine Houdon
(1741–1828)
Plaster, height 27¾″
Bronze cast, 1905
Pennsylvania Academy
of the Fine Arts,
Broad and Cherry Streets

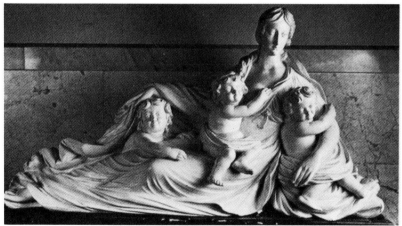

Charity

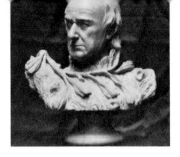

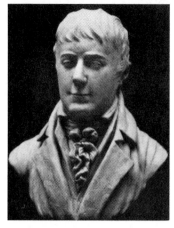

Self-Portrait (Pine Knot) c.1822
by William Rush (1756–1833)
Bronze, height 19½"; cast 1905
from original terra cotta
Pennsylvania Academy
of the Fine Arts,
Broad and Cherry Streets

Joseph Wright c.1811
by William Rush (1756–1833)
Terra cotta, height 19½"
Pennsylvania Academy
of the Fine Arts,
Broad and Cherry Streets

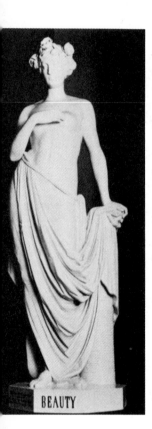
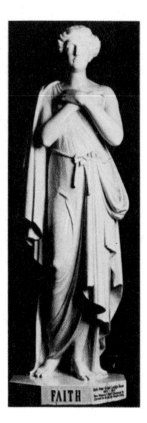
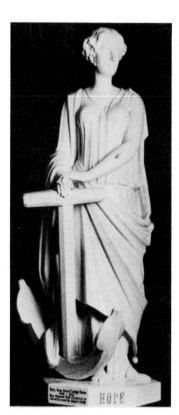
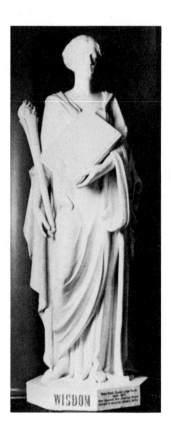
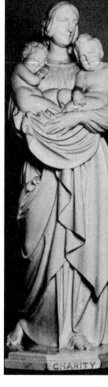

Beauty, Faith, Hope, Wisdom, Charity 1855
by Joseph A. Bailly (1825–83)
Wood painted white: *Beauty,* height 75";
Faith, height 72"; *Hope,* height 72";
Wisdom, height 72"; *Strength,* height 72";
lead painted white:
Charity, height 72"
Grand Lodge of Free and Accepted Masons
of Pennsylvania, 1 North Broad Street

These statues, representing the
female attributes of Masonry, are
early works of Joseph Bailly, one of
Philadelphia's most important
19th-century sculptors. The pro-
nounced formality of these figures
is a typical expression of the artis-
tic spirit of the period.

Lion Crushing a Serpent 1832
by Antoine Louis Barye (1796–1875)
Bronze, height 54″ (granite base 38″)
Rittenhouse Square,
Walnut Street between 18th and 19th

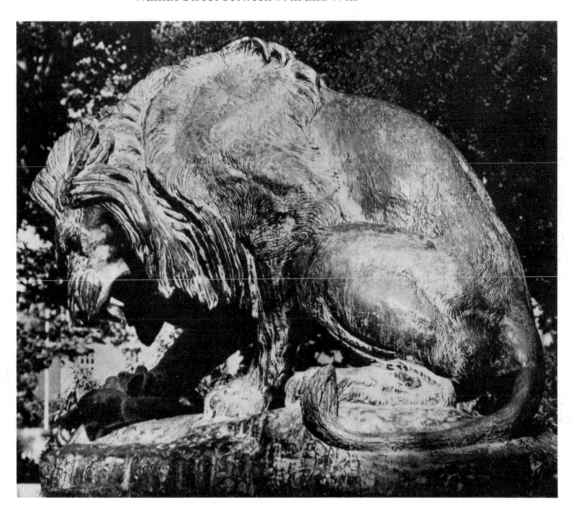

The startling realism of this masterpiece of sculpture never ceases to amaze and delight both young and old. Its creator, the great French Romantic sculptor Barye, chose animals to express his moral concerns; in this case, the triumph of good (the lion) over evil (the serpent). But his genuine fascination with, and love of, animals are apparent, and were equal in importance to the conveying of his ethical beliefs. Magnificent in its every detail and overall dramatic intensity, *Lion Crushing a Serpent* is one of Philadelphia's greatest treasures. This superb cast (the first cast is in the Louvre in Paris) was obtained by the Fairmount Park Art Association and appropriately placed in the center of Rittenhouse Square in 1892.

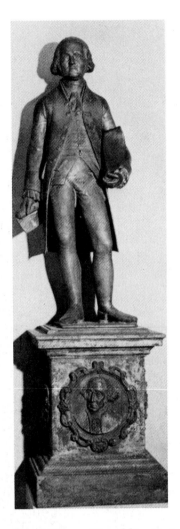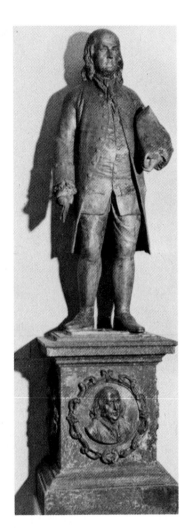

Washington, Franklin, Gutenberg, Fust c.1857
Unknown sculptor
Lead: *Washington*, height 49¼″;
Franklin, height 50¼″;
Gutenberg, height 49⅞″;
Fust, height 49½″
(each with a lead base of 27½″)
Free Library of Philadelphia,
Rare Book Department, 20th and Vine Streets

These four statues, along with four others, were originally facade ornamentation on the fifth-floor level of the old *Public Ledger* building, whose intricately detailed cast-iron front provided a handsome setting. The bas-reliefs, which enhance the bases of the statues, were added later. They first were architectural decoration at another story of the newspaper's headquarters.

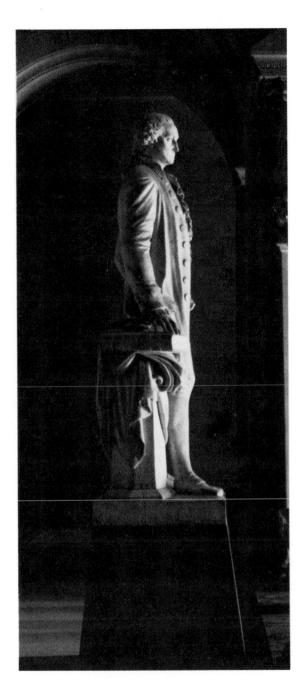

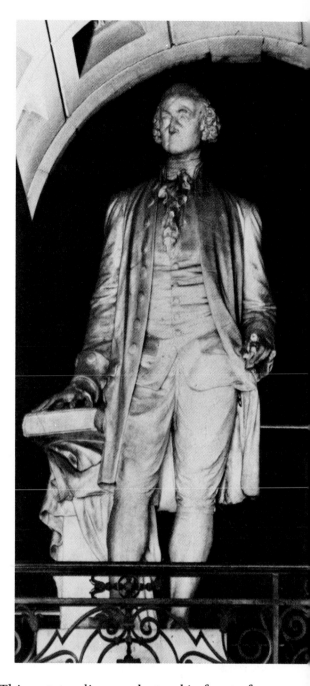

George Washington 1869
by Joseph A. Bailly (1825–83)
Marble, height 102″ (base 80″)
City Hall

This outstanding work stood in front of Independence Hall until the 1880s, when it was moved to City Hall, where it dominates a balcony above the north vestibule. Bailly, the sculptor, was born in Paris, and began his career as a wood carver. He fled from the Revolution of 1848 to the United States. After brief stays in several cities, he settled permanently in Philadelphia. He had a shop in "Marble Alley" and enjoyed a thriving business.

City Hall
by Alexander Milne Calder (1846–1923), sculptor
John B. McArthur, Jr. (1823–90), architect
Marble
Broad Street

Work on Philadelphia's monumental City Hall began in the 1870s. The style is basically that of the French Second Empire. Originally, there were no plans for elaborate sculptural ornamentation. Construction of the building took more than thirty years, and at completion the exterior and interior were adorned with over 250 figures. At the time, City Hall was the most heavily and elaborately ornamented public building in the United States. The incredible task of creating and supervising this sculptural program was undertaken by Alexander Milne Calder and a number of studio assistants. Extraordinary in its variety—from William Penn on top of the clock tower to a cat chasing a mouse on a panel in the south entrance vestibule— the sculpture of City Hall is a spectacular tour de force.

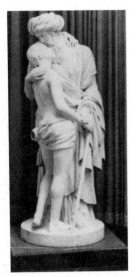

The Prodigal Son
by Joseph Mozier
(1812–70)
Marble, height 75″
Pennsylvania Academy
of the Fine Arts,
Broad and Cherry Streets

Hero 1869
by William Henry Rinehart
(1825–74)
Marble, height 35¾″
Pennsylvania Academy
of the Fine Arts,
Broad and Cherry Streets

The Freedman
by John Quincy Adams Ward (1830–1910)
Plaster, height c. 25″
Pennsylvania Academy
of the Fine Arts,
Broad and Cherry Streets

The Peri 1856
by Thomas G. Crawford (1813–57)
Marble, height 70″
Pennsylvania Academy
of the Fine Arts,
Broad and Cherry Streets

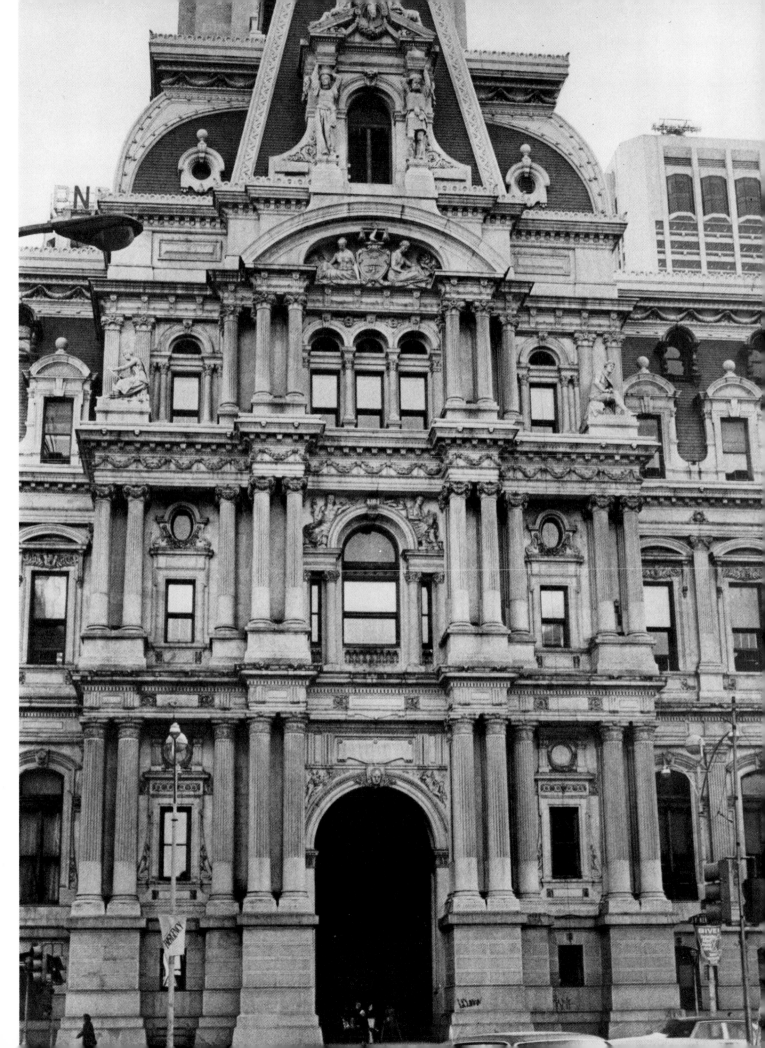

Buffalo Head Keystone
by Alexander Milne Calder (1846–1923)
Marble
City Hall

This massive buffalo head appears on a keystone between the north vestibule and the crypt, under the clock tower. It symbolizes the American continent. Other keystones bear animals representing the continents of Europe, Asia, and Africa.

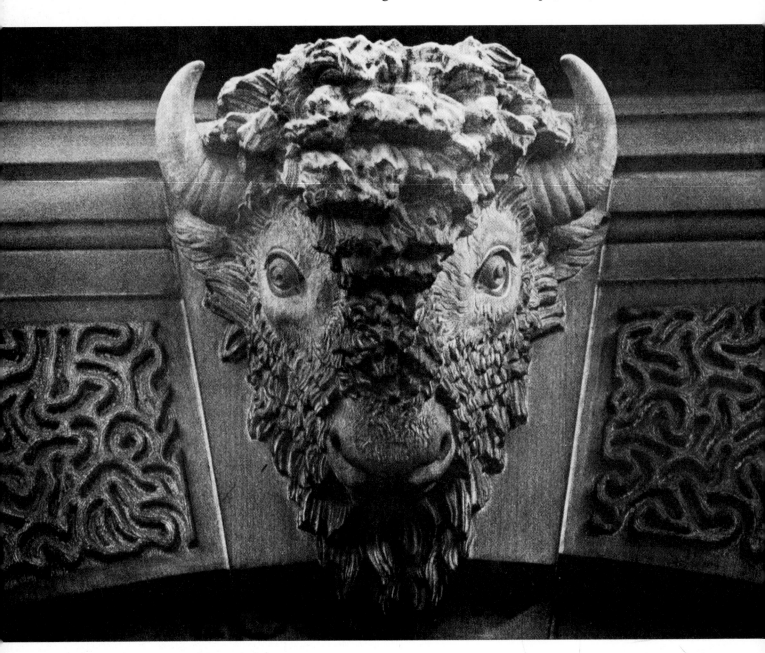

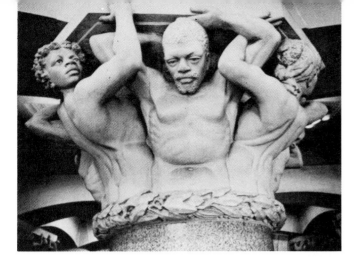

African figures form the capital
of a marble column.

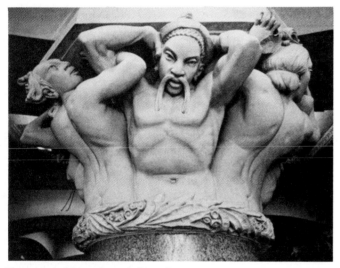

The capital of this column is formed
by figures representing Asia.

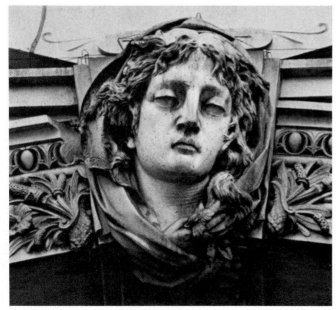

The face of Sympathy watches from a keystone
under which prisoners once entered City Hall.

This seated figure, symbolizing Law,
guards the entrance to the law courts.

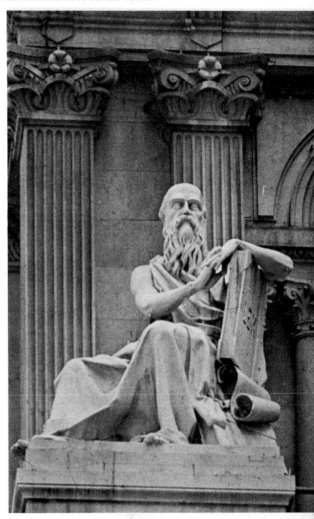

A return to Classicism is seen in this
high-relief stairway spandrel.

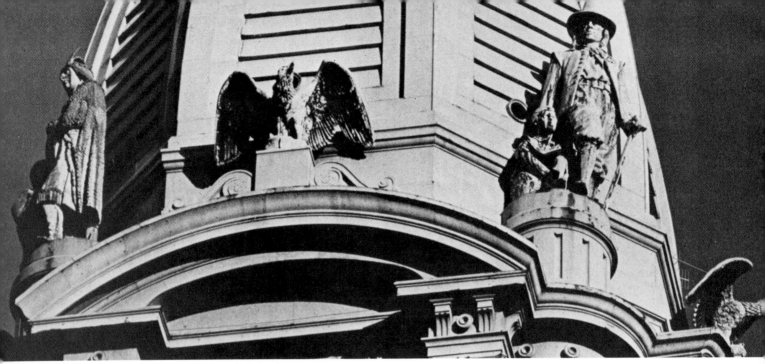

*Eagle and standing figures at the
first story of the clock tower.*

Dormer caryatids and crowning figures on top.

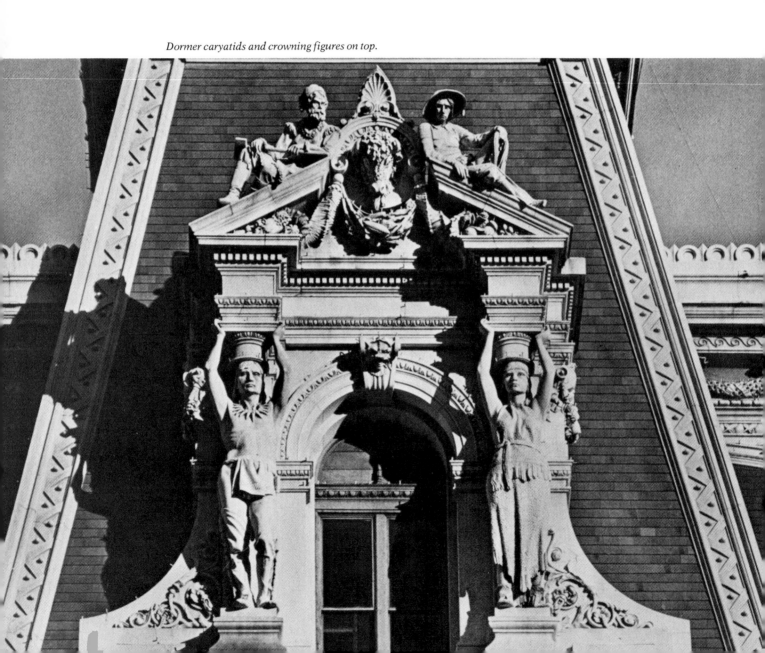

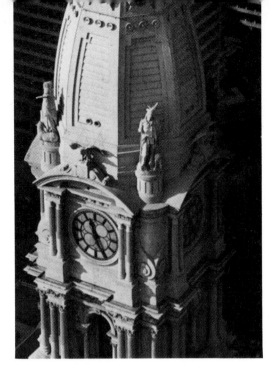

Domed clock tower.

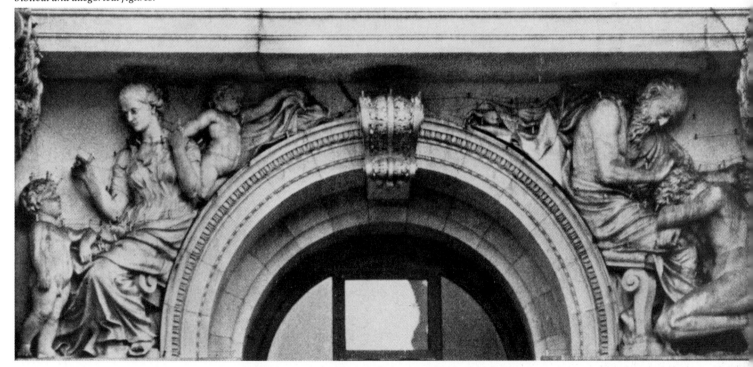

Keystone (William Penn) and spandrels portraying biblical and allegorical figures.

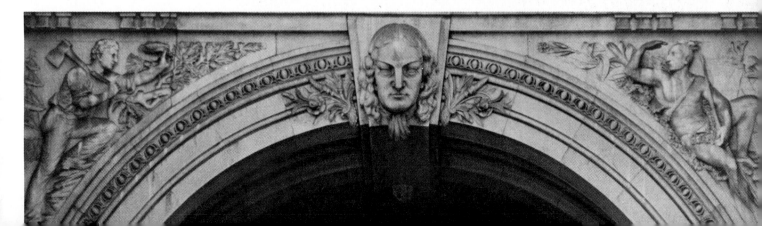

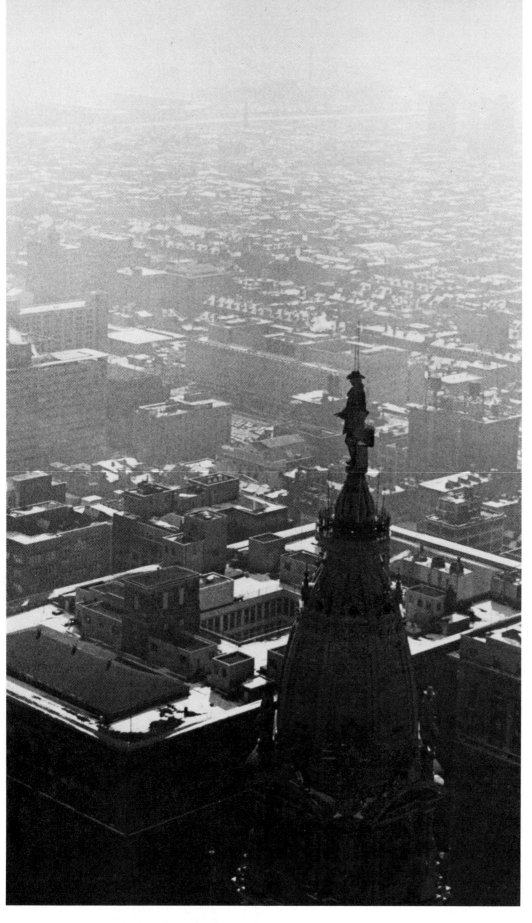

William Penn 1894
by Alexander Milne Calder (1846–1923)
Bronze, height 436″
Top of City Hall tower

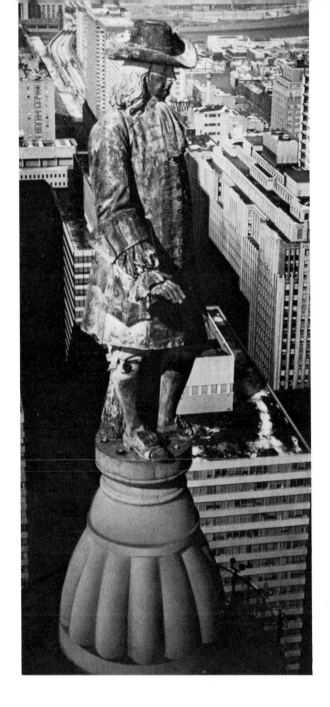

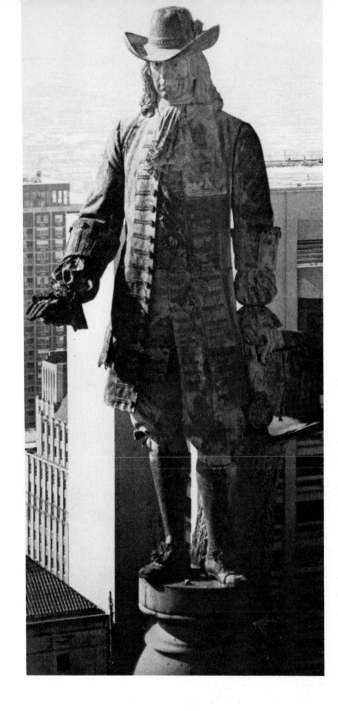

This remarkable statue of "Billy Penn" is almost 37 feet tall and weighs some 27 tons. It is the largest statue on top of a building in the world. This colossus is one of Alexander Calder's finest creations. Penn is portrayed in the prime of life, and Calder rendered the features and costume of the man with surprising historical accuracy. The young and aristocratic founder of Pennsylvania stands facing Penn Treaty Park, where he had met with the Leni Lenape Indians. In his left hand is the Charter of Pennsylvania. Photographing this enormous structure was done from a helicopter over several months and at different times of day.

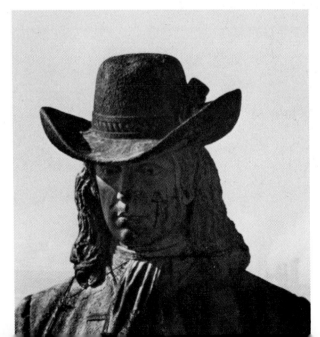

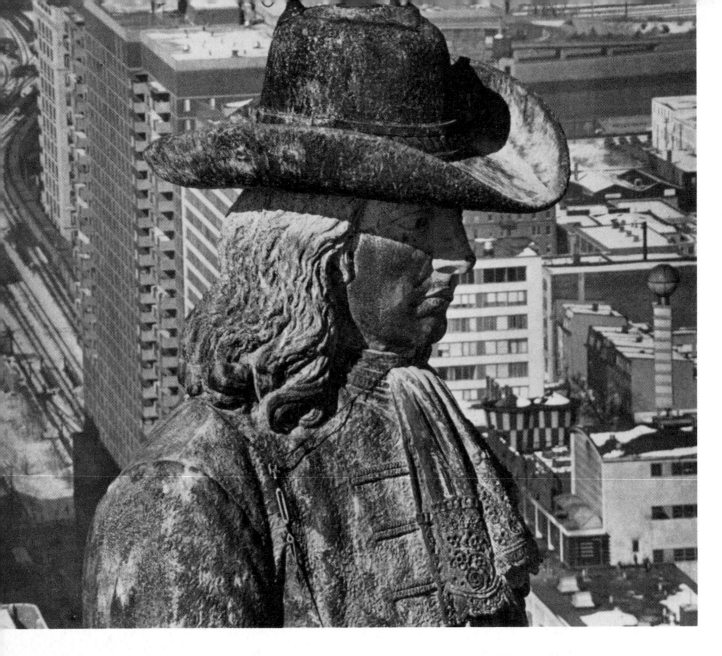
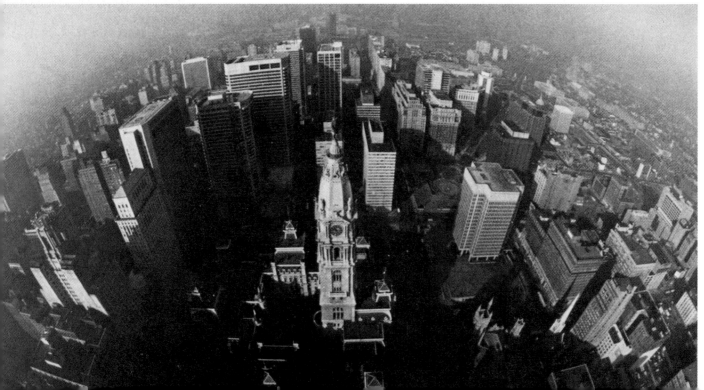

LEFT:
William McKinley 1908
by Charles Albert Lopez (1869–1906)
and Isidore Konti (1862–1938)
Bronze, height 114″ (granite base 174″)
City Hall, South Plaza

BELOW
General John Fulton Reynolds 1884
by John Rogers (1829–1904)
Bronze, height 144″ (granite base 120″)
North City Hall Plaza

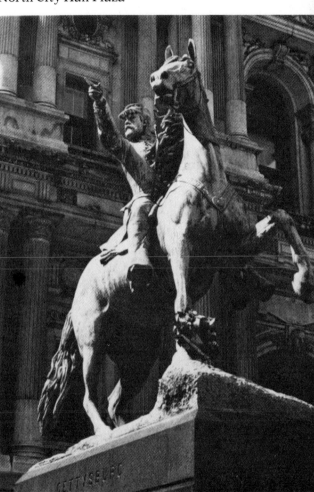

After the assassination of our 25th President, Philadelphians moved swiftly to honor his memory with an appropriate monument. They remembered McKinley's visits to the city for the dedication of the Washington and Grant memorials. This statue portrays the slain President in the typical act of making a speech.

Philadelphia's first equestrian statue was commissioned as a tribute to General Reynolds, who lost his life while fighting for the Union at Gettysburg. The general is shown on the first day of battle in the act of giving orders to his aides. The superb rendering of his horse attests to the sculptor's skill and knowledge of the animal's anatomy. Philadelphia's first public monument to a Civil War soldier, it was unveiled on Grand Army Day, 1884, with a parade and elaborate ceremonies.

Spirit of '61 1911
by Henry Kirke Bush-Brown (1857–1935)
Bronze, height 106″, to bayonet tip 120″
(polished granite base 72″)
Union League of Philadelphia
140 South Broad Street

This spirited representation of the Union soldier was commissioned by the First Regiment on its 50th anniversary. It commemorates the regiment's response to Lincoln's call to arms on April 17, 1861. Although intended for Fairmount Park, it still stands where it was originally placed in front of the Union League.

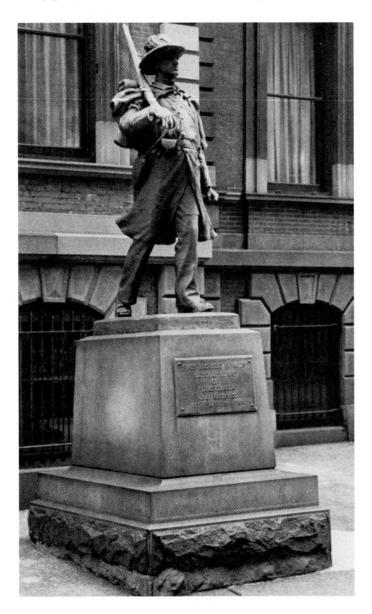

Billy 1914
by Albert Laessle (1877–1954)
Bronze, height 26″
(granite base 22″)
Rittenhouse Square,
Walnut Street
between 18th and 19th

OPPOSITE PAGE
Long a favorite of children who visit Rittenhouse Square, this billy goat has had so many riders that the patina has been worn off his horns so that the points appear tipped with gold.

Duck Girl 1911
by Paul Manship (1885–1966)
Bronze, height 61″
(limestone base 32″)
Rittenhouse Square,
Children's Pool,
Walnut Street
between 18th and 19th

OPPOSITE PAGE
This lovely girl in Greek dress was lost for a time in storage, but was found in the 1960s and placed in Rittenhouse Square, where she continues her silent dance through seasons.

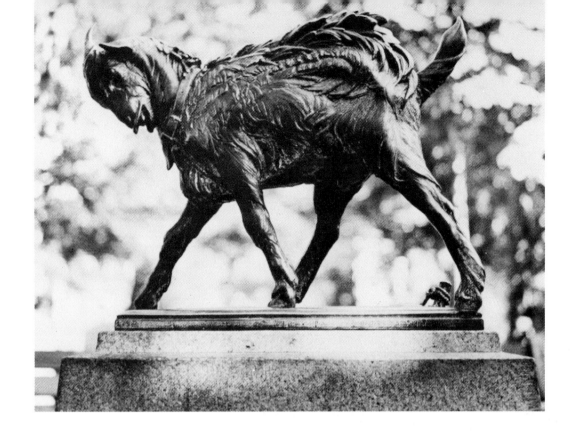

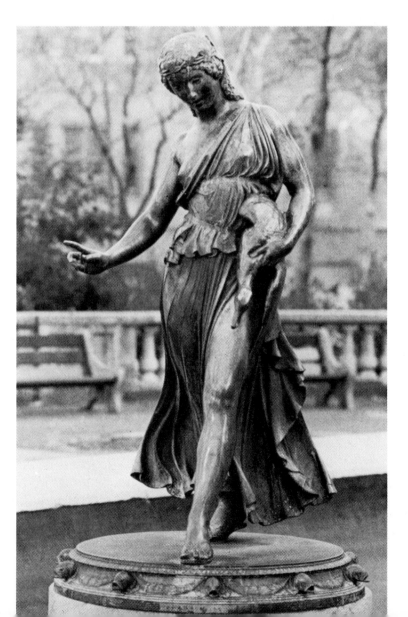

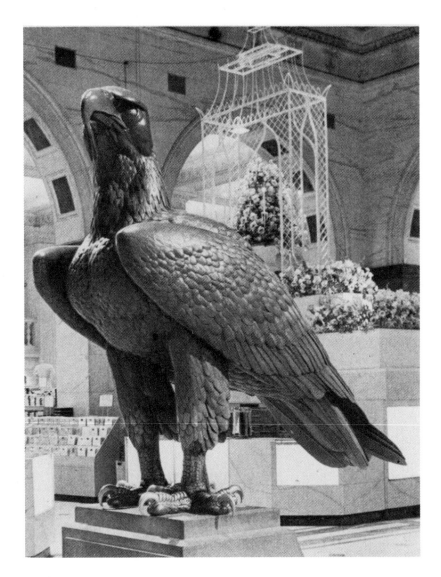

Eagle 1904
by August Gaul (1869–1921)
Bronze, height 78″;
length 118″; width 39″
John Wanamaker's,
Center Court,
13th and Chestnut Streets

The famous Wanamaker eagle has been a favorite meeting place for Philadelphians for years. Made in Germany, it was sent to this country in 1904 for the Louisiana Purchase Exposition in St. Louis. Wanamaker's store bought it after the exposition closed. The colossal bird weighs 2,500 pounds. Each feather was wrought and attached by hand. Forged from a special bronze, it has a warm golden luster.

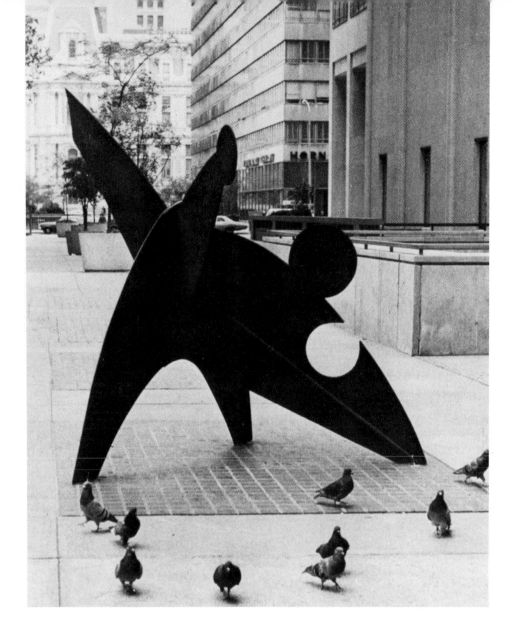

Three Disks One Lacking 1964
by Alexander Calder (1898–)
Painted metal sheeting,
height 102″, width 84″
Penn Center Plaza,
17th Street and
John F. Kennedy Boulevard

This cheerful stabile is representative of the
work of Philadelphia-born Alexander Calder,
scion of the renowned family of sculptors.
A sense of humor is usually present in his crea-
tions, whether stabiles or mobiles, as well as a
love of play and movement. "Sandy" Calder is
the son of Alexander Stirling Calder, creator of
the Swann Fountain, and the grandson of
Alexander Milne Calder, who directed the
sculptural program on City Hall.

Leviathan 1963
by Seymour Lipton (1903–)
Nickel silver on monel metal, height 40½″
(granite base 94½″)
Penn Center Plaza, 17th Street between
Market and John F. Kennedy Boulevard

This strikingly contemporary sculpture is distinguished by its dramatic interplay of hollows and curves. The sculptor's aim is to use "the plastic language of today" to represent symbolically the soul of man. *Leviathan* stands appropriately in the revitalized commercial area in Penn Center.

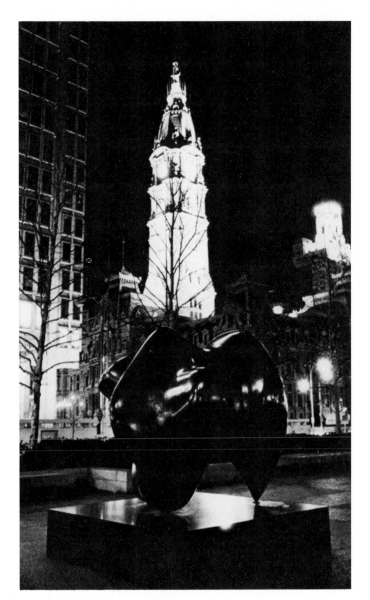

Three-Way Piece Number 1: Points 1964
by Henry Moore (1898–)
Bronze, 54″ (granite base)
John F. Kennedy Plaza, 15th and Arch Streets

This is an imposing example of the great humanist sculptor's massive bronze forms. *Three-Way Piece* refers to three jutting points of a pebble that may have inspired the work. The form is faultlessly balanced on these three points. This outsize reflection of the natural world has been modeled into a smooth hulking shape that dominates its immediate surroundings. Of a dull golden color, it is as prepossessing as the concrete skyscrapers inhabiting the city around it. The soaring curves are typical of Henry Moore's forms, which echo the spirit of the plant and animal world enlarged to symbolic proportions. *Three-Way Piece* has reminded many observers of a large animal poised on its haunches.

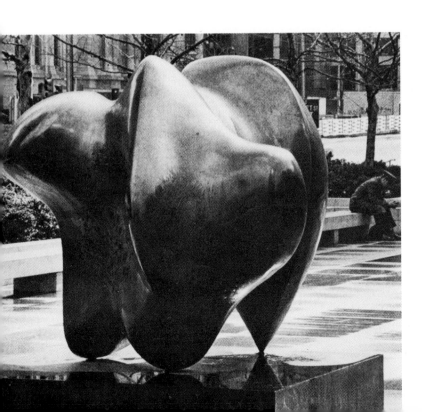

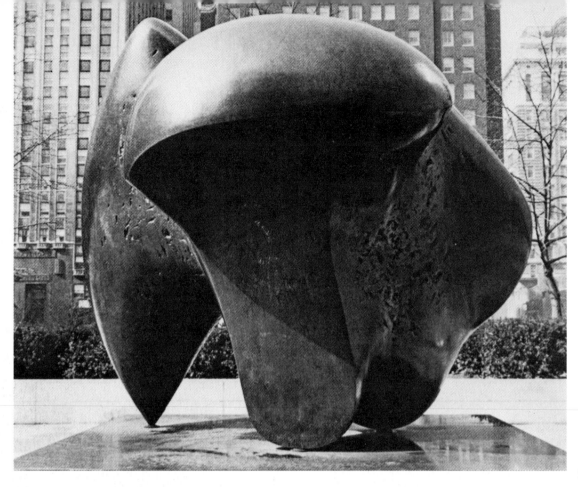

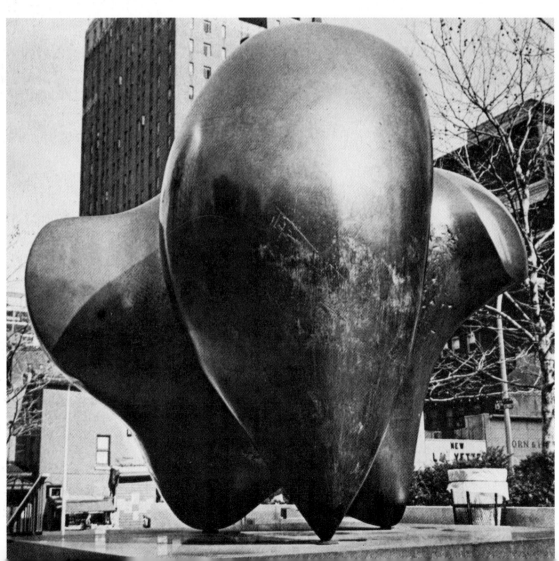

Two more views of Henry Moore's Three-Way Piece Number 1: Points.

Decorative Plaques c.1877
by Alexander Kemp
Terra cotta, 60″ by 58½″
Pennsylvania Academy
of the Fine Arts,
Broad and Cherry Streets

Much of Philadelphia's architecture has been characterized by the use of figurative sculpture on a facade to explain the interior function of a building. Frank Furness, the architect of the Pennsylvania Academy of the Fine Arts, selected Alexander Kemp to create a series of six panels for the Academy, each portraying a group of great medieval and Renaissance painters, architects, and sculptors. Three of the reliefs are represented here. The plaque at top, right, depicts important medieval and Renaissance architects. The two at bottom, right, are of painters.

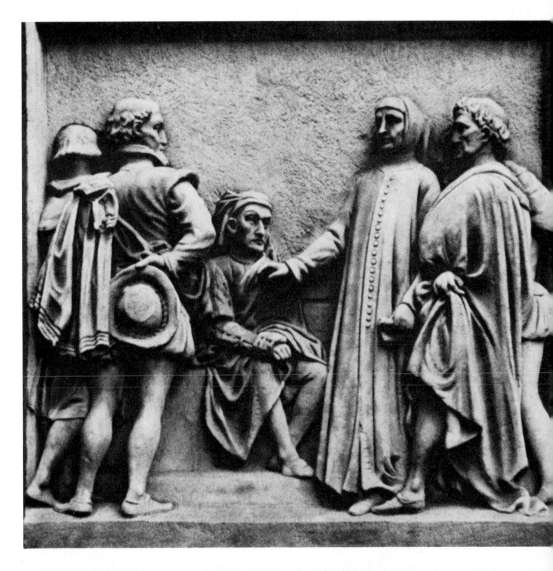

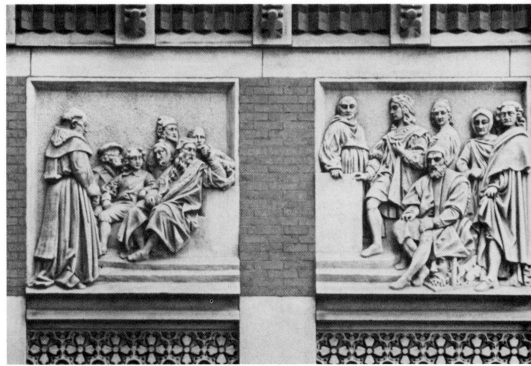

Swann Memorial Fountain 1924
by Alexander Stirling Calder (1870–1945)
Bronze, figures 132″ high
(granite base 62″ above pool bed)
Logan Circle,
19th Street and Benjamin Franklin Parkway

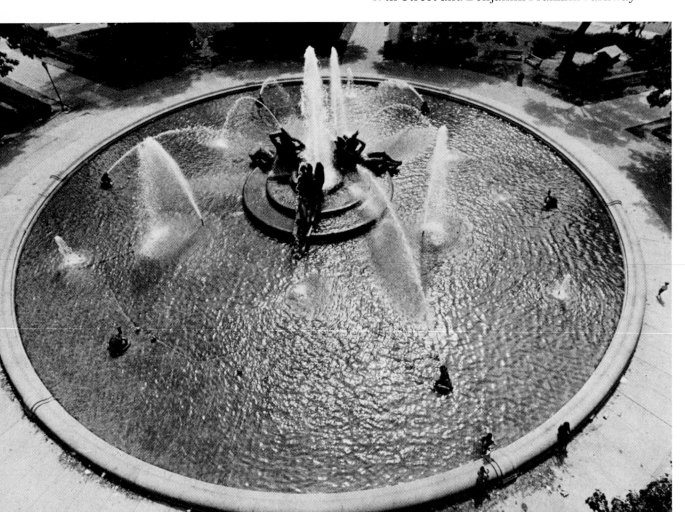

For this fountain, Philadelphia's well-known sculptor Alexander Stirling Calder used allegorical figures to represent the three rivers that enclose the city of Philadelphia, and bronze frogs and turtles in the surrounding low-lying basin.

An interesting contrast is created by the passivity of reclining figures, over and around which there is the constant rush of water.

The Wissahickon creek is represented by the sculptor's version of Leda leaning against a water-spouting swan. This languid female form is a lovely incarnation of the mythological princess.

The second river, the Delaware, is symbolized by a virile nude Indian, who conveys the calm strength associated with the Delaware. The river god is depicted in a pensive mood, reinforcing the general impression of great dignity.

(continued on page 58)

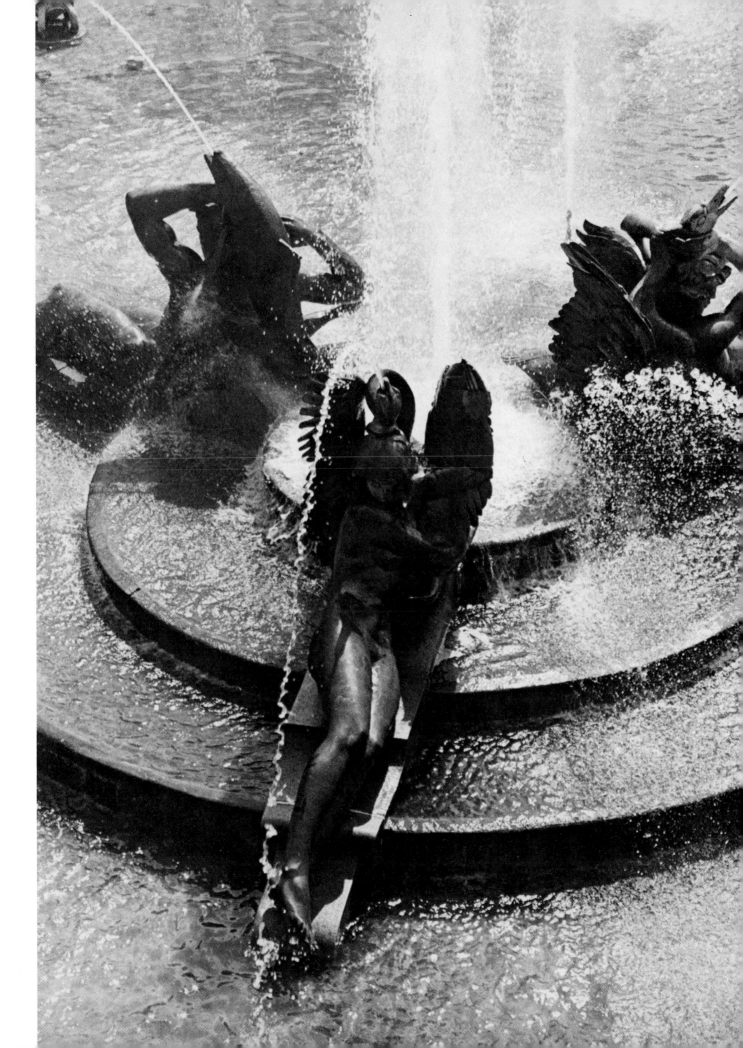

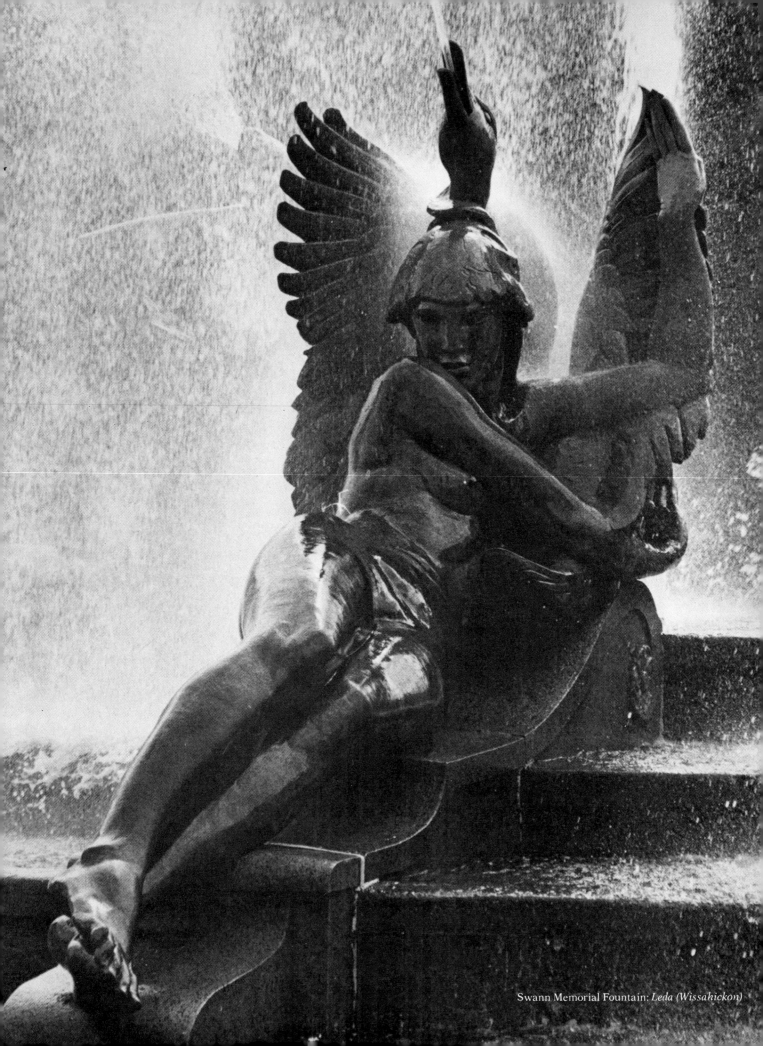

Swann Memorial Fountain: *Leda (Wissahickon)*

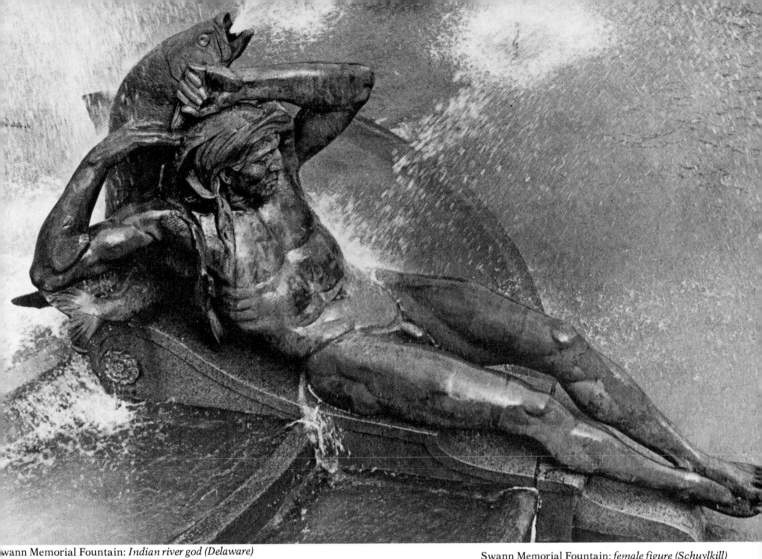

wann Memorial Fountain: *Indian river god (Delaware)*

Swann Memorial Fountain: *female figure (Schuylkill)*

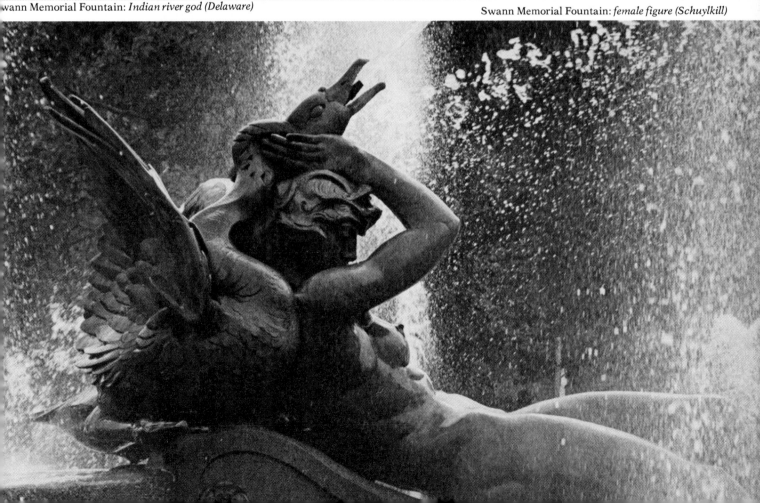

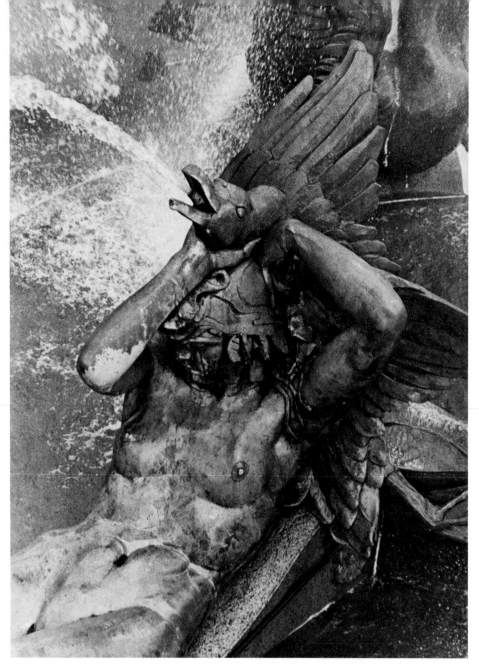

Swann Memorial Fountain: *female figure*

(continued from page 54)

The powerful female figure symbolizing the Schuylkill River holds the neck of an agitated swan, which perches on her shoulders.

The sculptures that comprise the Swann Fountain are not excessively monumental, allowing for a feeling of elegant spaciousness and an unobstructed view up the Parkway to the Philadelphia Museum of Art.

The fountain was the gift of the Fountain Society; it was to be their largest and last gift to Philadelphia before they merged with the Women's Society for the Prevention of Cruelty to Animals.

Benjamin Franklin 1938
by James Earle Fraser (1876–1953)
Marble, height 150″ (marble base 100½″)
Franklin Institute,
Benjamin Franklin Parkway at 20th Street

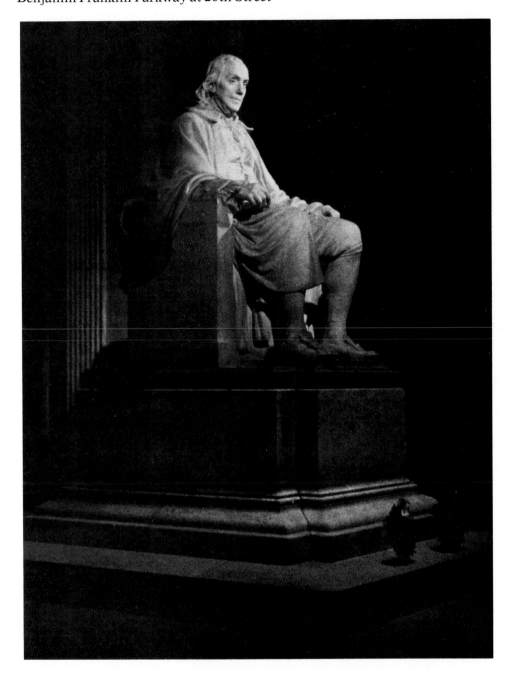

Famous for his design of the buffalo nickel, James Earle Fraser
brought the full concentration of his outstanding talent to this
subtle characterization of one of America's most beloved his-
torical figures. Almost twenty-one feet high, and with a thirty-
ton pedestal, the statue is a calm Franklin. The face, however,
is alive—the eyes alert and intelligent.

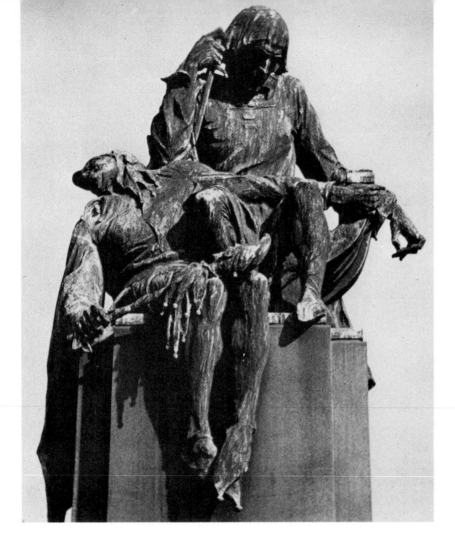

Shakespeare Memorial 1926
by Alexander Stirling Calder
(1870–1945)
Bronze, height 72″
(black marble base 170″)
Logan Square,
Parkway near 19th Street

This dramatic memorial to the great playwright is one of Alexander Stirling Calder's most moving masterpieces. Hamlet is leaning his head against a knife with the jester Touchstone at his feet, his head thrown back in laughter. The two figures represent Tragedy and Comedy. Inscribed on the base are the lines from *As You Like It:* "All the world's a stage, and all the men and women merely players."

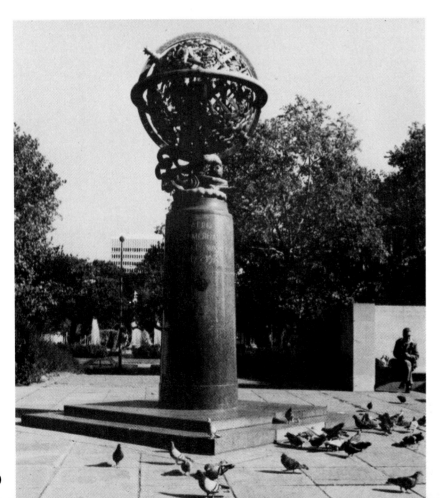

Aero Memorial 1948
by Paul Manship (1885–1966)
Bronze, height 96″ (limestone base 116″)
Logan Circle at 20th Street

As a memorial to the aviators who died in World War II, Paul Manship designed a celestial sphere bearing the names of the stars, planets, and constellations in Latin. Manship is known for a number of similar spheres that he executed. The largest one, dedicated to Woodrow Wilson, is in the League of Nations at Geneva.

Civil War Soldiers and Sailors Memorial 1921
by Hermon Atkins MacNeil (1866–1947)
Marble, height of both pylons about 480″ (granite bases)
Benjamin Franklin Parkway at 20th Street

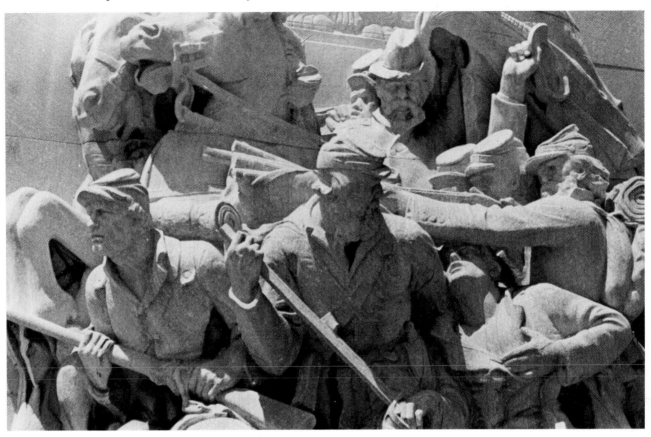

The stirring figures above were done by Hermon Atkins
MacNeil as a tribute to Civil War soldiers. They decorate
one of two dramatic pylons for the Benjamin Franklin
Parkway; the other pylon is similar, but dedicated to
sailors. Waldemar Raemisch's style in the sculpture below
is rather formal and medieval, and highly stylized. It was
cited for its "great strength of form and warmth of feel-
ing" by the Architectural League of New York.

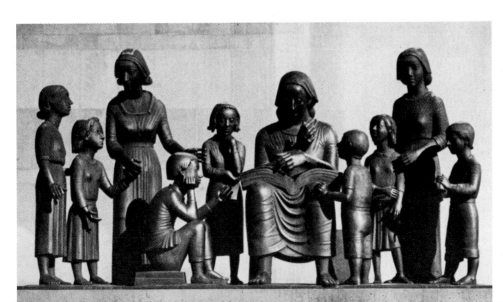

The Great Mother 1955
by Waldemar Raemisch
(1888–1955)
Bronze, height 119″
Youth Study Center,
20th and the Parkway

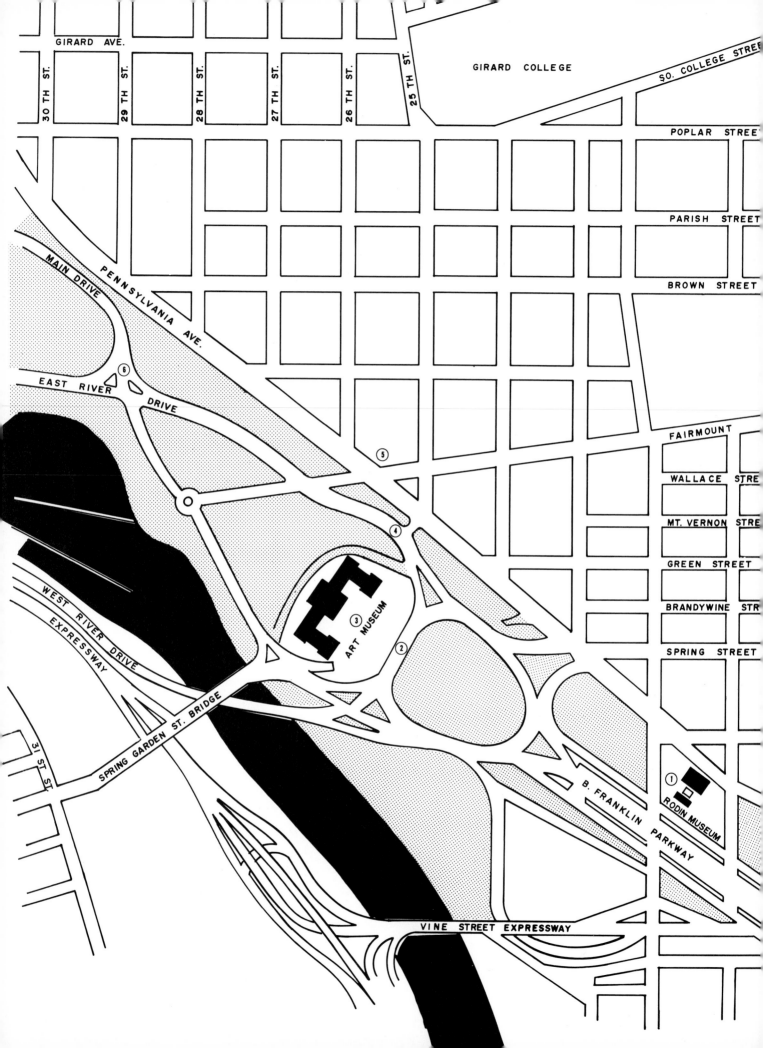

GIRARD AVE.

30 TH ST.

29 TH ST.

28 TH ST.

27 TH ST.

26 TH ST.

25 TH ST.

GIRARD COLLEGE

SO. COLLEGE STREET

POPLAR STREET

PARISH STREET

BROWN STREET

PENNSYLVANIA AVE.

MAIN DRIVE

EAST RIVER DRIVE

⑥

⑤

④

③ ART MUSEUM

②

FAIRMOUNT

WALLACE STREET

MT. VERNON STREET

GREEN STREET

BRANDYWINE STREET

SPRING STREET

WEST RIVER DRIVE EXPRESSWAY

SPRING GARDEN ST. BRIDGE

31 ST ST.

B. FRANKLIN PARKWAY

①

RODIN MUSEUM

VINE STREET EXPRESSWAY

THE PARKWAY:
Rodin Museum to the Lincoln Memorial

Known to Philadelphians as the Parkway, the Champs Elysées of the city is actually named for Benjamin Franklin. This street of museums replaced dense middle-income housing and provides an unbroken vista from City Hall to the Art Museum. The planning was begun in 1917 by Eli Kirk Price, a visionary philanthropist, and two French architect-planners, Paul Cret and Jacques Gréber, who also designed the Rodin Museum on the east side of the Parkway above Logan Circle. Starting near City Hall at J. F. Kennedy Plaza, the tourist passes the Cathedral of Saints Peter and Paul, the Academy of Natural Sciences, Franklin Institute, the Free Library of Philadelphia, and the Rodin, arriving at the Washington Monument in front of the large Greek temple-like Art Museum. This huge building, begun in 1919, is built over an old reservoir that was originally part of the second city water station at Fair Mount. Continuing past the east front, the East River Drive begins its long, scenic route through a magnificent public park, which is one of the largest in the world.

The Parkway and Drive are literally an outdoor sculpture museum, from Rodin's famous thinker, past the Washington fountain with its Indians, buffalo, bears, and bison and the General quietly riding atop the pyramid of forms, to Joan of Arc, bright gold in the sun. Just beyond, on an island in the East River Drive, is the quiet, pensive Lincoln, commissioned by the Lincoln Memorial Association, whose members' names only recently have been restored to history.

This tour, somewhat strenuous on foot, can be enjoyed by bicycle or by bus tours that leave from the Art Museum.

1. **Adam**
1. **Age of Bronze**
3. **The Amazon**
3. **Atmosphere & Environment, XII**
1. **Burghers of Calais**
3. **Diana**
3. **Eagle**
1. **Eve**
5. **Fidelity Mutual Life Insurance**
1. **Gates of Hell**
4. **Joan of Arc**
1. **John the Baptist Preaching**
6. **Lincoln, Abraham**
3. **Lion Fighter**
3. **Marshall, Chief Justice John**

3. **Mercury**
3. **Philadelphia Museum of Art**
3. **La Première Pose**
3. **Prometheus Strangling the Vulture**
3. **Pulaski, General Casimir**
3. **Puma**
3. **Reverence**
1. **Rodin Museum**
3. **Schuylkill Chained**
3. **Schuylkill Freed**
3. **Social Consciousness**
1. **The Thinker**
2. **Washington Monument**
3. **Water Nymph & Bittern**
3. **Wayne, General Anthony**

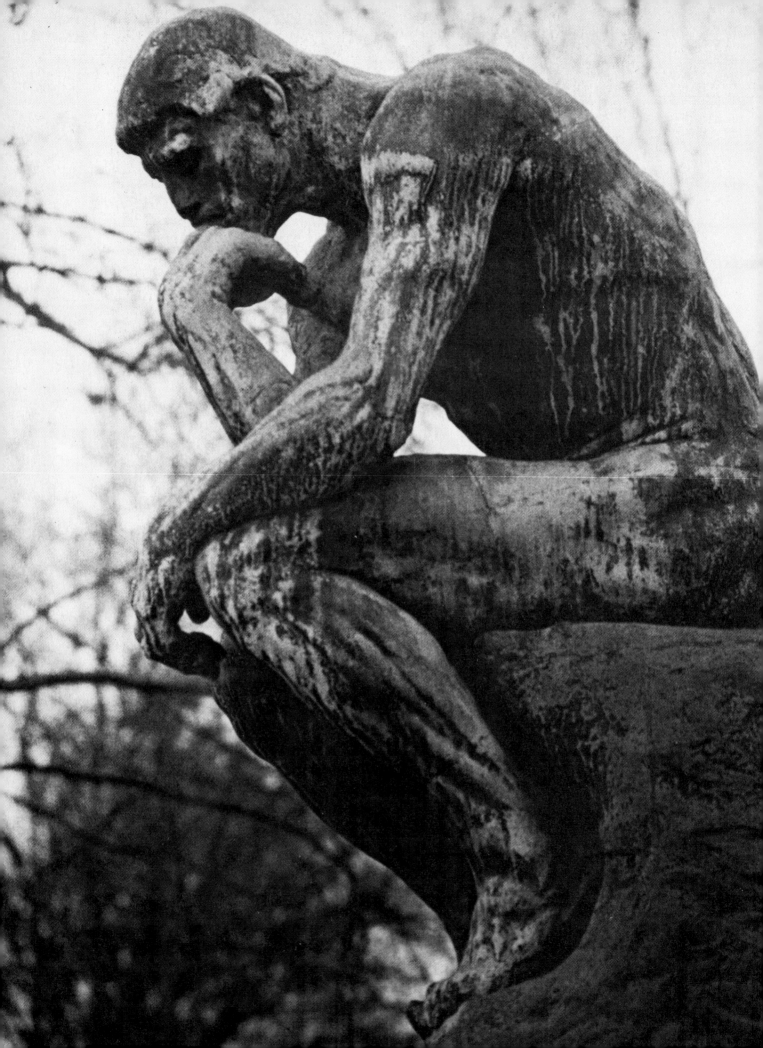

OPPOSITE PAGE
The Thinker 1880 (enlarged 1902–4)
by Auguste Rodin (1840–1917)
Bronze, height 79″ (limestone base)
Rodin Museum,
21st Street and Benjamin Franklin Parkway

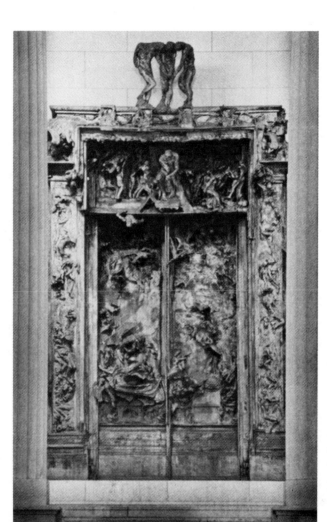

The Gates of Hell 1880–1917)
by Auguste Rodin (1840–1917)
Bronze, height 250¾″
Rodin Museum,
21st Street and
Benjamin Franklin Parkway

Standing at the entrance to the Rodin Museum on Benjamin Franklin Parkway is the first bronze cast of Auguste Rodin's *The Gates of Hell*. Commissioned at a turning point in his career, this work dominated Rodin's thoughts for ten years and remained a source of fascination and anxiety for the remainder of his life. *The Gates* may be regarded as a summary of a lifetime's preoccupation, and they convey Rodin's own overwhelming response to the beauty and expressive powers of the human body. The sculptor's thoughts on the tragic destiny of mankind are also reflected in the work. Many of Rodin's best-known

(continued on page 66)

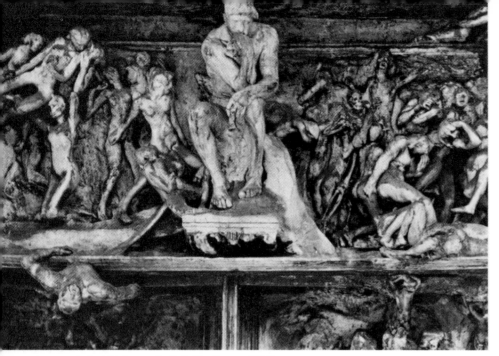

Close-up of The Thinker on Rodin's The Gates of Hell.

(continued from page 65)

sculptures were originally part of *The Gates of Hell. The Thinker,* perhaps the most famous, evolved from the smaller version which dominates the tympanum of *The Gates.* This masterpiece reveals more of Rodin's concern with the merging of the sensual and spiritual than an attempt to illustrate particular incidents from Dante's *Inferno.*

The typanum of Rodin's The Gates of Hell.

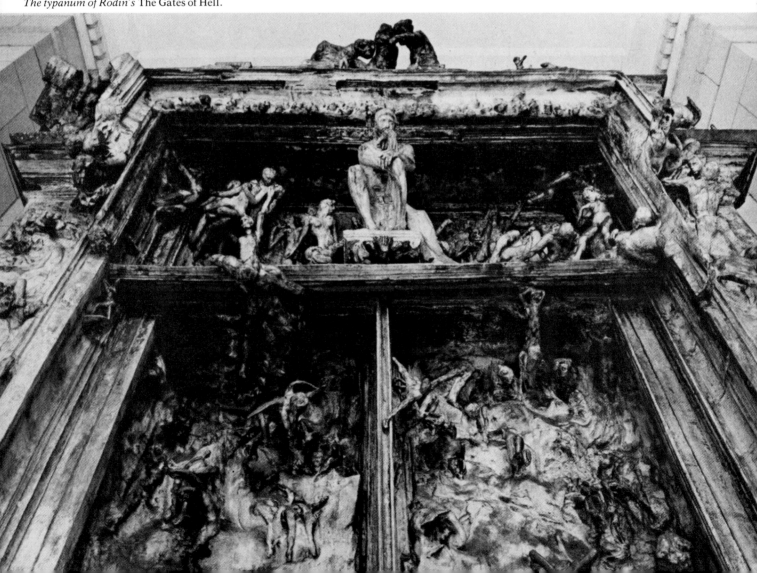

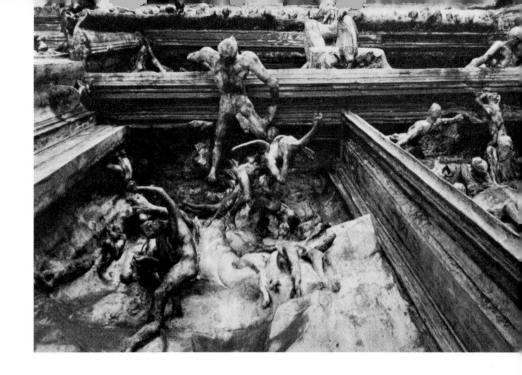

*A sea of figures rises from Rodin's
masterpiece* The Gates of Hell.

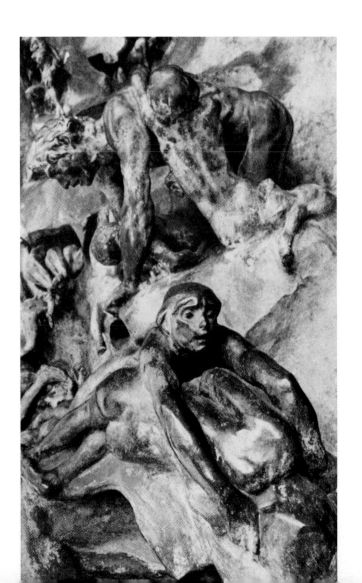

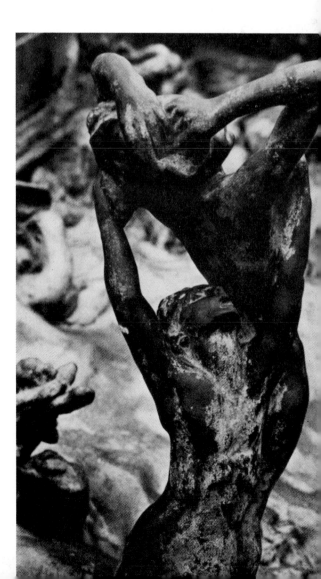

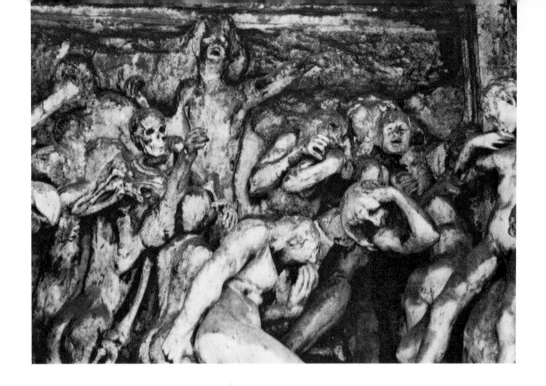

*The expressive power of the human body is evident
in details of Rodin's* Gates of Hell.

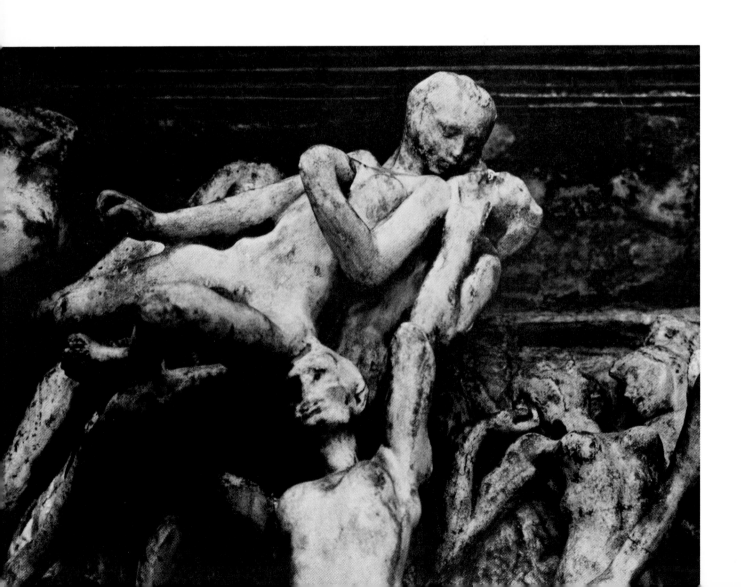

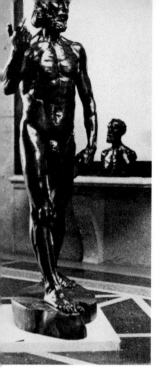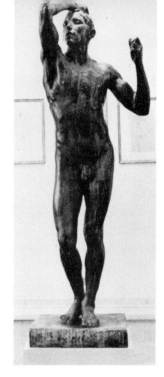

ABOVE, LEFT TO RIGHT: *Some of Rodin's most famous sculptures from the Rodin Museum are* St. John the Baptist Preaching, Adam, Eve, *and* Age of Bronze.

BELOW: *Rodin's powerful* The Burghers of Calais, *also in the Rodin museum.*

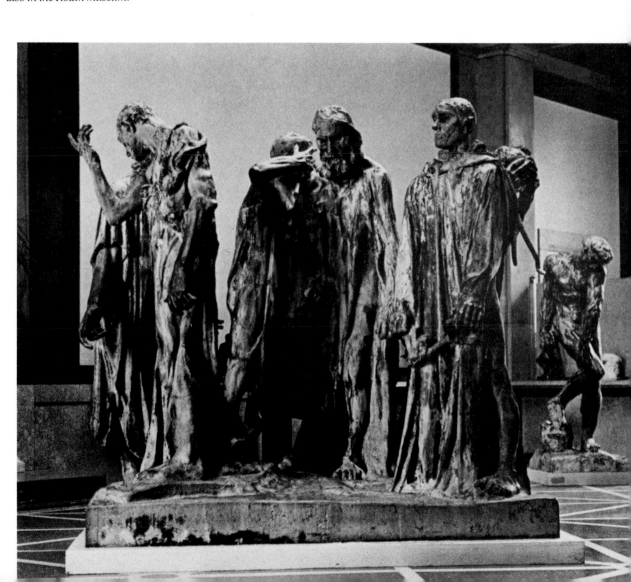

The Washington Monument 1897
by Rudolf Siemering (1835–1905)
Bronze and granite, total height 528″
East Front of the Philadelphia Museum of Art

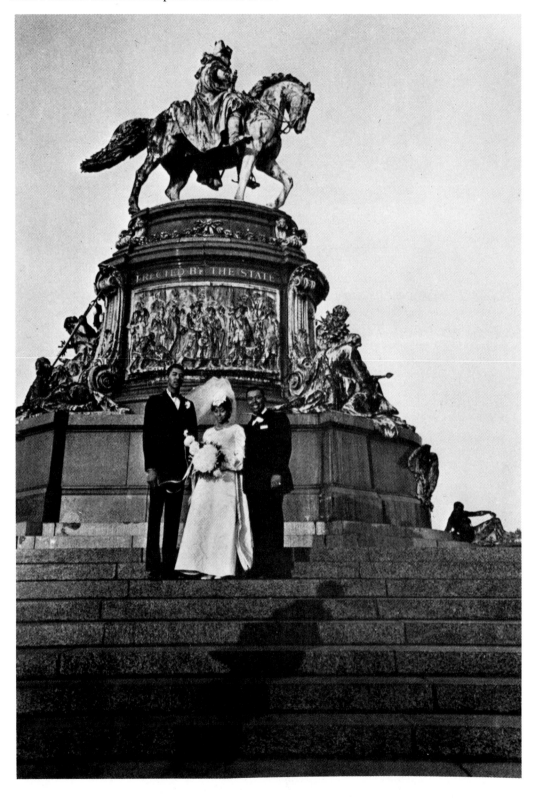

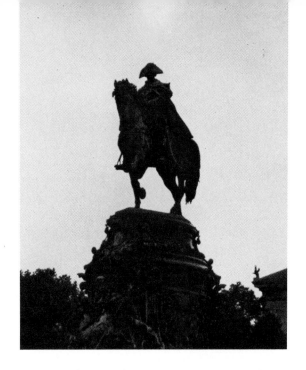

In commissioning the *Washington Monument,* the Society of the Cincinnati of Pennsylvania provided Philadelphia with one of its major sculptural adornments and one of the world's most spectacular equestrian monuments. After eighty years' planning, the contract for the work was given to one of the well-known German sculptors of the late 19th century. From the very beginning Siemering was anxious to make the monument as realistic and accurate in its detail as possible. He worked from photographs of prints of the Revolutionary

(continued on page 73)

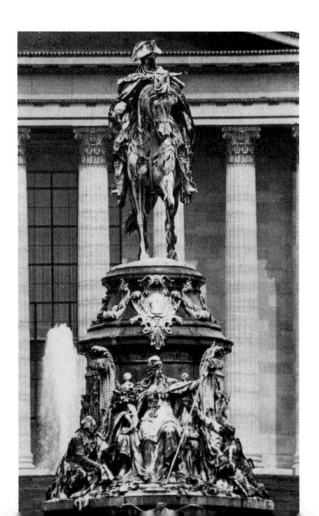

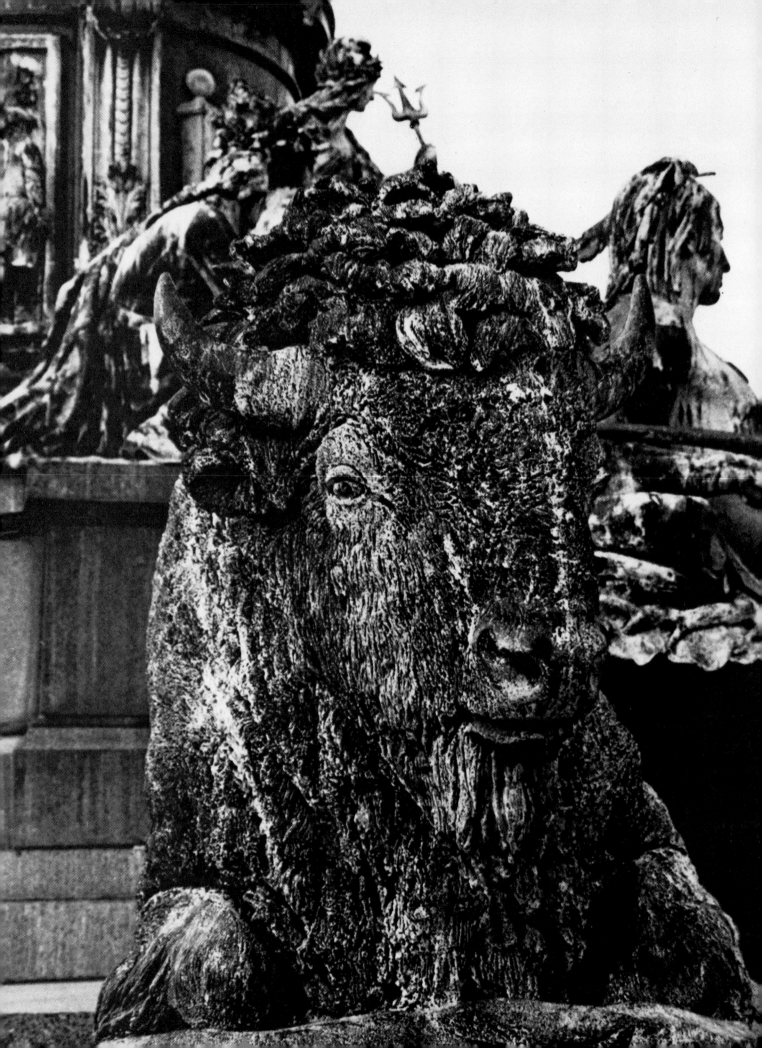

(continued from page 71)

heroes who were to be portrayed, and even used Indians from a visiting troupe as models. In view of the fanatical attention to detail that characterized his work on the project, it is surprising that the composition and grouping of masses were so well integrated.

The sculptor divided his monument into three levels—the hero, his time (on the middle level), and his country (on the lowest level). Seen from the bottom of the steps, the sculptured forms seem to cascade off the monument, an effect heightened by the downward flowing water in the fountains. Although the profusion of intricate forms is almost overwhelming, the formal organization of the whole monument is controlled. Wherever the spectator stands, his eye is drawn upward to the imposing figure of Washington, the national hero.

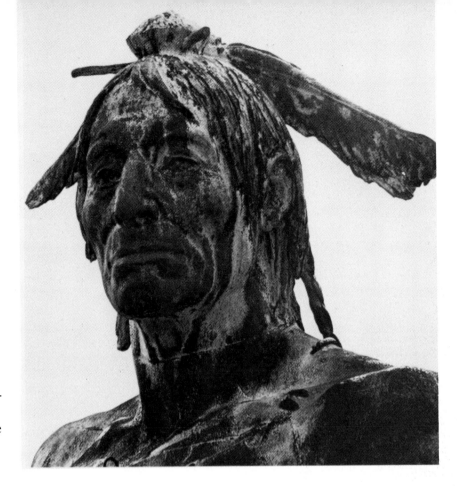

OPPOSITE PAGE, ABOVE, AND BELOW
Details of the Washington Monument.

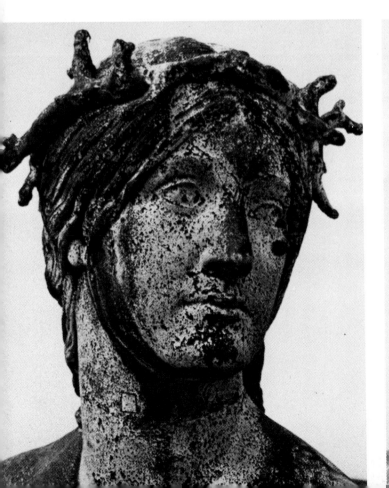

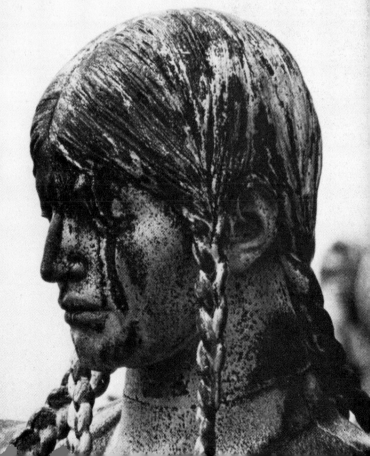

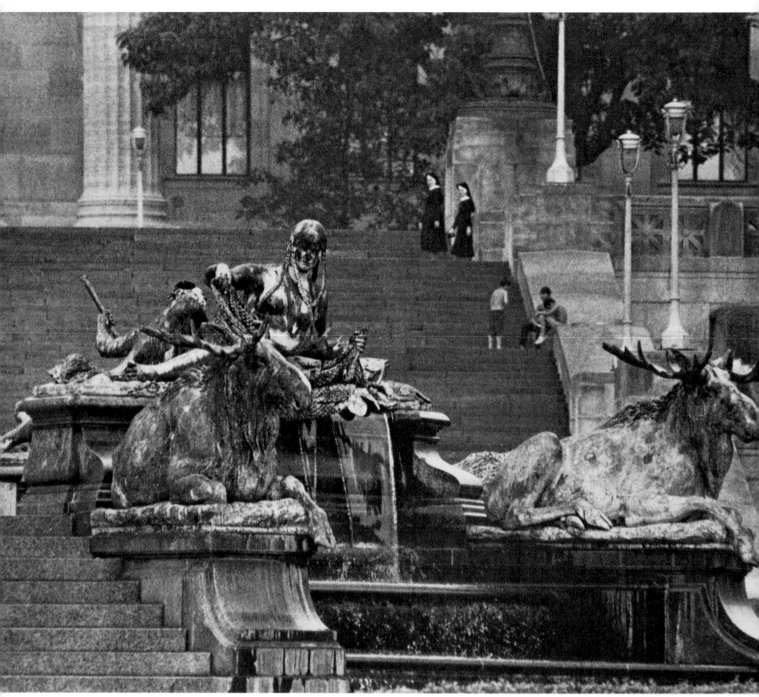

Detail of the Washington Monument.

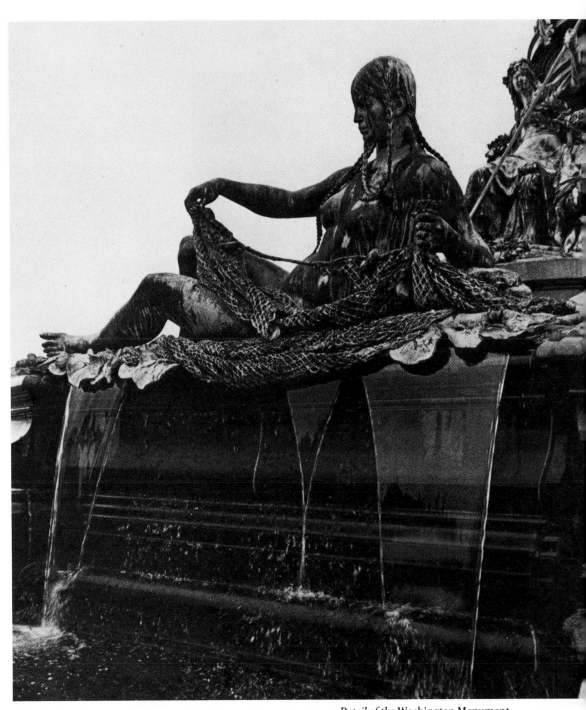

Detail of the Washington Monument.

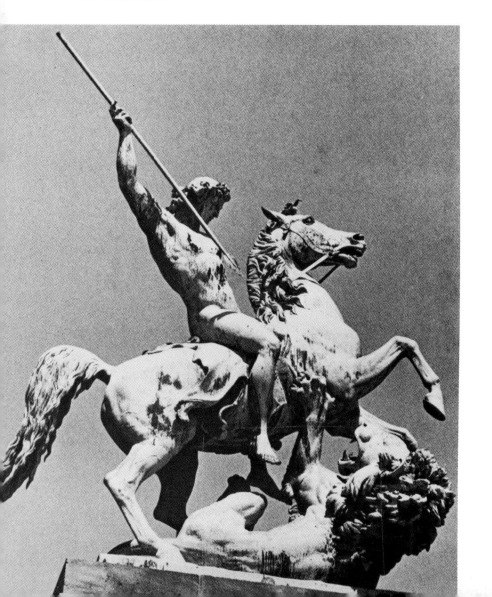

OPPOSITE PAGE
Pediment 1932
by Carl Paul Jennewein (1890–)
Polychrome terra cotta,
height 144″, length 840″
Philadelphia Museum of Art,
East Courtyard

The Lion Fighter 1858
by Albert Wolff (1814–92)
Bronze, height approx. 168″
(limestone base 204″)
Philadelphia Museum of Art,
East Entrance

OPPOSITE PAGE
The Amazon 1843
by August Kiss (1802–65)
Bronze, height 135″
(limestone base 204″)
Philadelphia Museum of Art
East Entrance

The Lion Fighter (LEFT) and *The Amazon* (RIGHT) are spirited companion pieces by prominent German sculptors of the 19th century. Remarkably powerful, they convey a sense of action and are distinguished by their realistic rendering of anatomical detail.

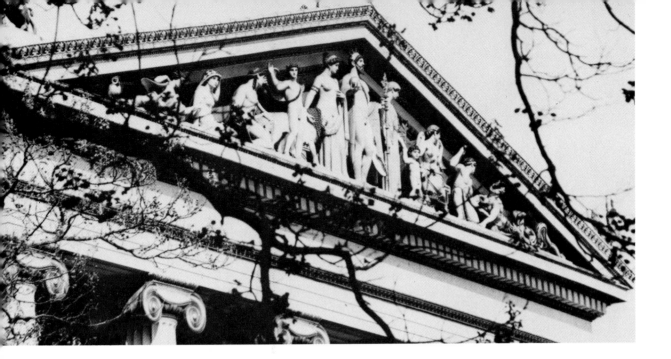

The thirteen free-standing figures that compose this Classical pediment of the Philadelphia Museum of Art are covered with brilliant ceramic glazes. The central figure, Zeus, and the other mythological figures that surround him represent Sacred and Profane Love.

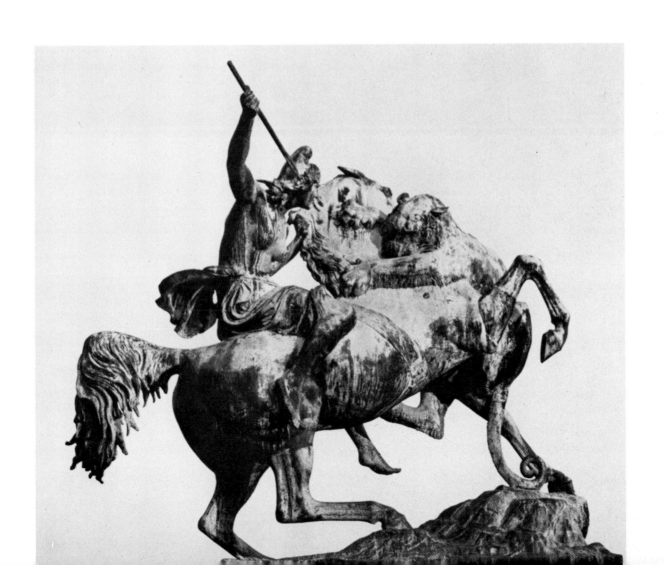

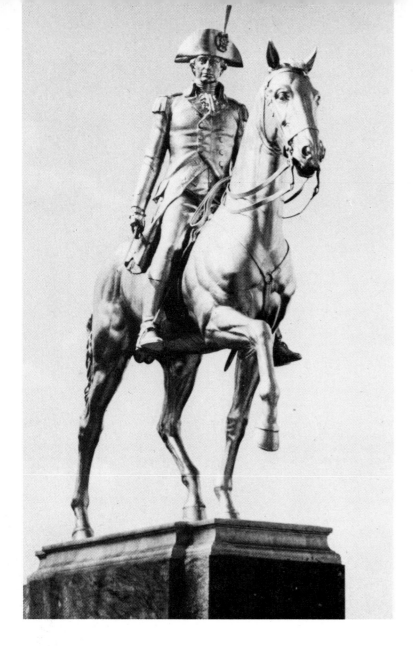

General Anthony Wayne 1937
by John Gregory (1879–1958)
Gilded bronze, height approx. 144"
(granite base 162")
Philadelphia Museum of Art, East Terrace

Pennsylvania's foremost Revolutionary officer was Major General Anthony Wayne. This full-size equestrian statue is a handsome tribute to the patriot. Impetuous and hotheaded, Wayne was known as "Mad Anthony," but he was recognized by all as one of our most able and effective generals. The monument was dedicated in 1937 on the 150th anniversary of the signing of the Constitution.

Prometheus Strangling the Vulture 1952
by Jacques Lipchitz (1891–1973)
Bronze, height 96"
Philadelphia Museum of Art, East Courtyard

This magnificent work expresses Jacques Lipchitz's deeply felt social and religious feelings. The standing figure of Prometheus chokes the vulture with one hand and defends himself with the other against the claws of the bird. Lipchitz used the mythological Prometheus to represent man's struggle to conquer the forces of darkness —the vulture. In the sculptor's words, "The struggle is terrible, but it needs only a glance of the eye to see on which side Victory will lie. The vulture is conquered."

This powerful work is representative of the free, spontaneous approach to sculpture that marked Lipchitz's mature style. Dominating the steps of the Philadelphia Museum of Art, *Prometheus Strangling the Vulture* is one of the major sculptural achievements of the century.

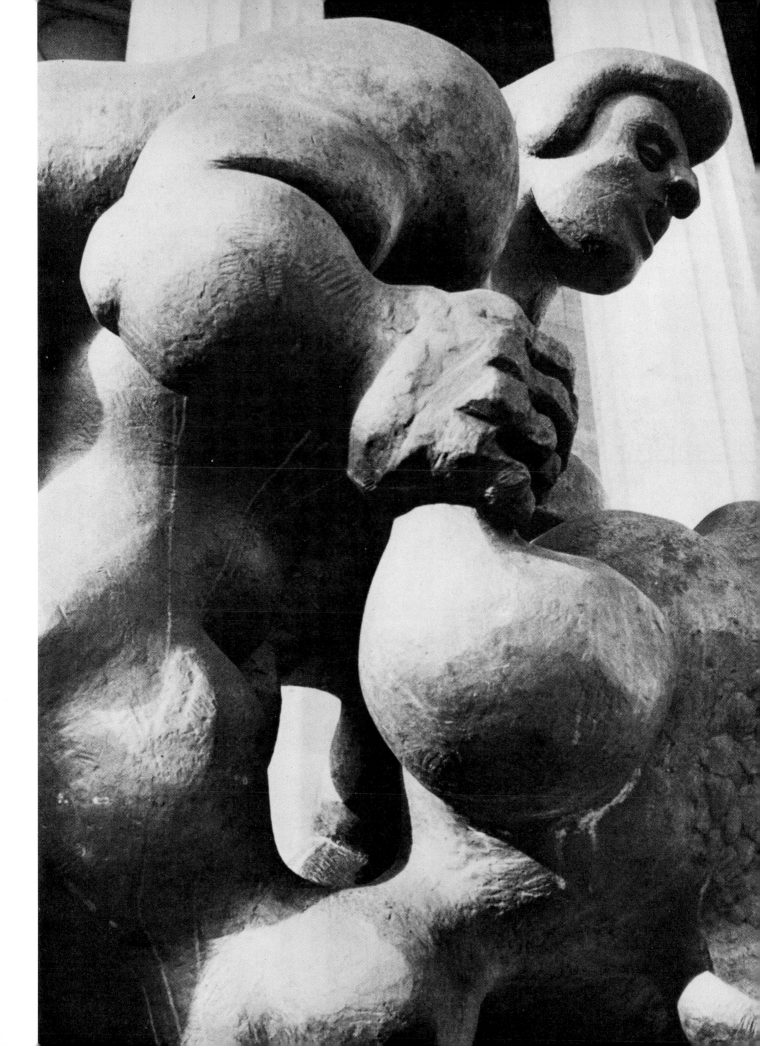

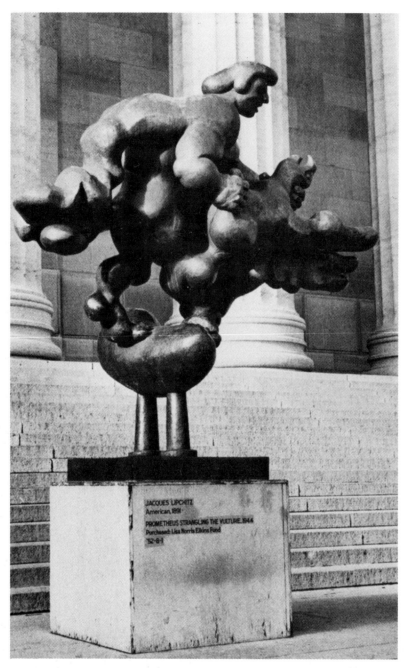

Prometheus Strangling the Vulture *by Jacques Lipchitz.*
OPPOSITE PAGE: *Detail of the work.*

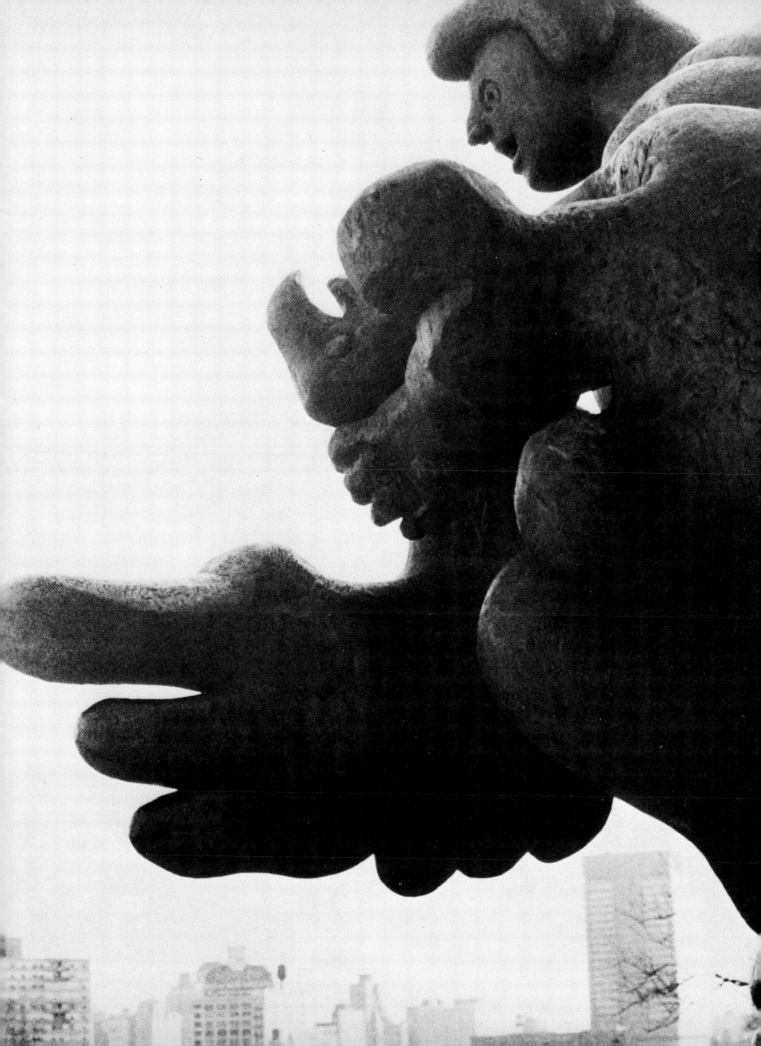

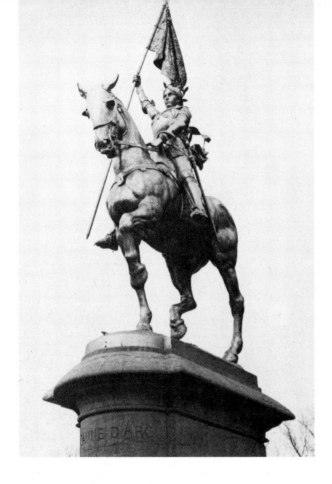

Joan of Arc 1890
by Emmanuel Frémiet (1824–1910)
Bronze, gilded, height 180″
(granite base 100″)
East River Drive at the
Philadelphia Museum of Art

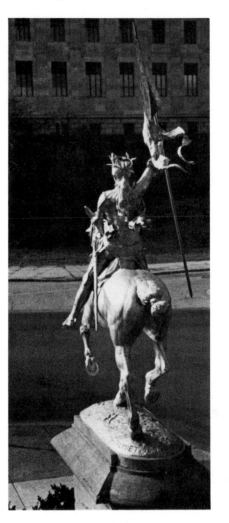

Philadelphia has its French colony to thank for this heroic statue of the Maid of Orléans. Plans to commission the work were initiated in 1889, shortly before Bastille Day. The noted French sculptor Emmanuel Frémiet was chosen to execute an equestrian statue of Joan of Arc. His version of this famous historical figure is remarkable for the careful rendering of details and the homogeneity of horse and maid. Frémiet was also a student of history who looked to 15th-century sculpture and tapestries for details of armor and conventions of posture. Although Joan's face is sympathetically childlike, her determined spirit is unmistakably conveyed. There have been many interpretations of the legendary heroine, and Frémiet's concept was from the beginning controversial. The sculptor destroyed his first version in Paris, and replaced it with a cast of the Philadelphia Joan of Arc. Few, however, have doubted its striking originality, and many have found it to be a gracious and noble tribute to the maid. When the statue is seen glistening in the sunlight, its appeal is irresistible.

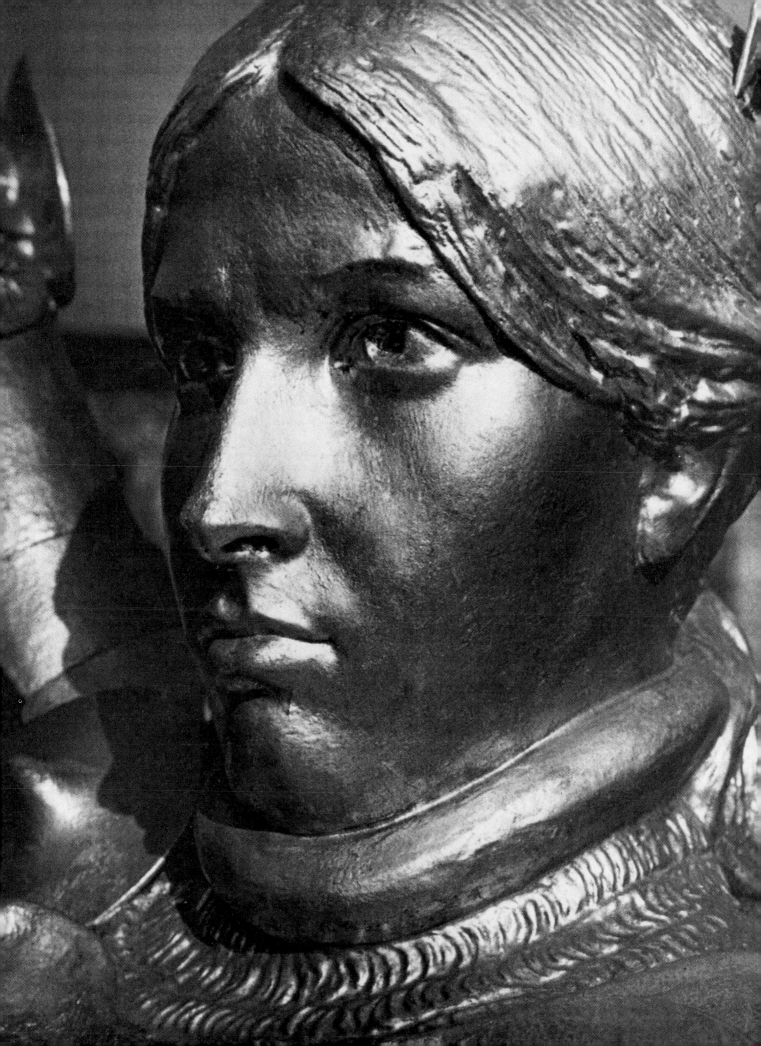

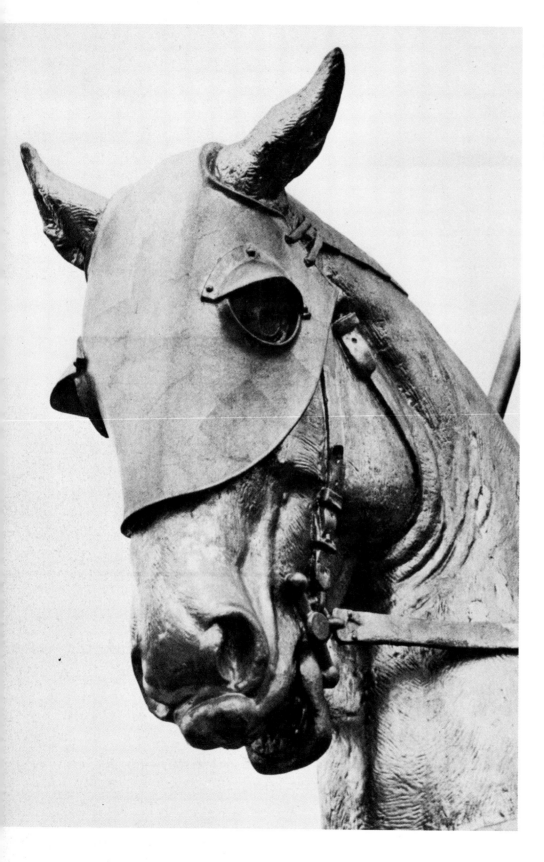

Joan of Arc by Emmanuel Frémiet. The sculptor's extensive knowledge of animal anatomy is shown in the modeling of the horse. Frémiet's work is a masterpiece of realistic representation.

Fidelity Mutual Life Insurance Company 1927
by Lee Lawrie, sculptor
Bronze and limestone
Pennsylvania and Fairmount Avenues, at 25th Street

BELOW: A massive figure, representing Fidelity, that appears on the facade of the building near the main entrance. UPPER RIGHT: A highly decorative bronze figure—one of several that adorn the entrance doors. LOWER RIGHT: The entrance to the Fidelity Mutual Building, a superb example of the Art Deco style.

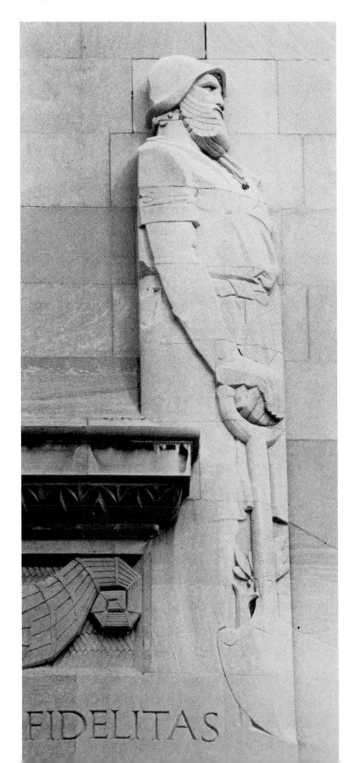

FIDELITAS

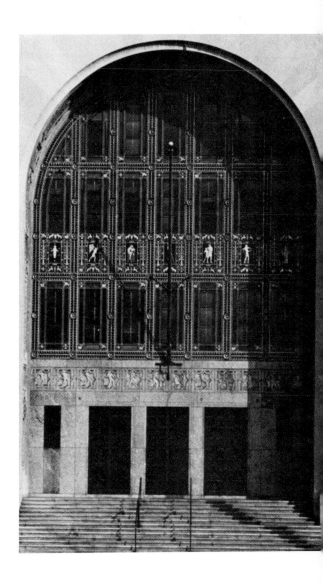

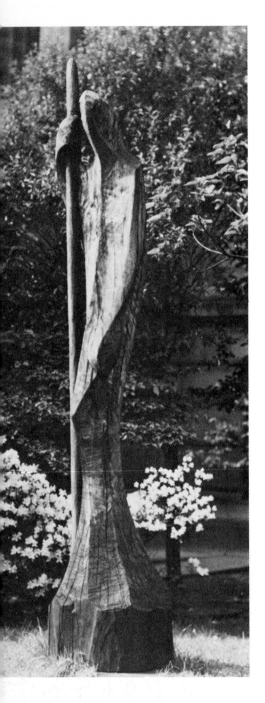

Reverence 1942
by Wharton Esherick (1887–1970)
Black walnut, height 108″
Philadelphia Museum of Art

This hauntingly beautiful figure
of *Reverence* uses the simplest
elements of the human form and
invests the wood with something
of human dignity.

General Casimir Pulaski 1947
by Sidney Waugh (1904–63)
Bronze, height 112″ (granite base 90″)
Philadelphia Museum of Art, West Side

This statue is a fitting memorial to
the great Revolutionary soldier who
came from his native Poland to fight
for liberty with the Colonial Ameri-
cans. Benjamin Franklin was the first
to befriend the young nobleman,
and gave him a letter of introduction
to Washington.

Puma 1954
by William Zorach (1887–1966)
Labrador marble, height 40½"
(granite base 25")
Azalea Garden, northwest of the
Philadelphia Museum of Art

This sleek cat sits serenely in
Philadelphia's Azalea Garden. It was
given to the city by the Fairmount
Park Art Association. The grace and
power of one of nature's most beauti-
ful animals have been faithfully cap-
tured in lustrous Labrador marble.

Atmosphere & Environment, XII 1970
by Louise Nevelson (1899–)
Corten steel, height 219", length 120",
width 60" (plywood base)
Philadelphia Museum of Art, West Entrance

A few simple forms, imaginatively
arranged, characterize the recent
work of Louise Nevelson. *Atmos-
phere & Environment, XII*, is a mag-
nificent example of her current
style. Some critics find it reminis-
cent of a Manhattan skyscraper
with its ordered repetition of basic
shapes and its severity.

Social Consciousness 1955
by Jacob Epstein (1880–1959)
Bronze, 146″ (granite base 27½″)
Philadelphia Museum of Art, West Entrance

Chief Justice John Marshall 1883
by William Wetmore Story (1819–1895)
Bronze, height 80″ (granite base 66″)
Philadelphia Museum of Art, West Entrance

This splendid likeness of the first Chief
Justice of the Supreme Court is one of
William Wetmore Story's finest works.
It is a replica of the original, which is on
the grounds of the Capitol in Wash-
ington. The sculptor was the son of Jus-
tice Joseph Story, one of Marshall's
closest friends.

Jacob Epstein's starkly arresting *Social
Consciousness* fulfilled a commission from
the Fairmount Park Art Association for a
work that was to represent part of the Ameri-
can Dream. It was the kind of undertaking
that the sculptor had always wanted, a sub-
ject he could sink his teeth into. Throughout
his career, Epstein had stressed the humanis-
tic values of sculpture, so with characteristic
restraint he created what he believed to be
one of his major works.

The central seated figure with out-
stretched arms is "The Eternal Mother," who
symbolizes mystical permanence. To the left,
"Compassion" is described by the sculptor as
"a gentle and saving hand extended to help
the afflicted and downhearted of the
world." The ease with which

(continued on page 91)

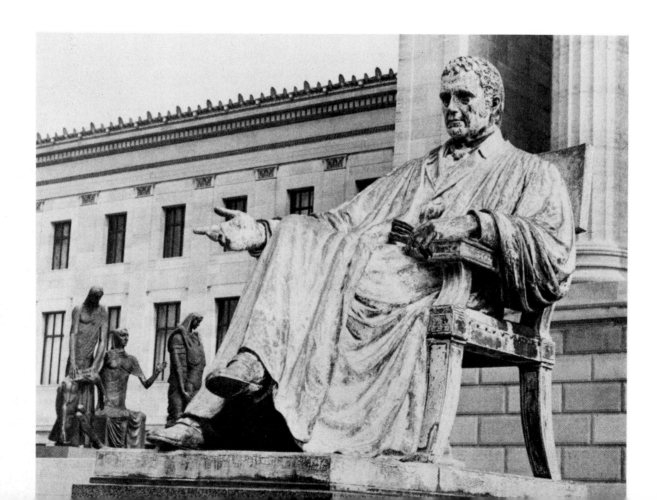

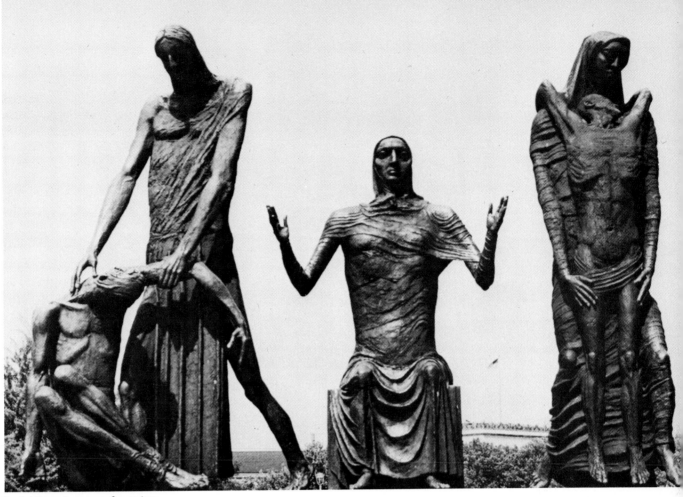

Social Consciousness, *front view*.

Social Consciousness, *rear view*.

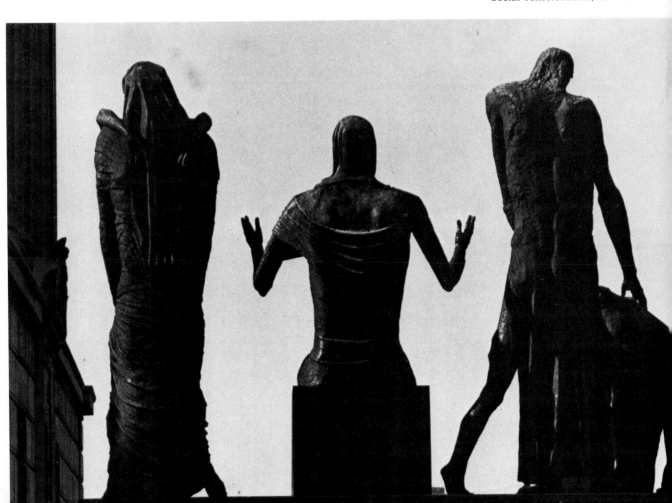

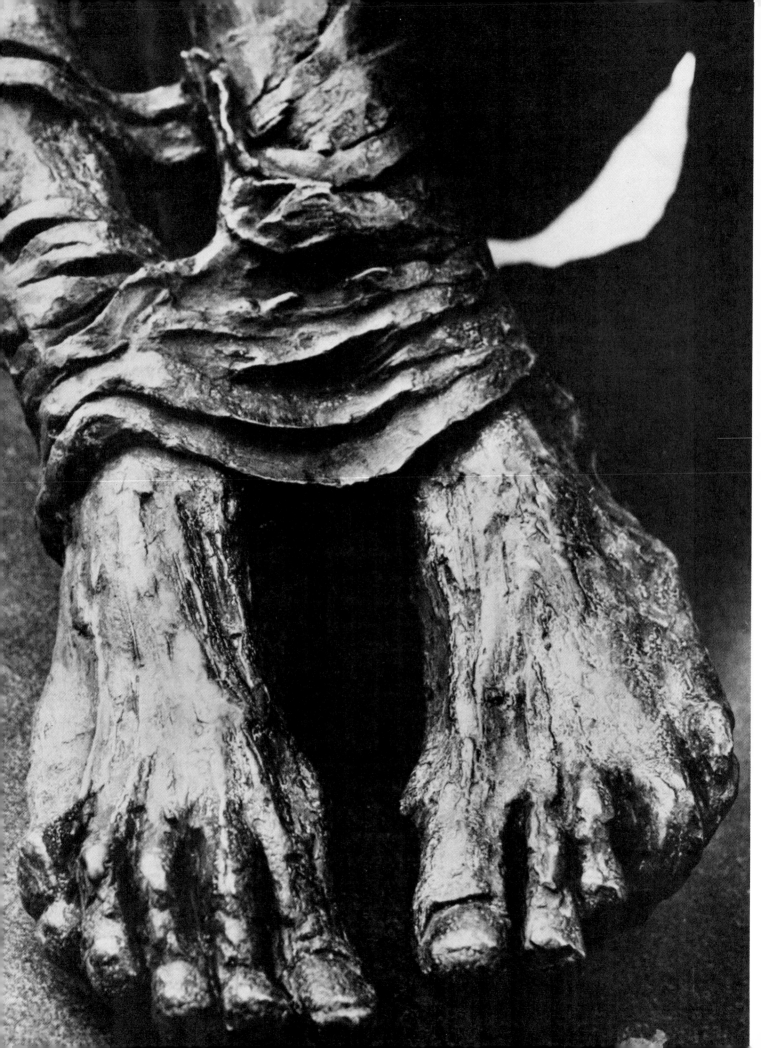

Social Consciousness *by Jacob Epstein.*
OPPOSITE: *Close-up detail.*
BELOW: *Side view.*

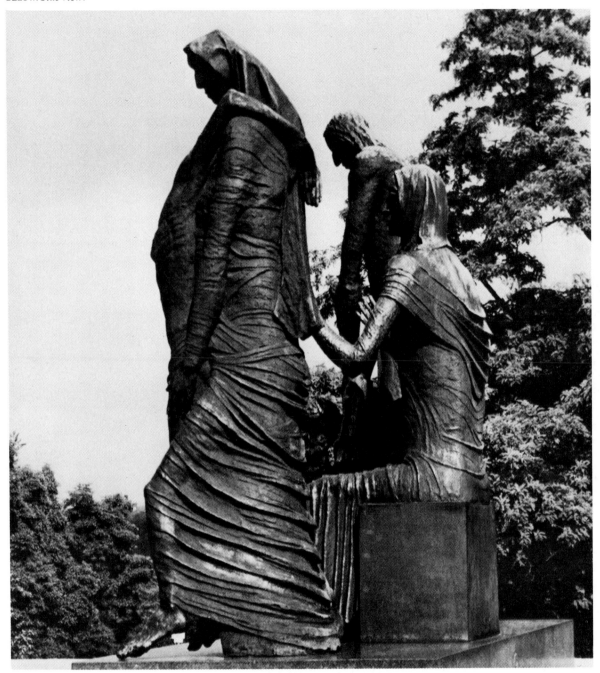

(continued from page 88)

the relationship between the two figures has been handled is
striking. "Succor (or Death)," at right of the central figure,
consists of a draped standing female figure supporting at the
hips a youth who bends back to clasp her shoulders. Accord-
ing to Epstein, the figures represent a mother receiving her
manchild or the idea of death receiving mankind. The whole
work is suffused with a strange intensity.

This large and moving monument is seen to advantage at
the west entrance of the Philadelphia Museum of Art.

This recumbent figure originally capped one of the great entrances through which the pumps and wheels of the Fairmount Waterworks were reached. It was rushed to completion, along with the other sculptures commissioned for the waterworks, because Lafayette was returning to Philadelphia for a second visit in 1825. Appropriately, the lady sits on a cushion of steel with her left hand poised above a water wheel and her right arm resting on a pump.

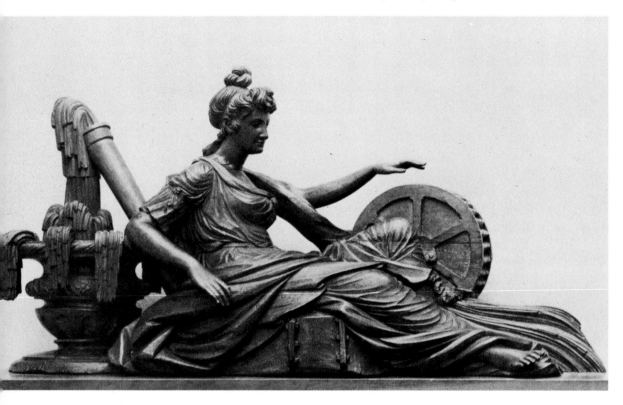

Schuylkill Freed 1825
by William Rush (1756–1833)
Wood
Philadelphia Museum of Art, American Gallery

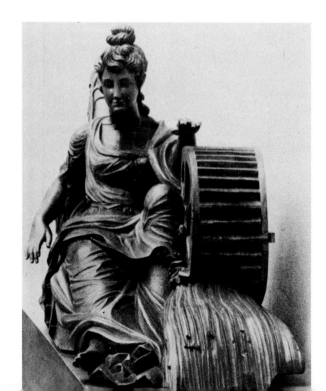

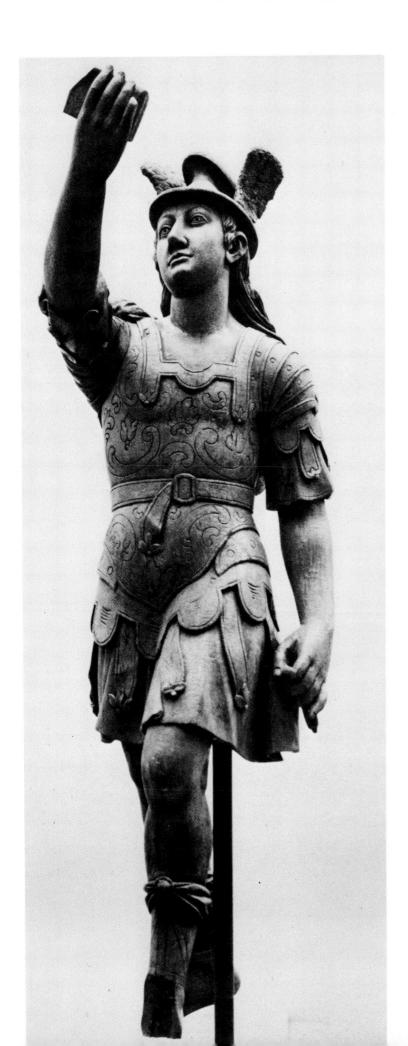

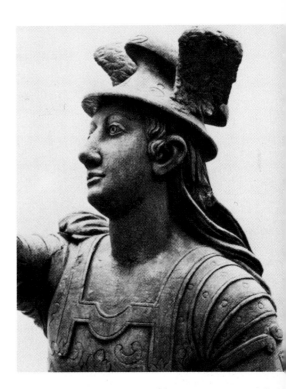

Mercury 1829
by William Rush (1756–1833)
Wood
Philadelphia Museum of Art

This representation of the Messenger of the Gods first stood on the roof of the gazebo halfway up "Fair Mount." Though his sandals' wings have disappeared, and only the base of his caduceus is left, Mercury still clutches the packet of good news in his right hand.

Eagle c.1810
by William Rush (1756–1833)
Painted pine, wing spread 29¾";
height to top of wings 24¾"
Philadelphia Museum of Art

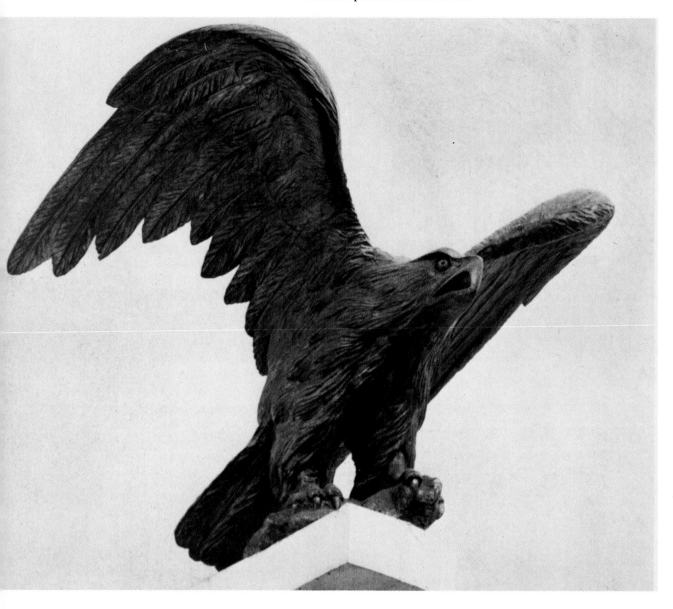

Eagles were popular symbols of the newly founded
Republic. William Rush was a well-known carver of
eagles for ships, trade signs, and fire houses. The feroc-
ity and attractive patternization of feathers have
been superbly rendered. It is representative of a long
tradition of familiar images that added color to
Philadelphia's streets.

Water Nymph and Bittern 1809
by William Rush (1756–1833)
Bronze, originally of wood
Philadelphia Museum of Art

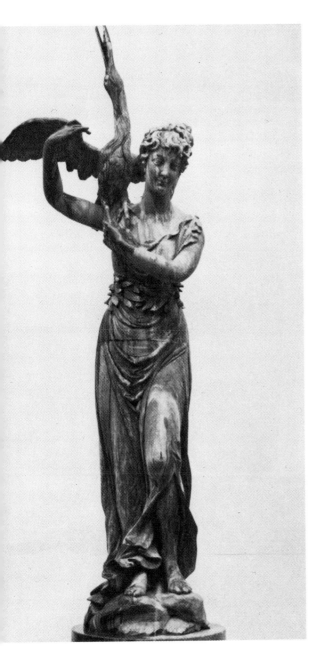 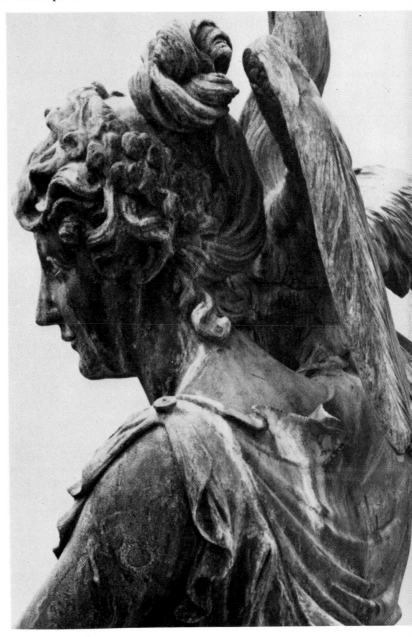

This playful nymph is believed to have been America's first decorative fountain built with public funds. Standing seven and one-half feet tall, the lovely maiden holds a large bird on her shoulder. Jets of water originally flew high in the air from the bird's beak and rose all about the feet of the nymph. A work of great beauty, it served its purpose well and was the central attraction of Philadelphia's first public water system.

Schuylkill Chained 1825
by William Rush (1756–1833)
Wood
Philadelphia Museum of Art,
American Gallery

This recumbent symbolic figure is
the companion piece of *Schuylkill
Freed* on page 92. A male form, rep-
resenting strength, is stretched out
on a bed of flowing water. His beard
and garment echo the water's flow,
and at his feet the American eagle
spreads its protective wings.

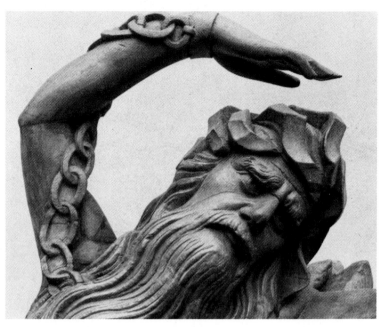

OPPOSITE PAGE
Lot's Wife
by Howard Roberts (1843–1900)
Marble
Exhibited at the 1876
Centennial;
at present in a private collection.

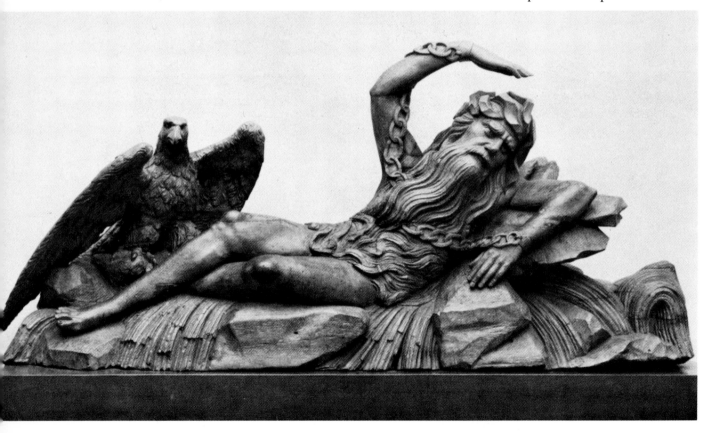

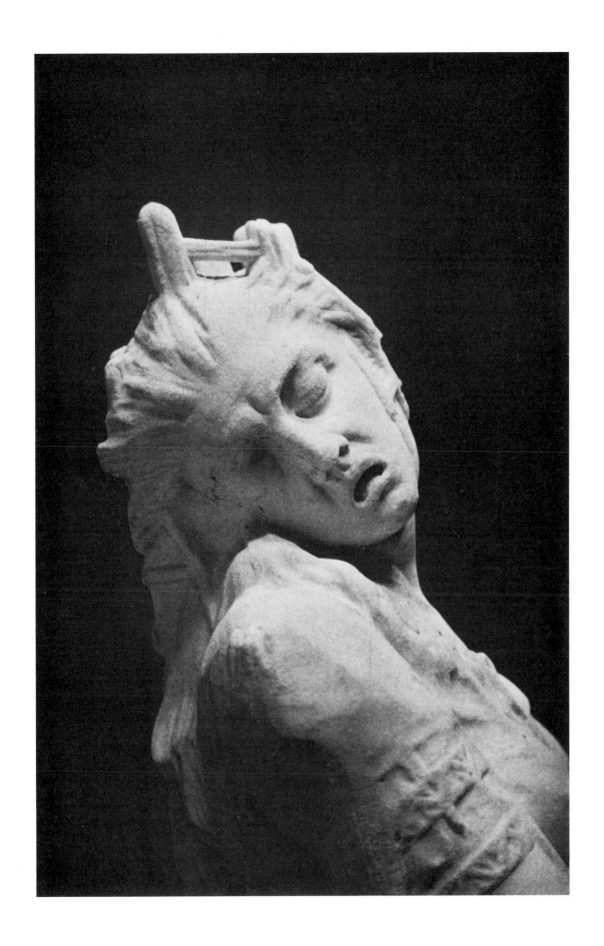

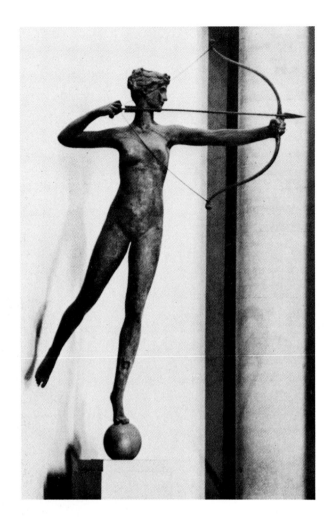

OPPOSITE PAGE
La Première Pose 1876
by Howard Roberts (1843–1900)
Marble, height 52″ (base 23¾″)
Philadelphia Museum of Art

Philadelphia's Howard Roberts exe-
cuted this realistic work for the 1876
Centennial Exposition. American ar-
tists were beginning to study in Paris
instead of Rome, Roberts foremost
among them. The technical skill
shown in this work caused a sensa-
tion in the Art Section of the Fair.

Diana 1892
by Augustus Saint-Gaudens (1848–1907)
Copper sheeting, height 184½″ (copper ball base 18″)
Philadelphia Museum of Art, East Foyer

This graceful figure originally stood atop the
tower of the old Madison Square Garden in
New York City. It was created by Saint-
Gaudens as a tribute to his friendship with
Stanford White, of McKim, Mead and White,
designers of the Garden. *Diana* was removed
from her perch in 1925 when the Garden was
torn down. After languishing in storage for
several years, she was rescued and brought to
Philadelphia in 1932, through the efforts of
Fiske Kimball with funds provided by the
Fairmount Park Art Association.

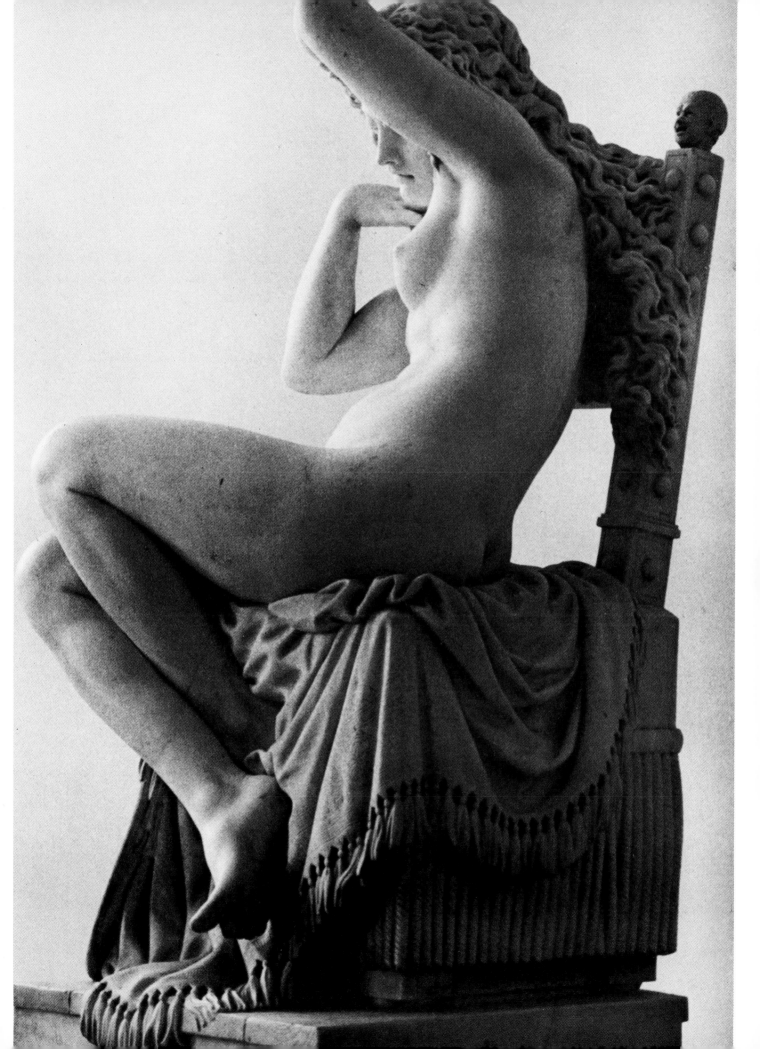

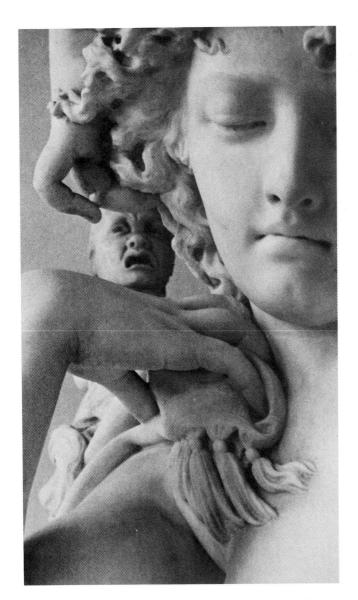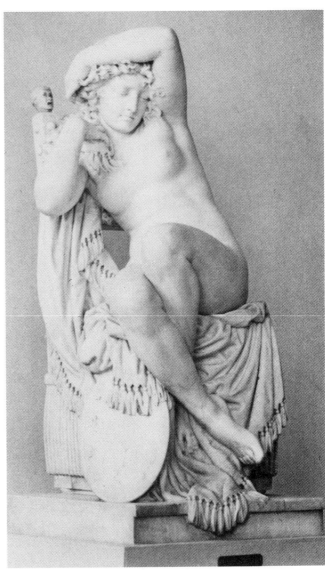

LEFT *and* RIGHT: *Detail and view of*
La Première Pose *by Howard Roberts.*

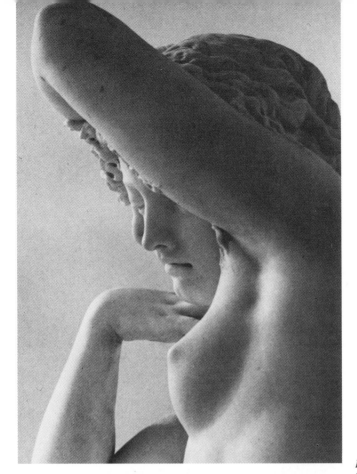

Details of La Première Pose
by Howard Roberts.

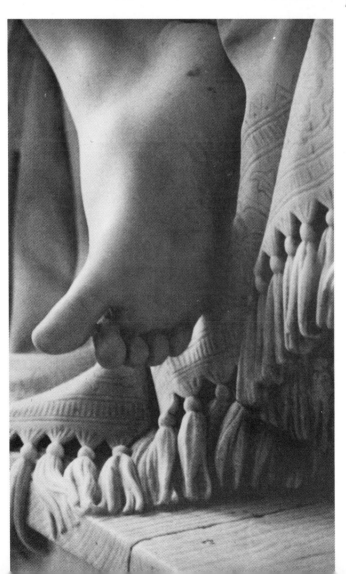

Abraham Lincoln 1871
by Randolph Rogers (1825–1892)
Bronze, height 114″ (granite base 270″)
East River and Lemon Hill Drives

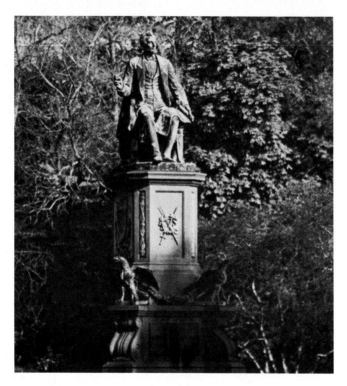

No man in history is closer to the hearts of the
American people than their 16th president—
Abraham Lincoln. Following his assassination
on April 14, 1865, the nation experienced a deep
mourning such as it had never known. Several
cities soon organized committees to erect memo-
rials and Philadelphia was among the first.

(continued on page 104)

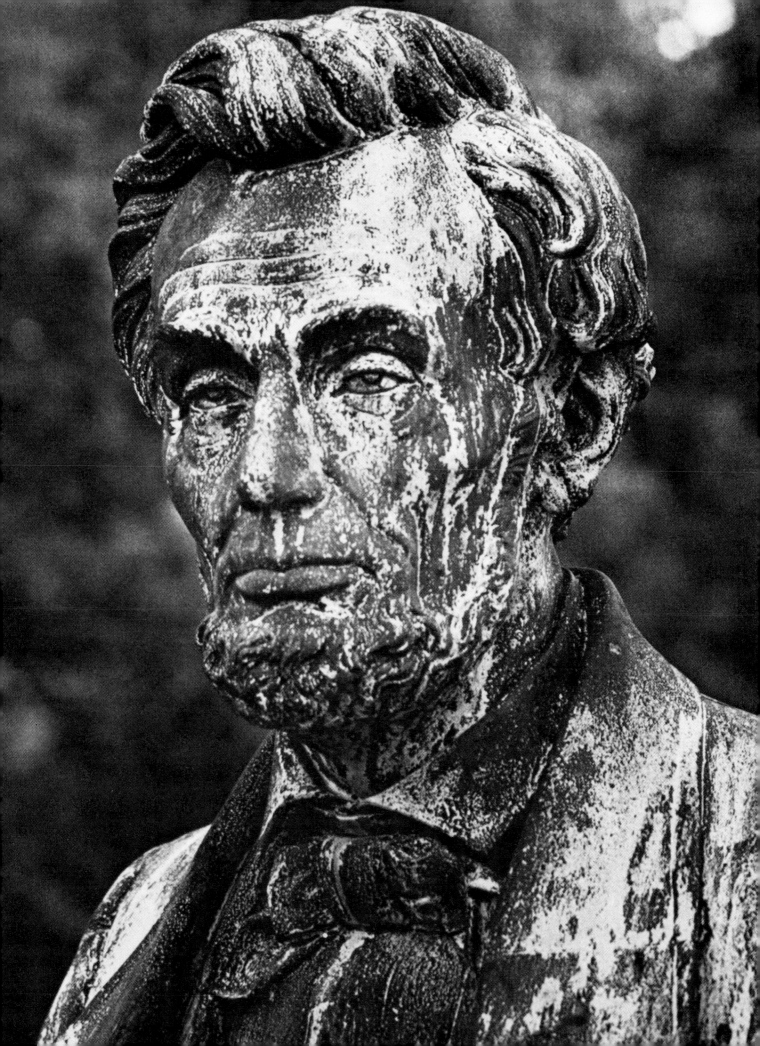

(continued from page 102)

Randolph Rogers, the distinguished American sculptor, was selected to execute the monument. In his own words, he presents "Mr. Lincoln in a sitting posture, holding in one hand the Emancipation Proclamation; and a pen in the other, his eyes turned toward heaven, asking the Almighty his approval for the act. It was the great event of his life." The photograph of the details of the face on the previous page reveals the character of the man and the gravity of his mood to better advantage than can be obtained by standing at the base, since the head is approximately 32 feet above the level of the ground. The sculpture also conveys Lincoln's strength and homely dignity. Following the tradition of naturalism that prevailed in the mid-19th century, Rogers labored carefully on details of the figure, the fabric of the garments, and the chair. The granite pedestal is decorated with four eagles, the plaque of the coat of arms of Philadelphia, and garlands. The inscription reads: "To Abraham Lincoln from a grateful people."

(continued on page 105)

ABOVE *and* BELOW: *Details of* Abraham Lincoln *by Randolph Rogers.*

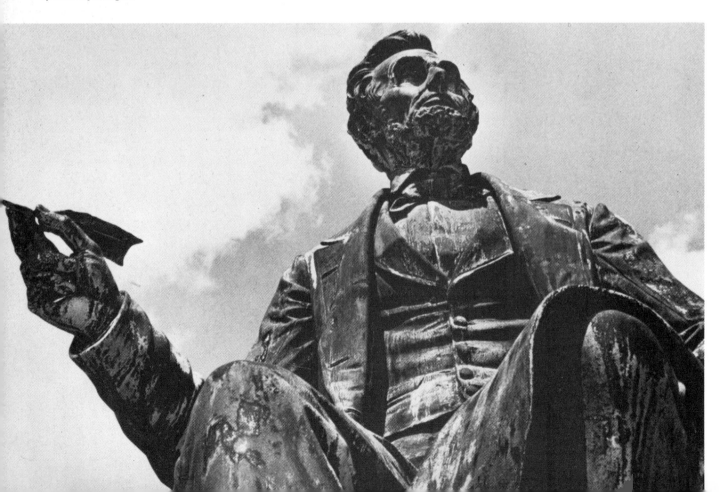

(Continued from page 104)

Randolph Rogers created a striking and effective likeness—an image of the martyred Lincoln that touches the heart.

LEFT *and* RIGHT: *Views of* Abraham Lincoln *by Randolph Rogers.*

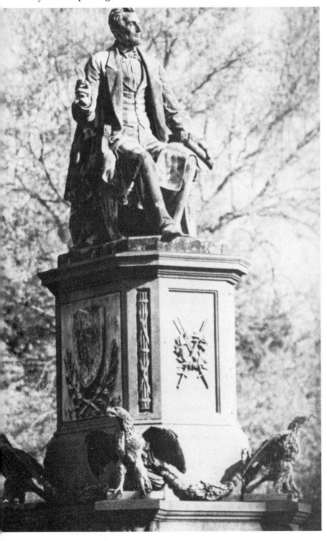

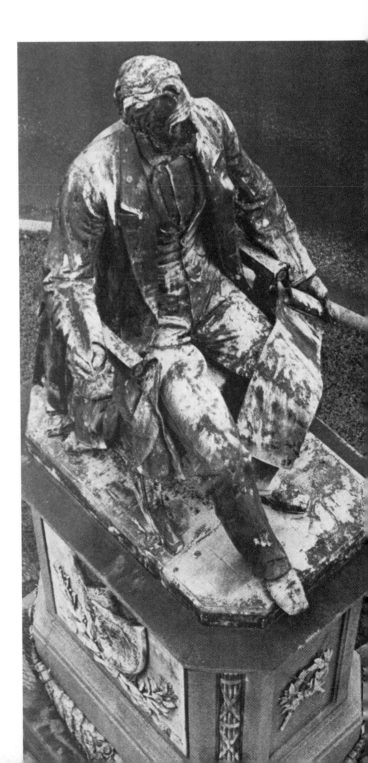

FAIRMOUNT PARK

GIRARD AVE.

POPLAR

PENNGROVE

WESTMINSTER

OGDEN

PARISH

BROWN

ASPEN

ZOOLOGICAL GARDEN

ZOOLOGICAL STREET

PENN CENTRAL

MANTUA AVE.

EAST RIVER DRIVE

FAIRM

WEST RIVER DRIVE

SCHUYLKILL

TO MEMORIAL HALL

41ST STREET

40TH STREET

FAIRMOUNT

UNION

39TH STREET

38TH STREET

37TH STREET

36TH STREET

35TH STREET

34TH STREET

LANCASTER AVE.

WALLACE

MT. VERNON

HAVERFORD

BRANDYWINE

FAIRMOUNT PARK:
East and West

The east bank of the Schuylkill, beginning with the boathouses, has some of the most pastoral sights in America, all within the city's limits—Lemon Hill, Mount Pleasant, Robin Hood Dell, and Strawberry Mansion. Once these summer estates were country seats for the wealthy city residents. Today they are maintained by the city and the Art Museum. Thomas Eakins, one of America's great realist painters, recorded rowers on the river, a still popular sport all year round. Fairmount Park is one of the largest in the world (over six square miles) and part of Philadelphia's way of life. It contains a huge collection of sculpture—a heroic Viking, a striding Pilgrim, three sculptured terraces commemorating America, a memorial to Garfield, a cowboy high on a cliff, and a somber Ulysses S. Grant looking across the Schuylkill toward the 1876 fairgrounds.

The West Park is filled with mementoes of the Centennial: Memorial Hall, the Ohio Pavilion, Columbus on Belmont Avenue, and Moses atop the Catholic Total Abstinence Fountain. There is also the zoo, filled with animal sculpture, Belmont Plateau, overlooking a bend in the river, and sculpture scattered from Sweetbriar Mansion to the Smith Memorial, one of the most monumental sculptural ensembles in America. Most local children now know it for its "whispering wall" and not for the Civil War heroes on its exterior.

- ⑪ **All Wars Memorial To Colored Soldiers and Sailors**
- ⑧ **Bear and Cub**
- ⑪ **Catholic Total Abstinence Union Fountain**
- ⑪ **Columbus Monument**
- ⑤ **Cowboy**
- ⑧ **Cow Elephant and Calf**
- ⑧ **Dying Lioness**
- ② **Garfield, James A.**
- ⑥ **Grant, General U. S.**
- ⑧ **Hudson Bay Wolves**
- ⑧ **Impalla Fountain**
- ② **Karlsefni, Thorfinn**

- ⑧ **Lioness Carrying to Her Young a Wild Boar**
- ⑪ **Meade, General George**
- ⑪ **Memorial Hall**
- ⑪ **Night**
- ⑧ **Penguins**
- ① **Pilgrim**
- ⑦ **Playing Angels**
- ④ **Samuel Memorial**
- ⑩ **Smith Memorial**
- ② **Spirit of Enterprise**
- ⑨ **Stone Age in America**
- ⑪ **Sundial**
- ③ **Washington Grays Monument**
- ⑪ **Witherspoon, Rev. John**

Map drawing by Hugh J. McCauley A.I.A.

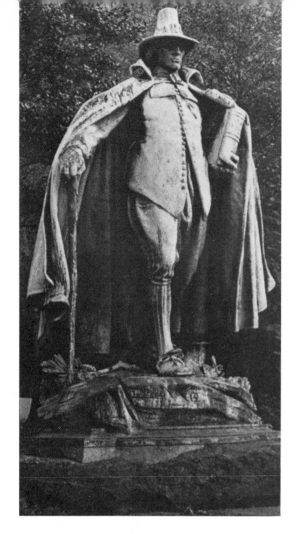

The perfect embodiment of a founder of the Plymouth Colony in Massachusetts, *The Pilgrim* conveys both sternness and mystery. With the Holy Bible in one hand and a cane in the other, he appears to be on his way to meeting. The superb rendering of facial features further enhances this major work by the great Saint-Gaudens. The statue was given to the City of Philadelphia by the New England Society of Pennsylvania.

The Pilgrim 1904
by Augustus Saint-Gaudens (1848–1907)
Bronze, height 109″ (fieldstone base 19″)
East River Drive, Boat House Row

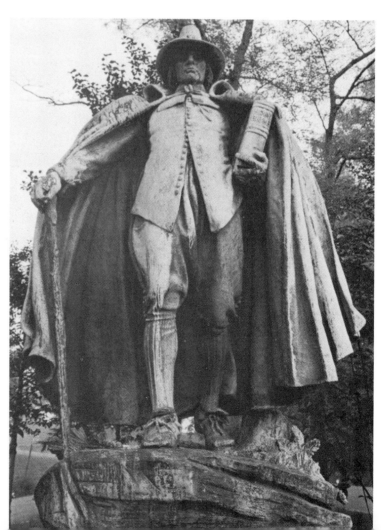

Thorfinn Karlsefni 1915–18
by Einar Jonsson (1874–1954)
Bronze, height 88″ (granite base 67″)
East River Drive, Boat House Row

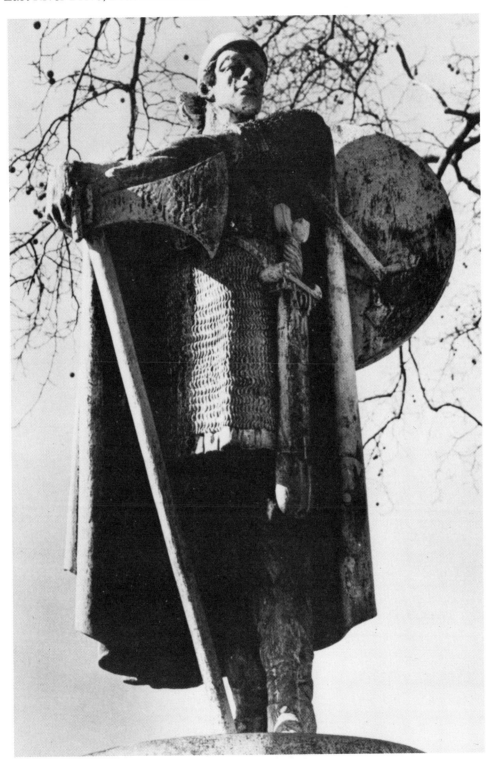

This dramatic statue is a fitting tribute to the great Icelandic
hero who attempted to colonize North America in the 11th
century. Since no likeness of Karlsefni exists, the sculptor created
an idealized image. Little is known of the man except what is
recorded in the Saga of Eric the Red, in which he is portrayed as
an intrepid explorer and a leader of men.

Washington Grays Monument 1872
by J. Wilson (dates unknown)
Bronze, height 87″ (granite base 114″)
Lemon Hill Drive, East Fairmount Park

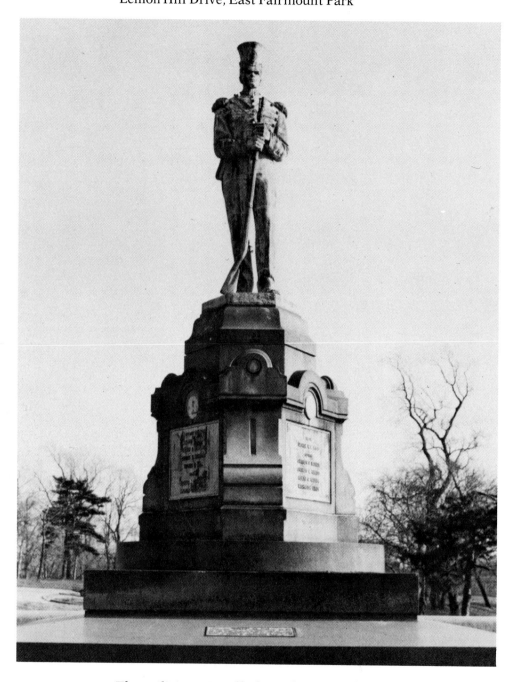

The militia unit called Washington Grays was
organized in 1822 in Philadelphia and soon
became one of the city's most popular military
outfits. This impressive memorial was erected
to commemorate those Grays who fell in the
Civil War.

The Ellen Phillips Samuel Memorial
Works by 16 sculptors
Granite and bronze
East River Drive, Fairmount Park

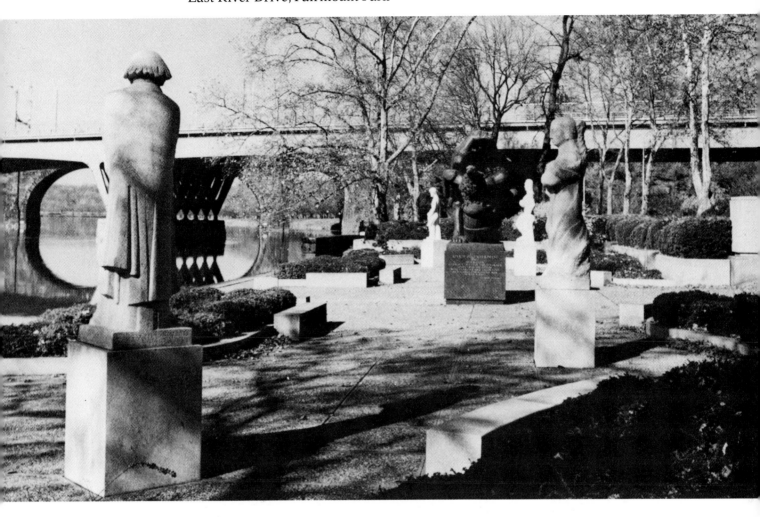

The creation of a sculpture garden "emblematic of the history of America" was the dream of Philadelphia's Ellen Phillips Samuel, a generous supporter of the arts. The works that compose the Memorial represent a wide variety of artistic expression. They represent the people and ideals that have created this country. The works of the 16 sculptors are typical of a style used in Federal projects in the 1930s.

(continued on page 112)

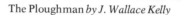

The Ploughman *by J. Wallace Kelly*

(continued from page 111)

Three terraces were designed as the setting for the statuary. The Central Terrace, the first one to be completed, illustrates the spanning of the continent. J. Wallace Kelly's stone *Ploughman* and Maurice Sterne's bronze *Welcome to Freedom* illustrate the program.

(continued on page 113)

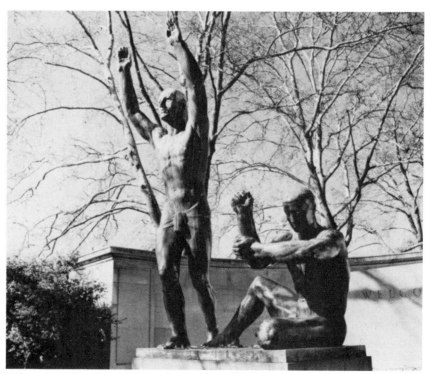

Welcoming to Freedom, *1939, by Maurice Sterne (1878–1957)*

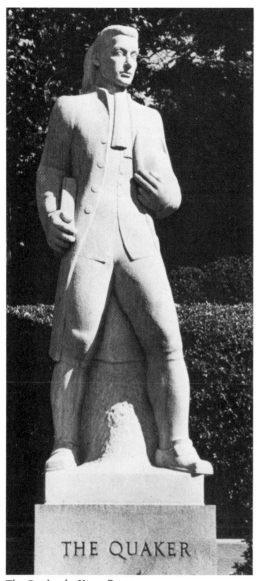

The Quaker *by Harry Rosen*

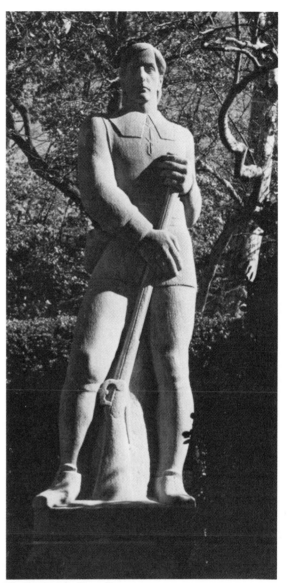

The Puritan *by Harry Rosen*

(continued from page 112)

Harry Rosen's *Quaker* and *Puritan* stand with a soldier
and statesman, by Edwin F. Frey, on the North Terrace,
which portrays the settling of the seaboard and the birth
of a nation. The physical and spiritual forces that made
America, the theme for the statues on the South Terrace,
is most successfully captured in Jacques Lipchitz's re-
markable *Spirit of Enterprise.* The sculpture is rooted
firmly to the ground, although ready to spring for-
ward. In its vigorous, even dogmatic statement of
forms, Lipchitz found the perfect equivalent for the
quality he set out to celebrate.

OPPOSITE PAGE
TOP—The Birth of a Nation *by Henry Kreis.*
BOTTOM—Settling of the Seaboard *by Wheeler Williams.*
South Terrace of the Ellen Phillips Samuel Memorial.

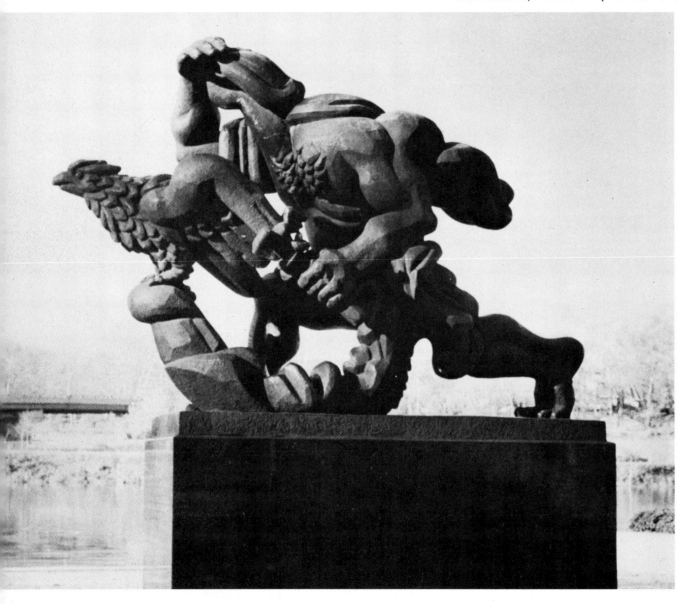

Spirit of Enterprise 1960
by Jacques Lipchitz (1891–1973)
Bronze, height 125″
(granite base 56″)
Samuel Memorial
East River Drive South
of Girard Avenue Bridge

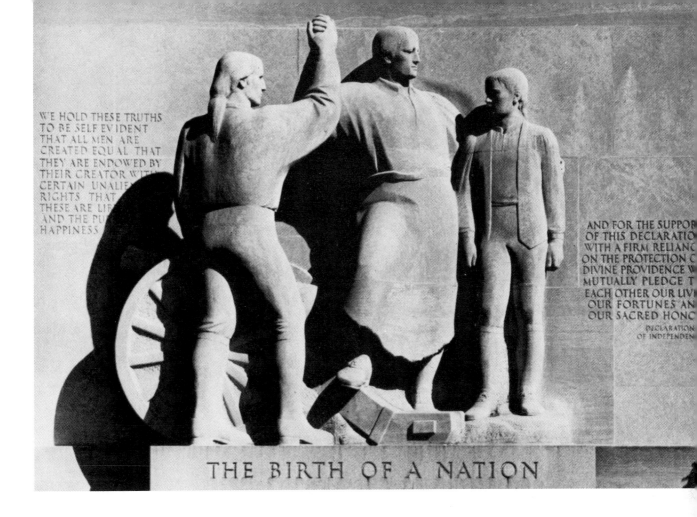

WE HOLD THESE TRUTHS
TO BE SELF EVIDENT
THAT ALL MEN ARE
CREATED EQUAL THAT
THEY ARE ENDOWED BY
THEIR CREATOR WITH
CERTAIN UNALIE...
RIGHTS THAT
THESE ARE LIF...
AND THE PU...
HAPPINESS

AND FOR THE SUPPOR...
OF THIS DECLARATIO...
WITH A FIRM RELIANC...
ON THE PROTECTION C...
DIVINE PROVIDENCE W...
MUTUALLY PLEDGE T...
EACH OTHER OUR LIV...
OUR FORTUNES AN...
OUR SACRED HON...

DECLARATION
OF INDEPENDEN...

THE BIRTH OF A NATION

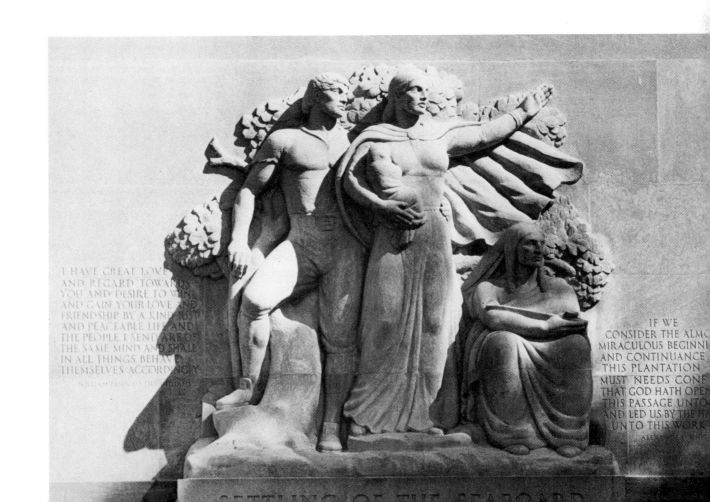

I HAVE GREAT LOVE
AND REGARD TOWARDS
YOU AND DESIRE TO WIN
AND GAIN YOUR LOVE AND
FRIENDSHIP BY A KIND JUST
AND PEACEABLE LIFE AND
THE PEOPLE I SEND ARE OF
THE SAME MIND AND SHALL
IN ALL THINGS BEHAVE
THEMSELVES ACCORDINGLY

WILLIAM PENN TO THE INDIANS

IF WE
CONSIDER THE ALM...
MIRACULOUS BEGINNI...
AND CONTINUANCE...
THIS PLANTATION
MUST NEEDS CONF...
THAT GOD HATH OPE...
THIS PASSAGE UNTO
AND LED US BY THE...
UNTO THIS WORK

SETTLING OF THE SEABOARD

Cowboy 1908
by Frederic Remington (1861–1909)
Bronze, height 144″
(natural stone base)
East River Drive

On a rocky crag in Fairmount Park, a visitor comes
upon one of the most exciting examples of Ameri-
can sculpture. He sees a horse that has stopped at
the edge of a precipice after galloping at full speed.
The sense of furious movement, suddenly halted,
is caught, from the horse's outflung foreleg to
its windswept tail. The cowboy is an excellent
character portrait—

(continued on page 118)

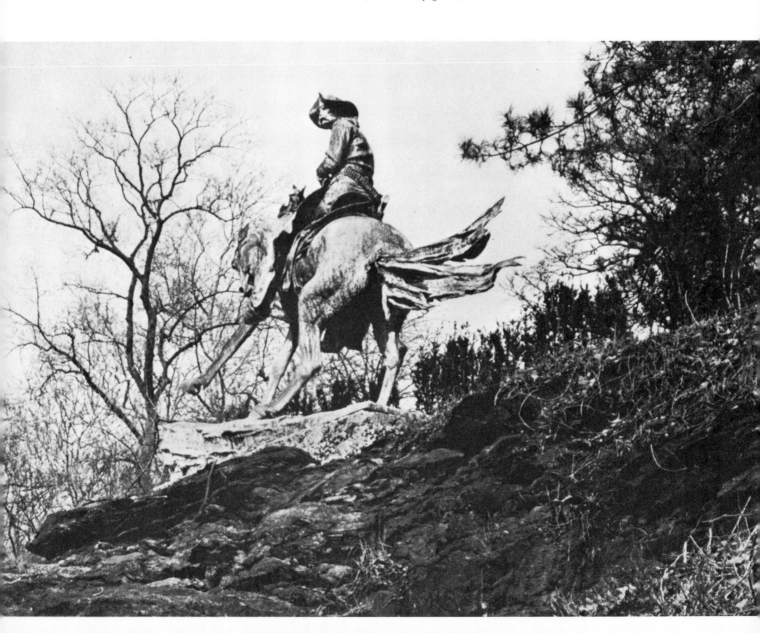

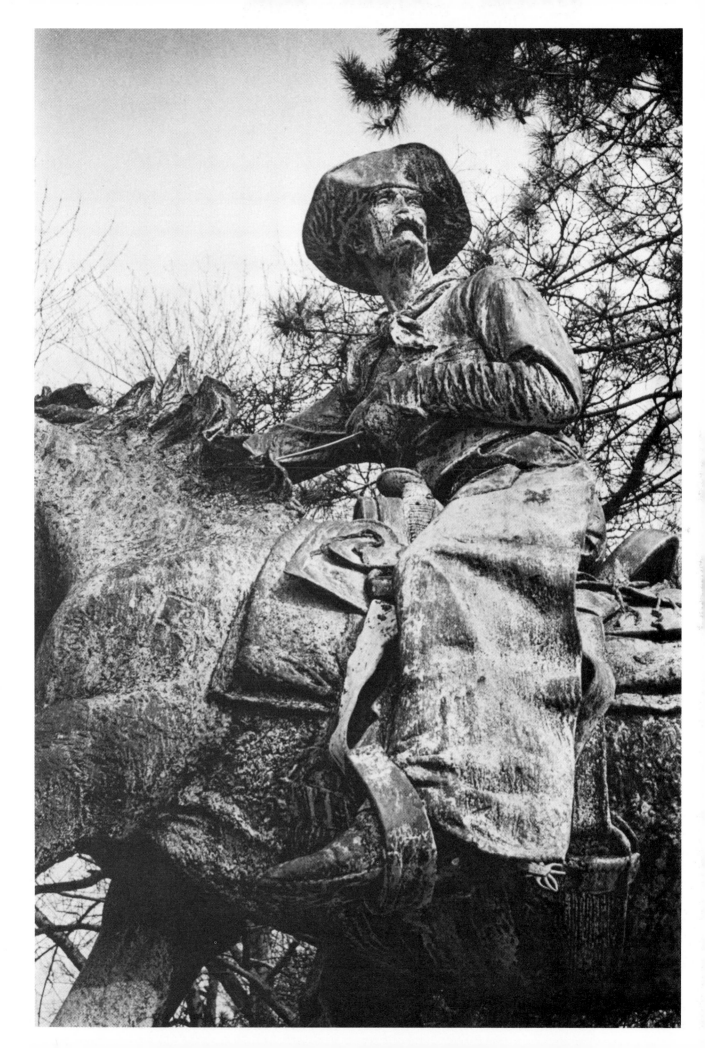

(continued from page 116)

nonchalant, rugged, and completely at one with the animal he rides. The model for the rider was an old friend of Remington's, Charlie Trego. Born in Pennsylvania, he went West in the 1880s and found work on the Cody ranch, eventually becoming the manager of Buffalo Bill's Wild West Show.

Remington was a painter and illustrator as well as a sculptor. A master of Western art, he is known for his sympathetic and realistic treatment of the horses, soldiers, Indians, and cowboys he observed during his years on the Western Plains. It is not surprising that Teddy Roosevelt, Rudyard Kipling, and Buffalo Bill knew Remington. They all shared his passion for action.

(continued on page 119)

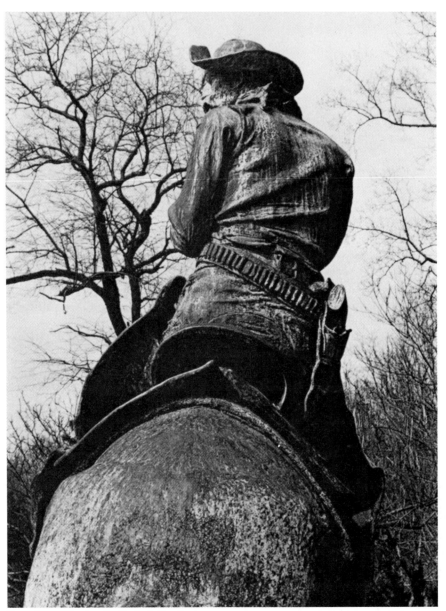

Rear view of Cowboy *by Frederic Remington.*

(continued from page 118)

Many critics believe that *Cowboy* is one of the greatest anatomical works of sculpture ever executed. Certainly it epitomizes a colorful American prototype of a bygone age. The mounted cowpuncher in Philadelphia was the first large-size bronze by the artist, and it proved to be his last. Not long after it was dedicated, Remington died. Fairmount Park is fortunate to have one of this American artist's greatest works.

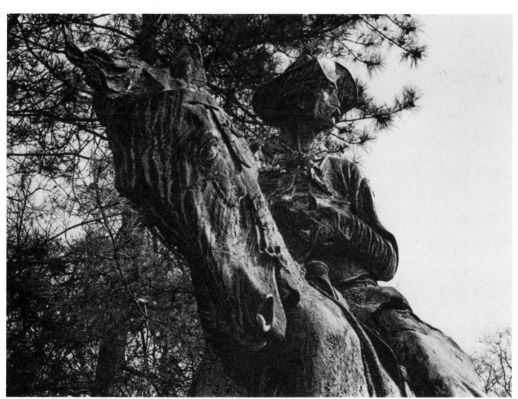

Two views of Frederic Remington's Cowboy.

A nighttime view of Cowboy, by Frederic Remington, shows the full setting that the sculptor selected for his masterpiece. He decided upon this spot for his work after having a horseman pose for him here.

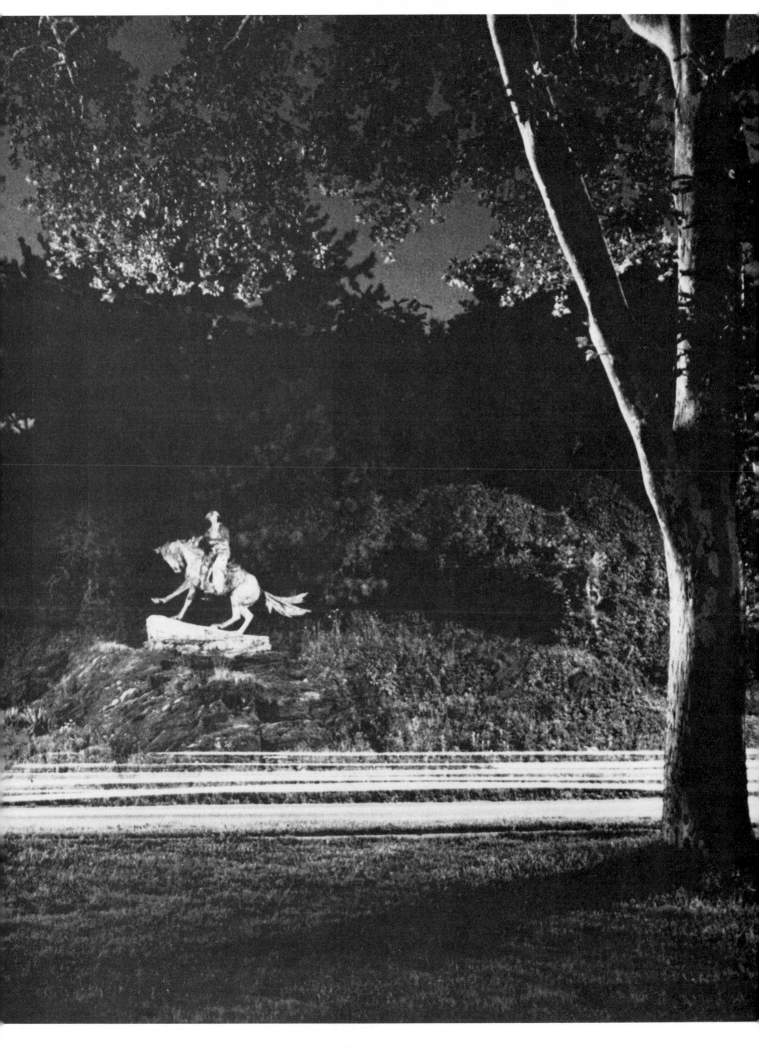

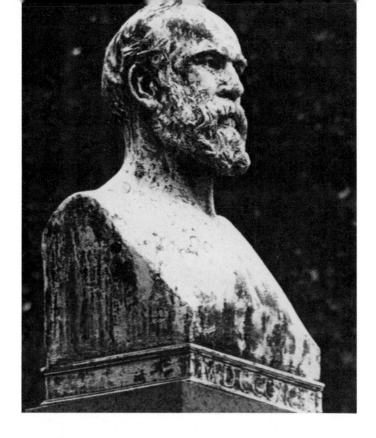

James A. Garfield 1895
by Augustus Saint-Gaudens (1848–1907)
Bronze, height of bust 42½",
of figure on pedestal 94"
(granite base 12", granite pedestal 180")
East River Drive below
Girard Avenue Bridge

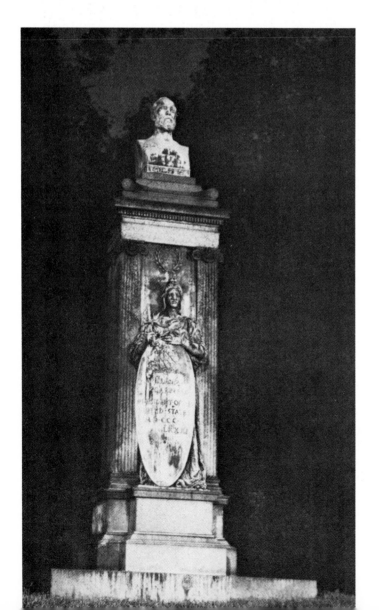

This monument to James A. Garfield, our 20th President, is one of the least-known works of the American sculptor Saint-Gaudens. Capping the monument is a stark, heroic bust of the assassinated President. Its precise realism was achieved by modeling from the actual death mask. On the front of the pedestal is an allegorical figure representing the Republic. Her stance—the way she holds shield and sword—conveys great strength and authority, while guarding the nation's virtues as well as the memory of her slain son. The shield which she holds bears a beautiful rendition of an American eagle, holding in its claws the fasces and the olive branch, and in the background the inscription "E pluribus unum." The architectural frame was designed by the noted Stanford White, who collaborated with Saint-Gaudens on a number of commissions. The landscaping respects the natural amphitheater surrounded by

(continued on page 124)

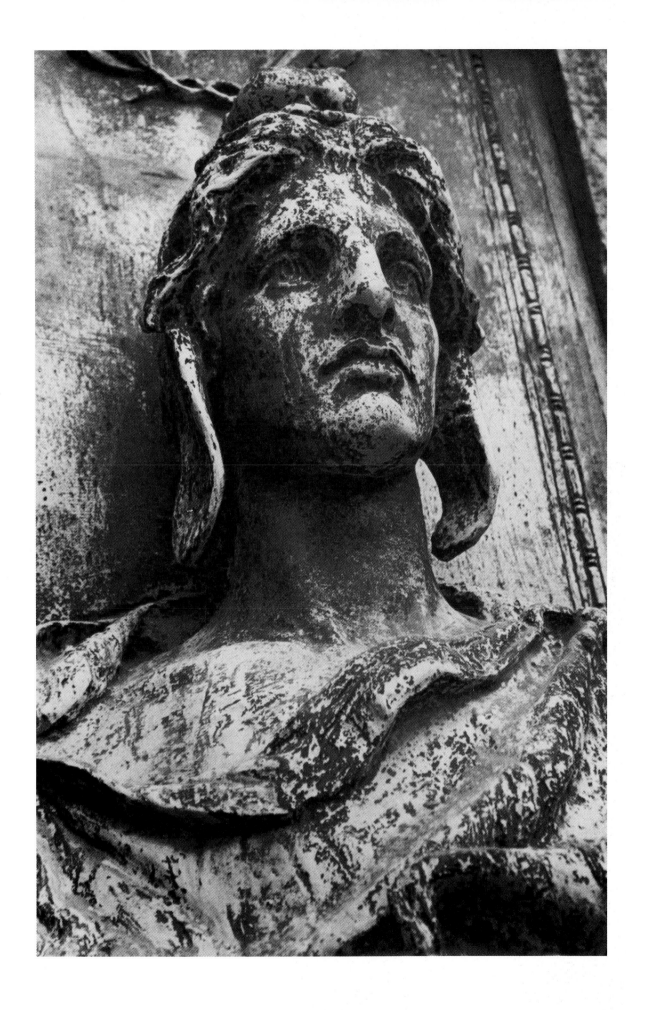

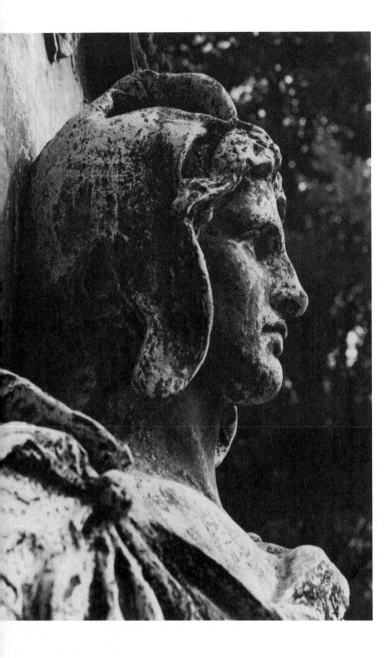

(continued from page 122)

rocks, trees, and a gentle mound, half-circled by a boxwood hedge. All of the elements in this work are well-balanced: the real with the ideal, the stone with the bronze, the architecture with the sculpture. Saint-Gaudens, "the Prince of Sculptors," has successfully created a refined and dignified memorial devoid of overt romanticism and drama.

Two views of Republic on the pedestal of Augustus Saint-Gaudens's James A. Garfield monument.

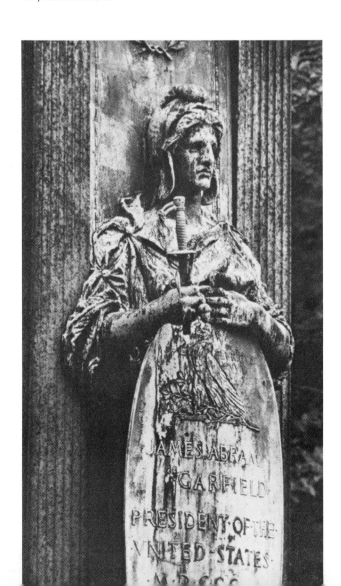

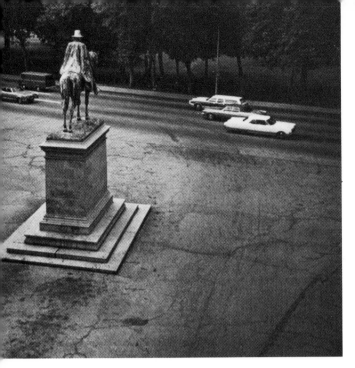

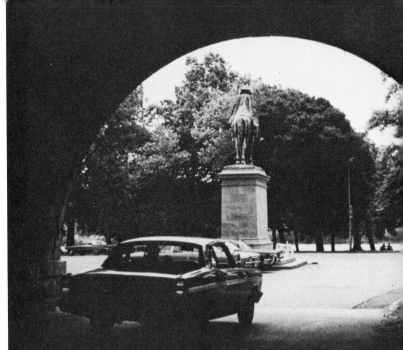

General Ulysses S. Grant 1897
by Daniel Chester French (1850–1931)
and Edward C. Potter (1857–1923)
Bronze, height 174″ (granite base 196″)
East River Drive and Fountain Green Drive

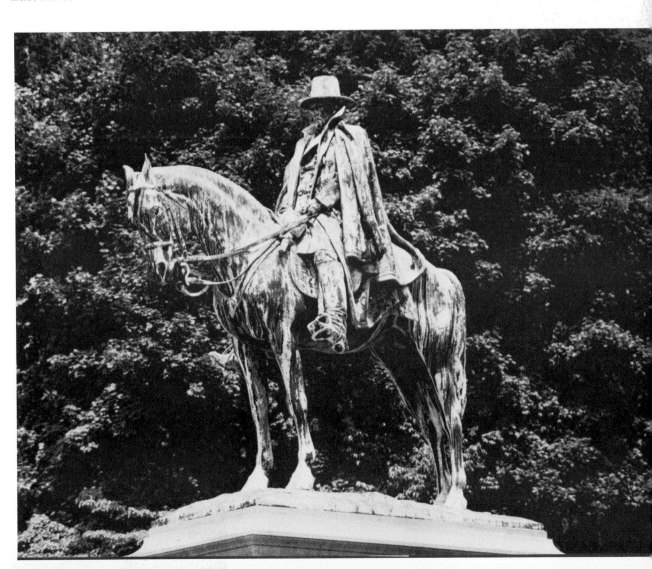

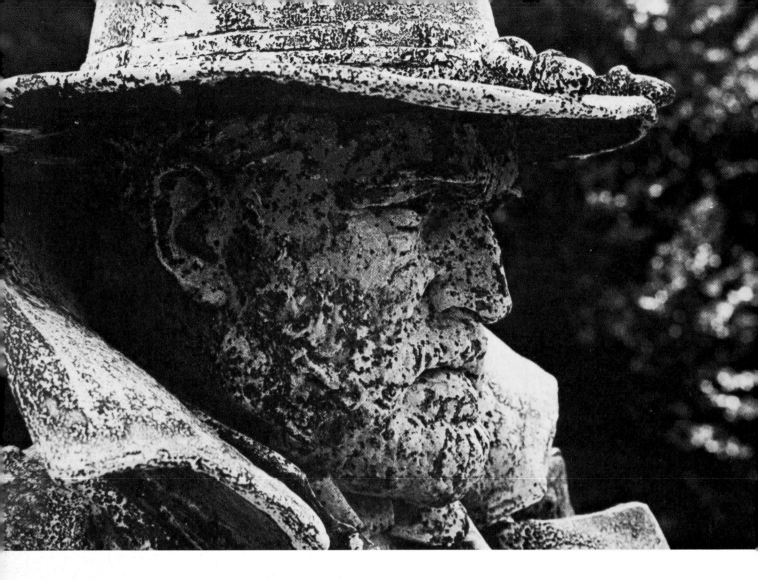

General Ulysses S. Grant *by Daniel Chester French and Edward C. Potter.*
ABOVE: *Detail of the General's rugged face.*
BELOW: *A view of the finely modeled head of the horse.*
OPPOSITE PAGE: *A dramatic nighttime view of the statue.*

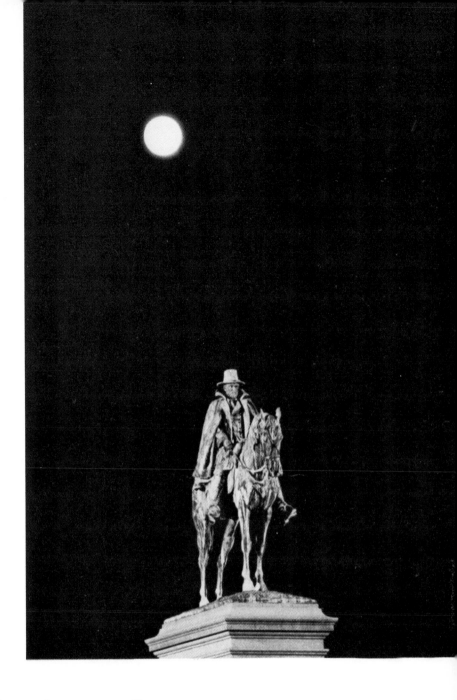

This splendid monument to our 18th President is generally considered to be the finest equestrian statue in Philadelphia. The American sculptor Daniel Chester French and his assistant, Edward C. Potter, have skillfully captured the stern expression of the General as he intently surveys the battlefield. Grant sits motionless in the saddle, legs locked, while the horse stands quietly, its head pulled down from the slight tension of the reins. Horse and rider are marvelously unified, and their posture heightens the mood of uneasy calm. At the same time, the underlying potential for dramatic and sudden action is subtly accented. With the aid of photographic close-ups, French was able to achieve a remarkably accurate likeness of Grant. The statue more than fulfills French's stated intention to "impress the beholder by its force" and to depict the "latent force of the man."

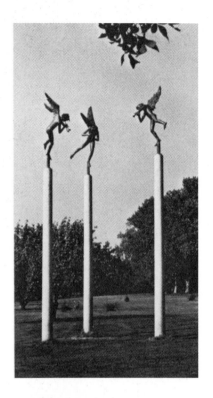

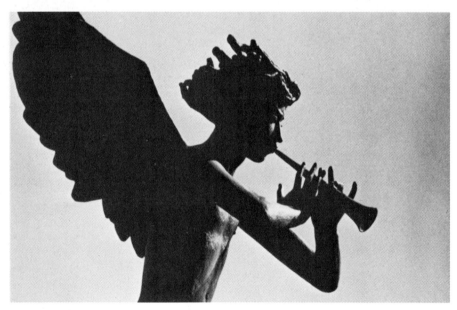

Playing Angels
by Carl Milles (1875–1955)
Bronze, height 84″
(concrete bases 240″–276″)
East River Drive at
Fountain Green Drive

This carefree trio of music-making angels was created by the internationally known Swedish sculptor Carl Milles. Especially fine examples of his work, the angels are second casts from a group of five originals, which are at Millesgarden—Sweden's great outdoor sculpture museum. *Playing Angels* reflect the sculptor's love of life and joyous spirit in a way that is both captivating and convincing.

Penguins 1917
by Albert Laessle (1877–1954)
Bronze, height 25″
(marble base 37″)
Philadelphia Zoological Gardens,
Entrance to Bird House

These three views of a pair of penguins disporting themselves give an uncannily accurate sense of these animals' antic personality. Albert Laessle's studio was near the Philadelphia zoo, where he went often to observe the animals. His intimate knowledge of his subjects enabled him to convey their droll humor and charm—as with this delightful penguin couple.

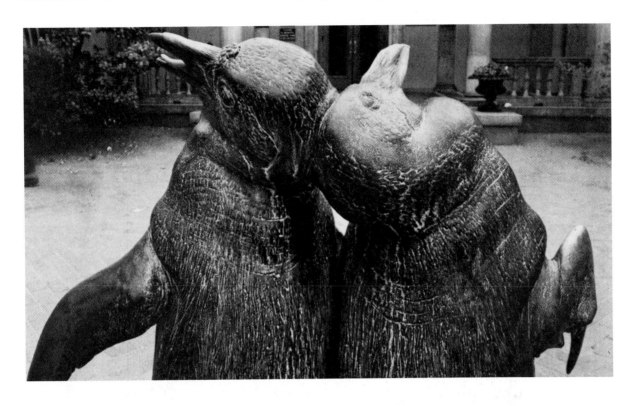

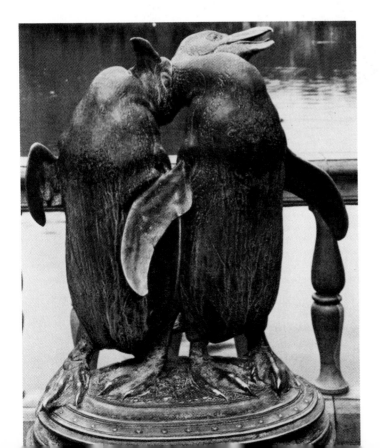

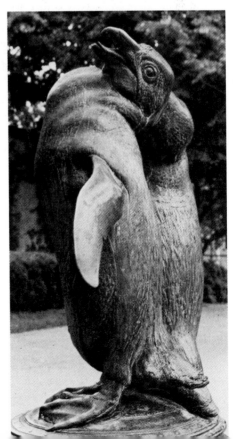

The Dying Lioness 1873
by Wilhelm Franz Alexander Friedrich Wolff (1816–87)
Bronze, height 69"
(granite base 48")
Philadelphia Zoological Gardens, Entrance

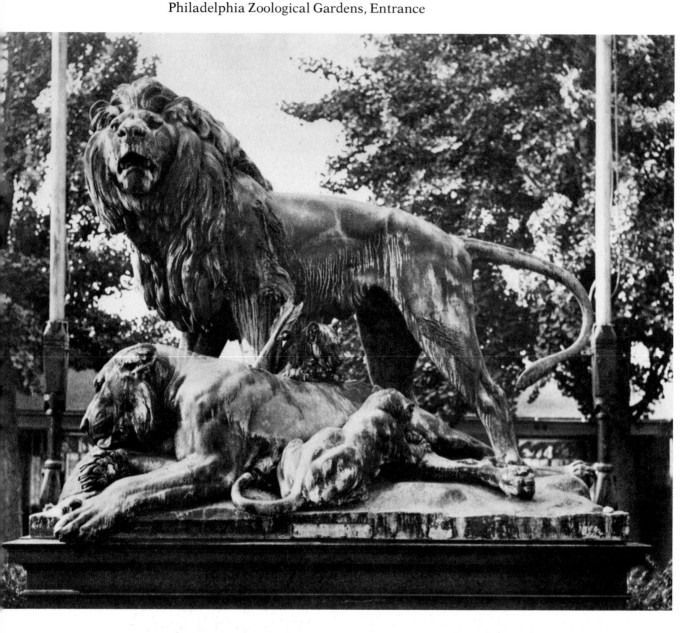

This powerful work by the German sculptor Wilhelm
Wolff depicts skillfully and with great feeling a dramatic
wildlife episode. A lioness in the throes of death is sur-
rounded by her uncomprehending, hungry cubs. Above
her looms the lion—a study of formidable though impo-
tent grief. The sculptor has conveyed both the spirit and
almost humanlike suffering of these majestic animals.

Lioness Carrying to Her Young a Wild Boar 1886
by Auguste Cain (1822–94)
Bronze, height 90″
(granite base 36″)
Philadelphia Zoological Gardens

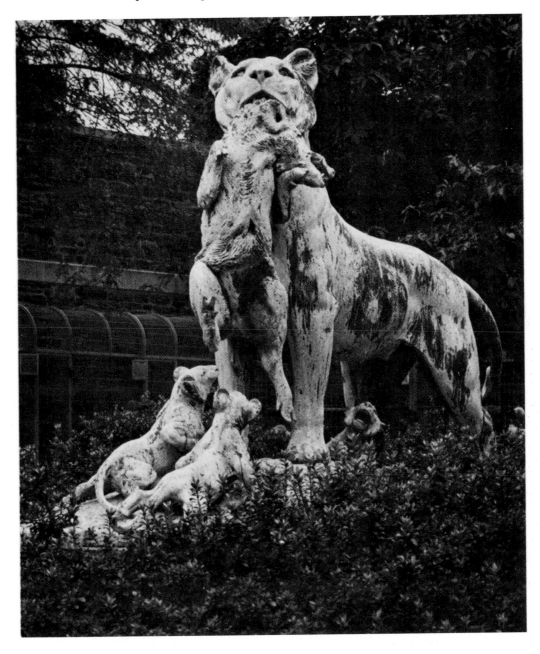

So lifelike is this ferocious *Lioness* that it used to terrify approaching horses and had to be moved from its previous site on the River Drive. The small shrubs surrounding and even growing past the base enhances the work's startling realism. The lioness's fierce pose and the cubs' tense, impatient crouch are captured with incomparable flair and technical skill. Recognized for his fine animal sculptures, French sculptor August Cain also has a tigress in New York City's Central Park.

Impalla Fountain 1964
by Henry Mitchell (1915–)
Bronze, height 240″
(black granite base)
Philadelphia Zoological Gardens

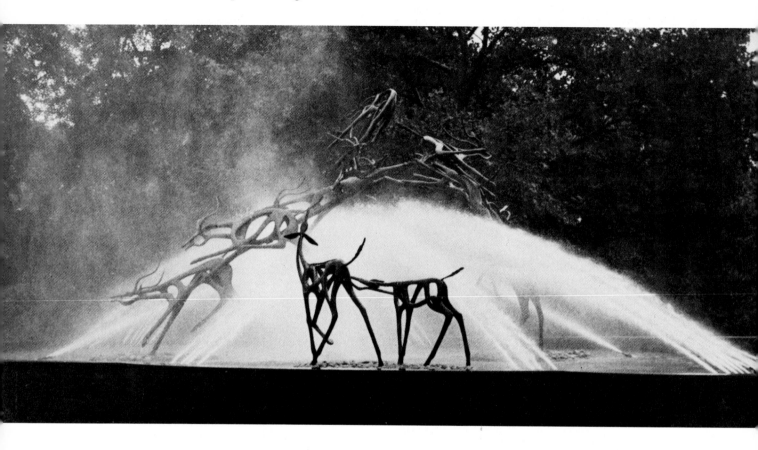

ABOVE: One of the most memorable sights in Africa is the impala antelope when it explodes into flight to escape danger. In *Impala Fountain* Henry Mitchell has reproduced the dazzling effect of these animals' sudden flight. His twelve life-size impalas vault over ten jets of water in three graceful arcs while a mother and her calf graze nearby, unaware of any danger. The sculptor has successfully endowed these skeletal bronze forms with the impala's characteristic lightness and agility.

OPPOSITE PAGE, TOP: With a minimum of detail and beautiful supple lines, Philadelphia-born sculptor Joseph J. Greenberg, Jr., has captured the essential form and movement of a bear and its cub.

OPPOSITE PAGE, BOTTOM: An even more direct depiction of the maternal instinct can be seen in this gigantic animal sculpture. Heinz Warneke's *Cow Elephant and Calf* weighs 37 tons and is the largest monolithic, free-standing sculpture in the United States.

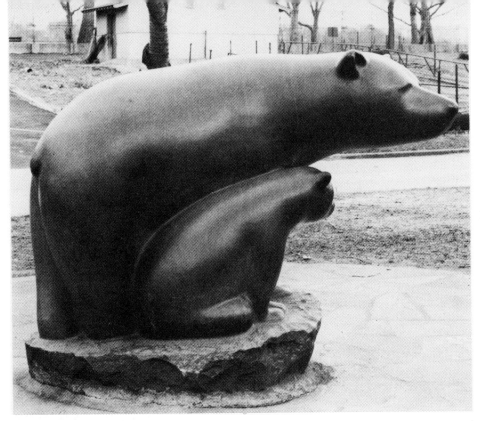

Bear and Cub 1957
by Joseph J. Greenberg, Jr. (1915–)
Black granite, height 43″
(base 11″)
Philadelphia Zoological Gardens,
Near Bear Pits

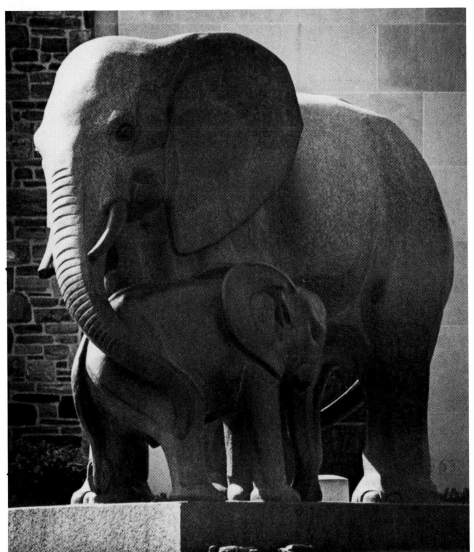

Cow Elephant and Calf 1962
by Heinz Warneke (1895–)
Granite, height 136″
(including base—single block)
Philadelphia Zoological Gardens,
Inside Main Gate

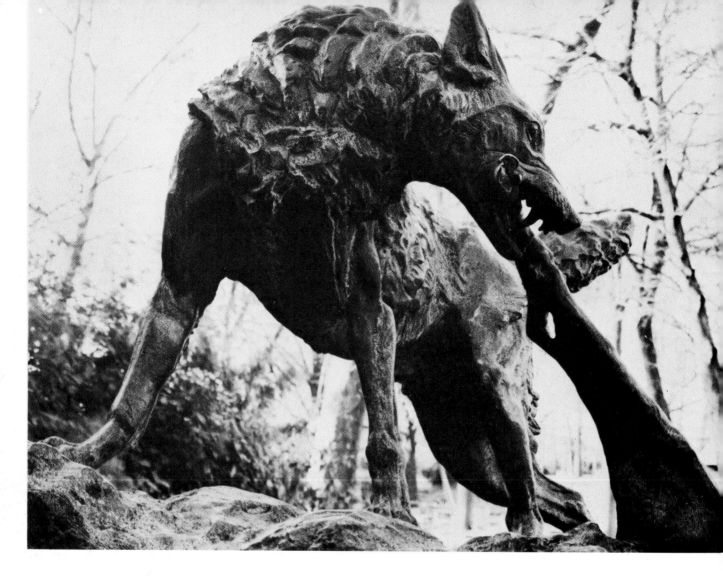

Hudson Bay Wolves 1872
by Edward Kemeys (1843–1907)
Bronze, height 50″ (granite base 30″)
Philadelphia Zoological Gardens, adjacent to Wolf Woods

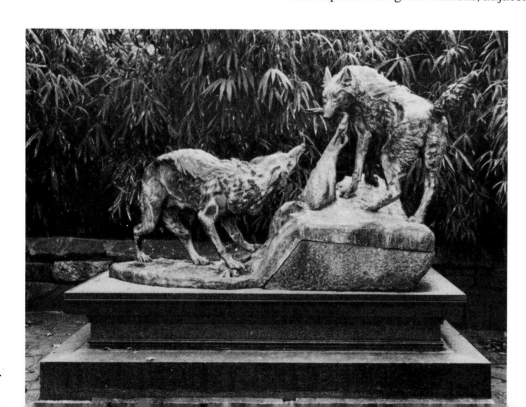

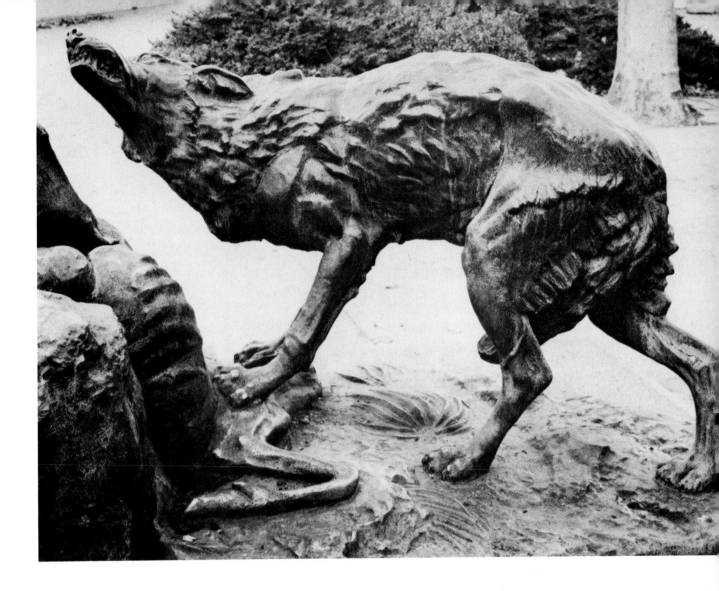

Hudson Bay Wolves is the first monumental animal sculpture to be executed by an American. Moreover, as the first accomplishment of a novice sculptor, it is nothing short of an artistic triumph. Kemeys chose to depict the moment when the wolves begin to contend for the prey they have chased and killed. The wolf on the upper ledge seems dominant as he holds the deer's leg in his mouth, but the other wolf, with front leg on the carcass, looks up at him in ferocious challenge. The beginnings of a grim and brutal struggle are signaled by a brilliant contrast of the challenging and furtive glances, the erect and flattened ears, and the clenched and smarting mouths. On the upper plateau the wolf is in an open stance, with front legs erect and tail jutting out sharply, while below the other wolf shrinks, his body tensely closed and his tail tucked between his legs. The animals' ruffled fur and strained muscles could not have been more convincingly rendered.

(continued on page 136)

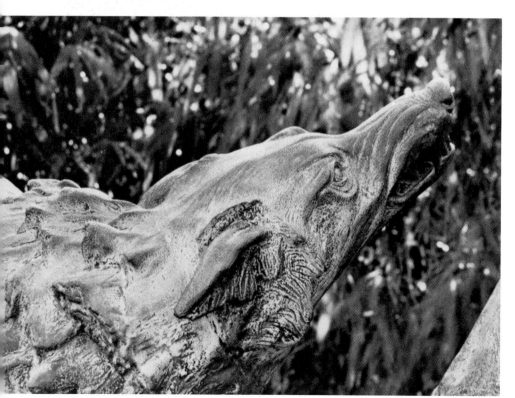

(Continued from page 135)

As a boy Edward Kemeys spent several summers in Illinois, and this exposure to the frontier helped instill in him a lifelong attachment to the West. He developed the desire to record the native American wildlife, and wolves in particular intrigued him. "I had but to go out on the prairie on a moonlight night to listen to the wolves howling," he said, "to feel . . . that strange uncanny inexplicable sensation stirring my blood; a creeping thrill at the roots of my hair."

DETAIL: *Head of the wolf on the upper level.* Hudson Bay Wolves *by Edward Kemeys.*

DETAIL: *Head of the wolf on lower level.*

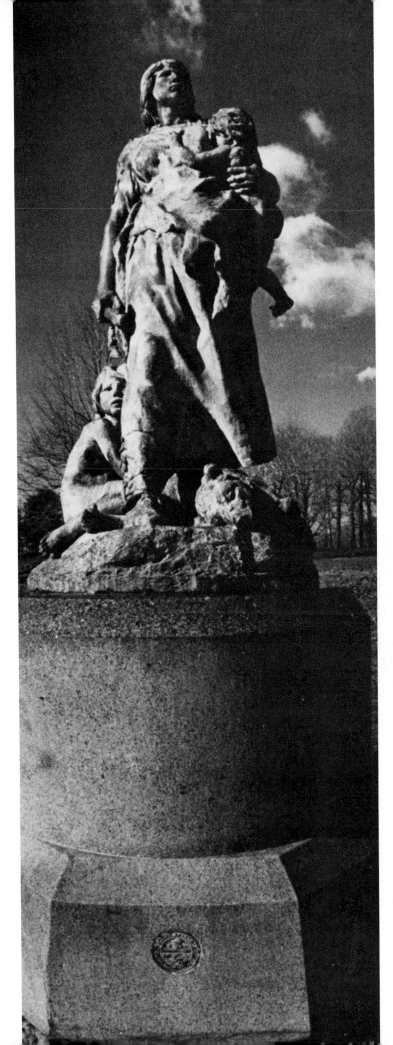

Stone Age in America 1887
by John J. Boyle (1851–1917)
Bronze, height 90″
(granite base 50″)
West Fairmount Park,
Near Sweetbriar Mansion

One of Philadelphia's most beautiful
monuments is John J. Boyle's Indian
group in bronze, *Stone Age in America.*
This heroic Indian mother staunchly
defends her children from the antici-
pated charge of the bear. At her feet lies
a dead cougar, with its head falling
over the base. A small boy kneels by the
mother's side while the youngest child
clings to her. The woman's right arm
tensely clutching a hatchet and her
penetrating stare, tightened lips, and
firmly set jaw all convey steely deter-
mination. The sculptor has varied the
patterns and folds of the woman's
animal-hide dress with marvelous
looseness. *Stone Age in America* is
Boyle's masterpiece.

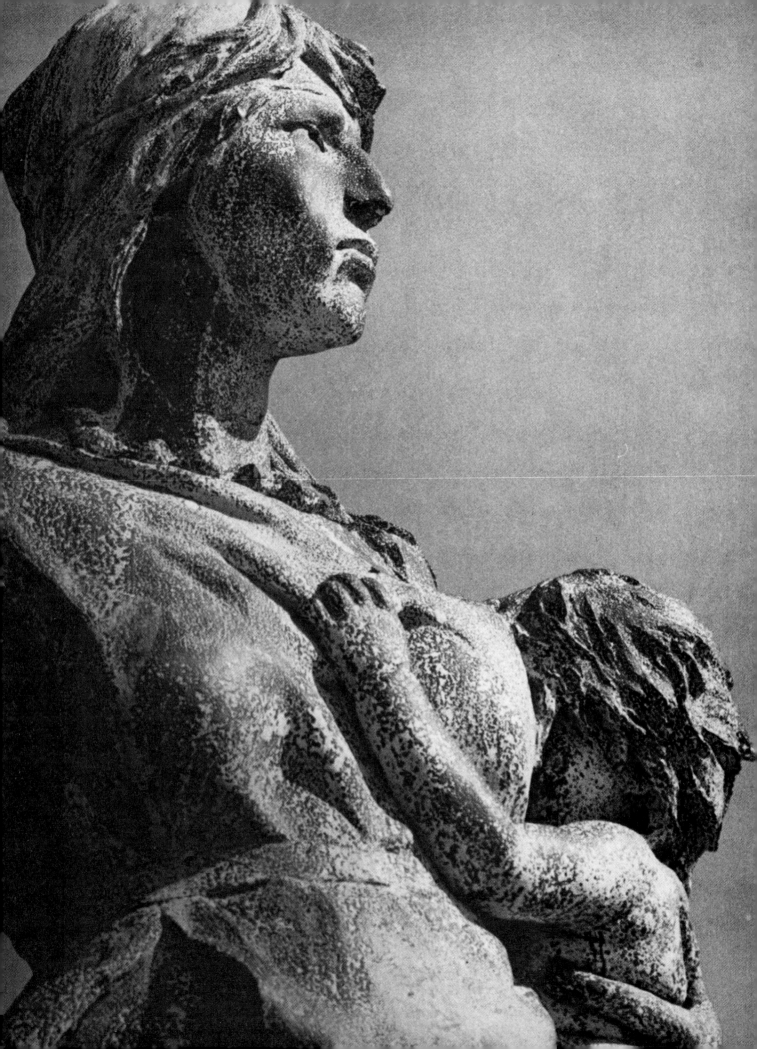

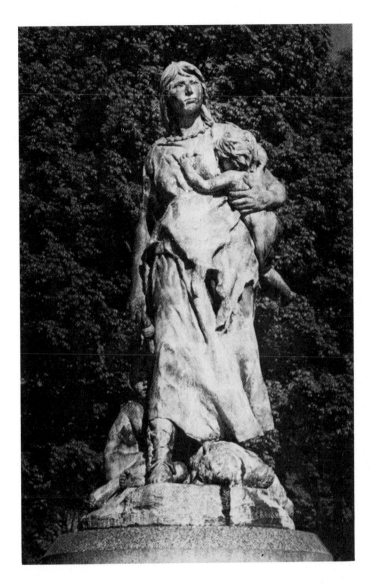

OPPOSITE PAGE and ABOVE: Additional views of
Stone Age in America by John J. Boyle. By making
the group only slightly larger than life-size and
by erecting the statue on a relatively low and
unobtrusive pedestal, the sculptor has effectively
captured the spectator's attention. Not only is
this work notable for presenting a characteristic

(continued on page 140)

John J. Boyle's Stone Age in America.
Detail of the Indian boy.

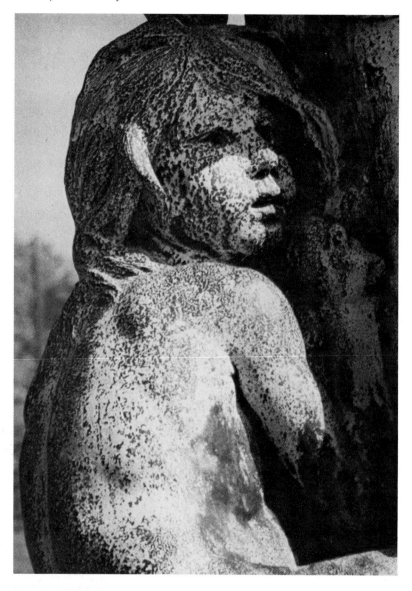

(continued from page 139)

episode from Indian life but also for its serious portrait of
the Indian. Sculptures depicting the red man were in-
frequently produced in Boyle's day, and when they did
appear, they often seemed nothing more than a convenient
excuse for sculpting a nude male or female. *Stone Age in
America* conveys, in idealized form, the courage of the
American Indian and his close relationship with nature.

140

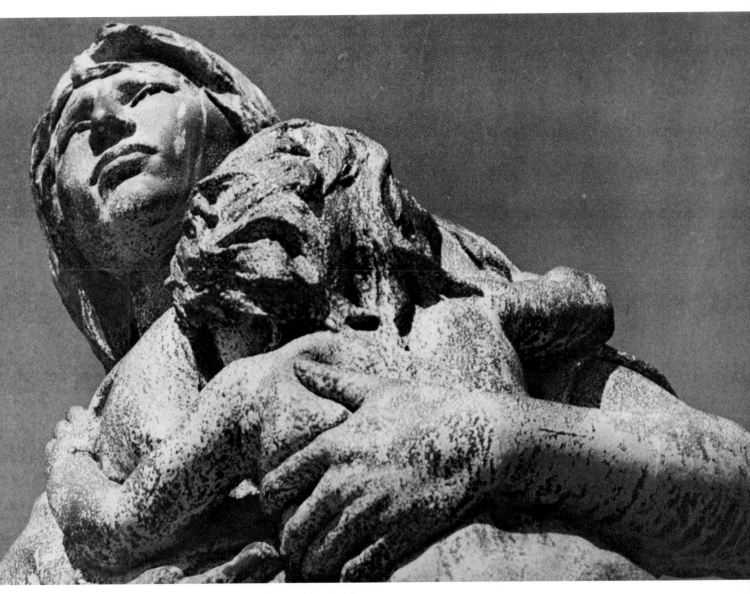

This detail of Stone Age in America *by John J. Boyle*
shows the stoic, determined expression of the Indian mother.

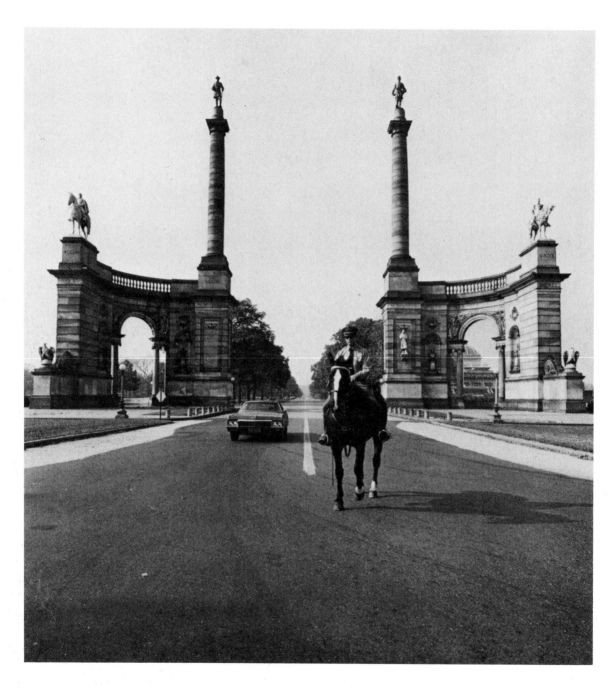

The Smith Memorial
West Fairmount Park

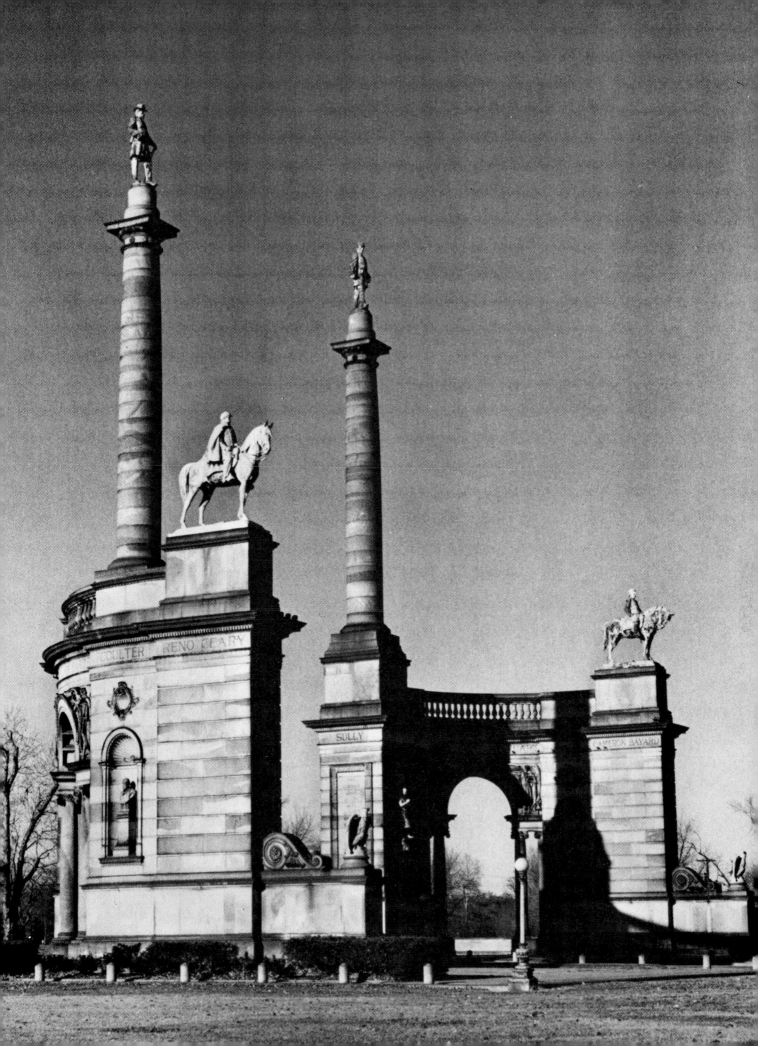

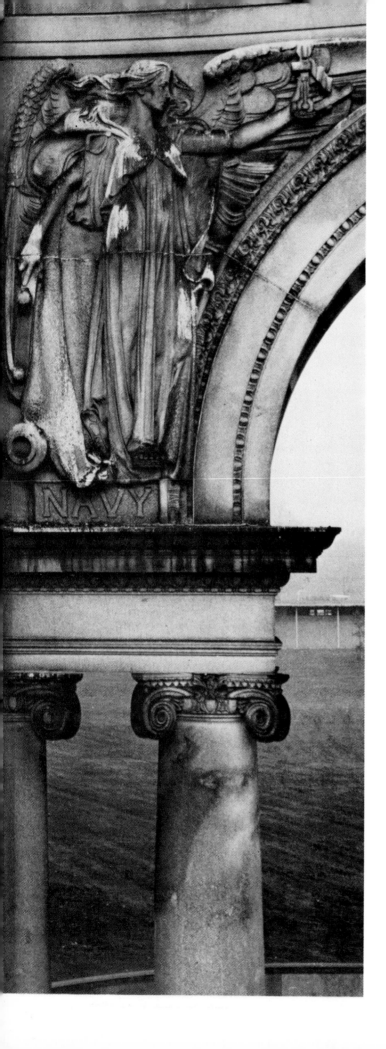

LEFT: Architectural relief on an arch of the Memorial.

The Smith Memorial, gateway to West Fairmount Park, is one of the most ambitious permanent sculpture projects ever undertaken. This structure contains fifteen individual pieces of sculpture executed by some of the leading American artists of the day. With its towering columns and sweeping semicircular arch, the Smith Memorial possesses an overwhelming picturesque quality that makes it one of the most visually striking public monuments erected at the turn of the century. Commemorating Pennsylvania's military and naval heroes of the Civil War, this enormous project took over 15 years and large sums of money to complete.

LEFT: Architectural relief on an arch of the Memorial.

OPPOSITE PAGE
Two colossal bronze statues atop pillars of the Smith Memorial.
LEFT: *Major General Meade* by Daniel Chester French.
RIGHT: *Major General Reynolds* by Charles Grafly.

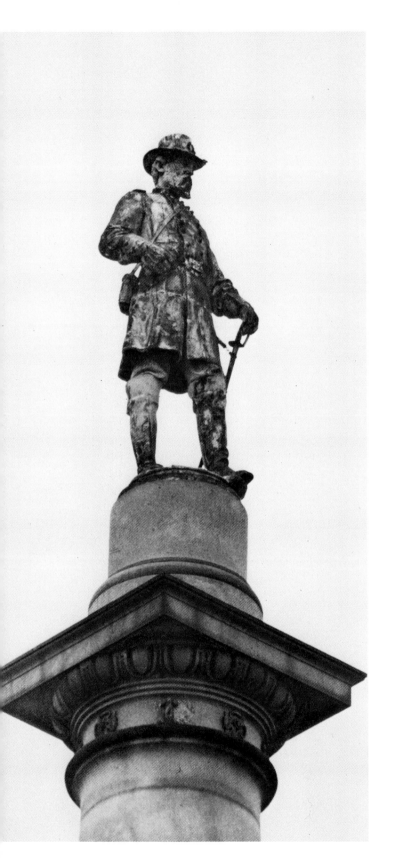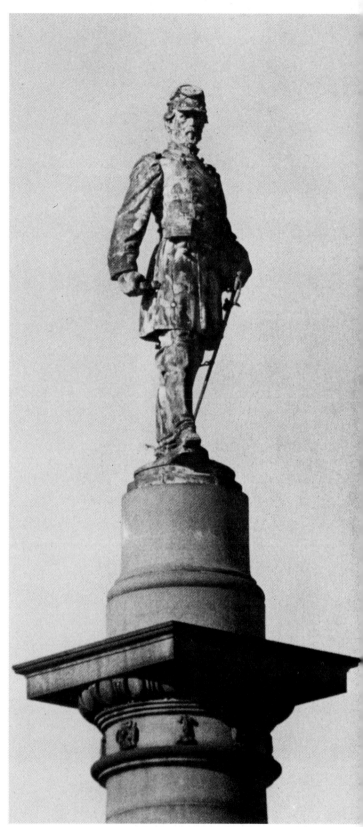

The Smith Memorial: *Major General McClellan* by Edward C. Potter.

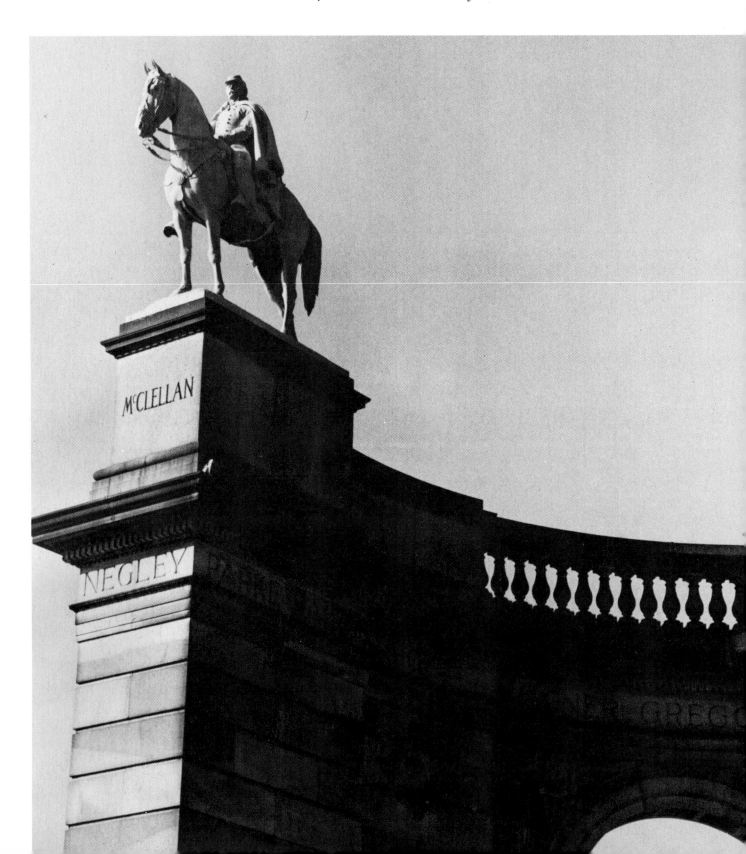

The Smith Memorial: *Major General Hancock* by Daniel Chester French.

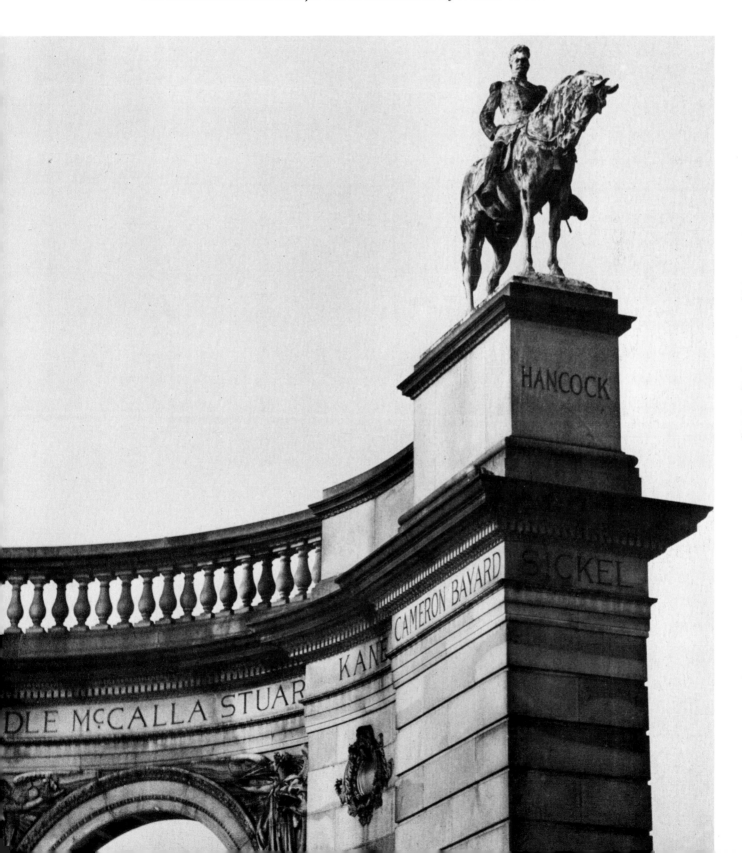

The Smith Memorial

ABOVE: Bust of Admiral David Dixon Porter by Charles Grafly. RIGHT: Colossal figure of Richard Smith by Herbert Adams. Adams's statue of the wealthy Philadelphia electroplate and type founder (1821–94) who provided the money for the Smith Memorial is possibly the finest piece of sculpture in the memorial. A fresh and unpretentious representation of a self-made man, the statue depicts Smith in the informal dress of a type founder, a lively, vibrant portrait.

RICHARD SMITH
TYPE FOUNDER

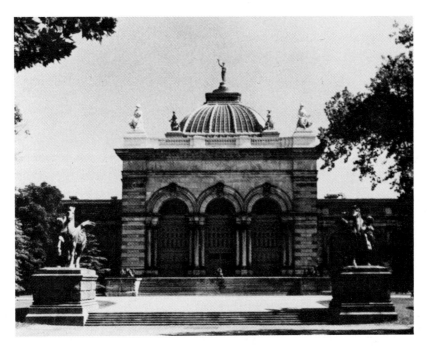

Memorial Hall 1876
West Fairmount Park

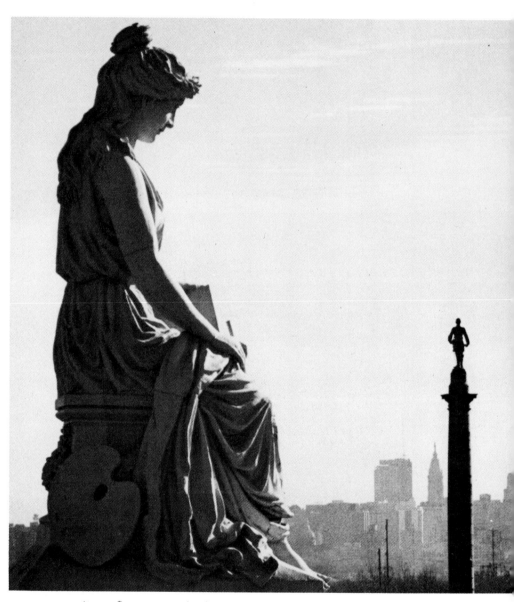

*MEMORIAL HALL: A stone figure representing Art
on the south front of the building.*

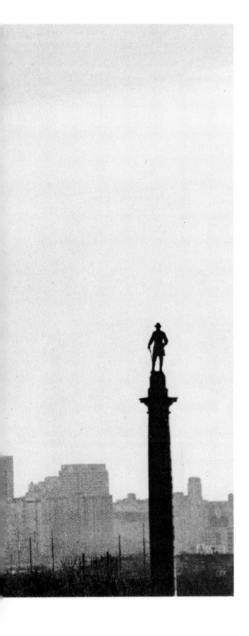

Memorial Hall was the focal point of the Centennial, held in Philadelphia in 1876. The colossal figure of Columbia crowns the cupola of the Hall. At her feet are personifications of the quarters of the globe, accompanied by Industry and Commerce on the south, and Agriculture and Mining on the north. On the south front, stone figures represent Science and Art. August J. M. Müller was the sculptor of Columbia.

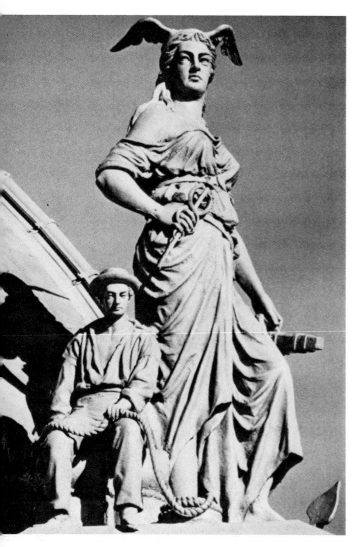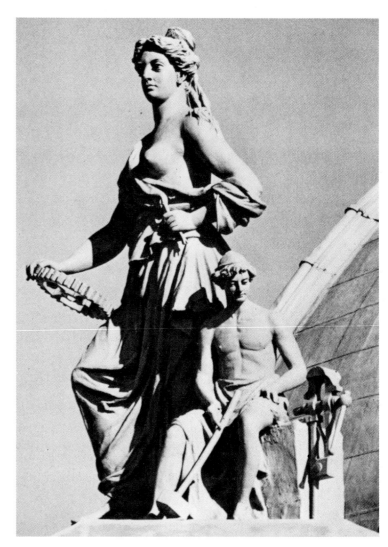

MEMORIAL HALL
LEFT: *Commerce.* RIGHT: *Industry.*

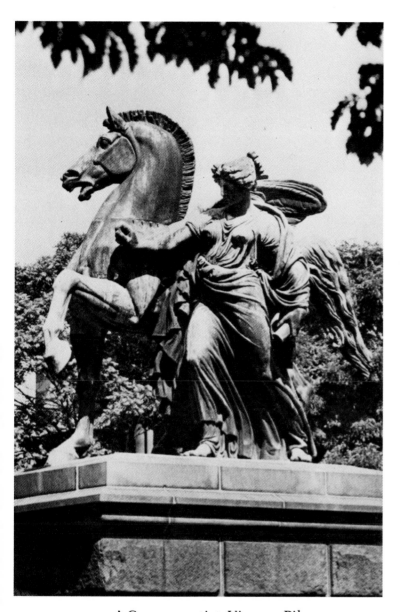

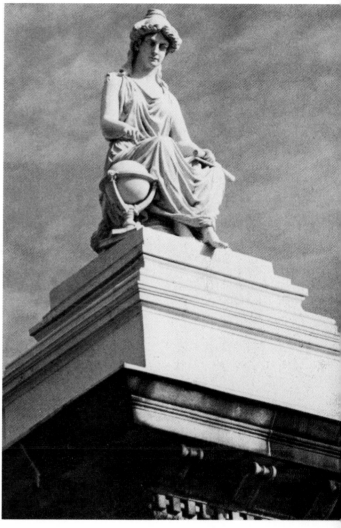

MEMORIAL HALL: *Science, south front of the building.*

A German artist, Vincenz Pilz (1816–96) executed this bronze statue of Pegasus, which stands at the entrance of Memorial Hall. One of a pair, it was created for the Vienna Opera House. Criticized for being out of scale, the giant winged horses were rescued by Robert H. Gratz of Philadelphia, who gave them to the city. They subsequently became part of the Memorial Hall complex.

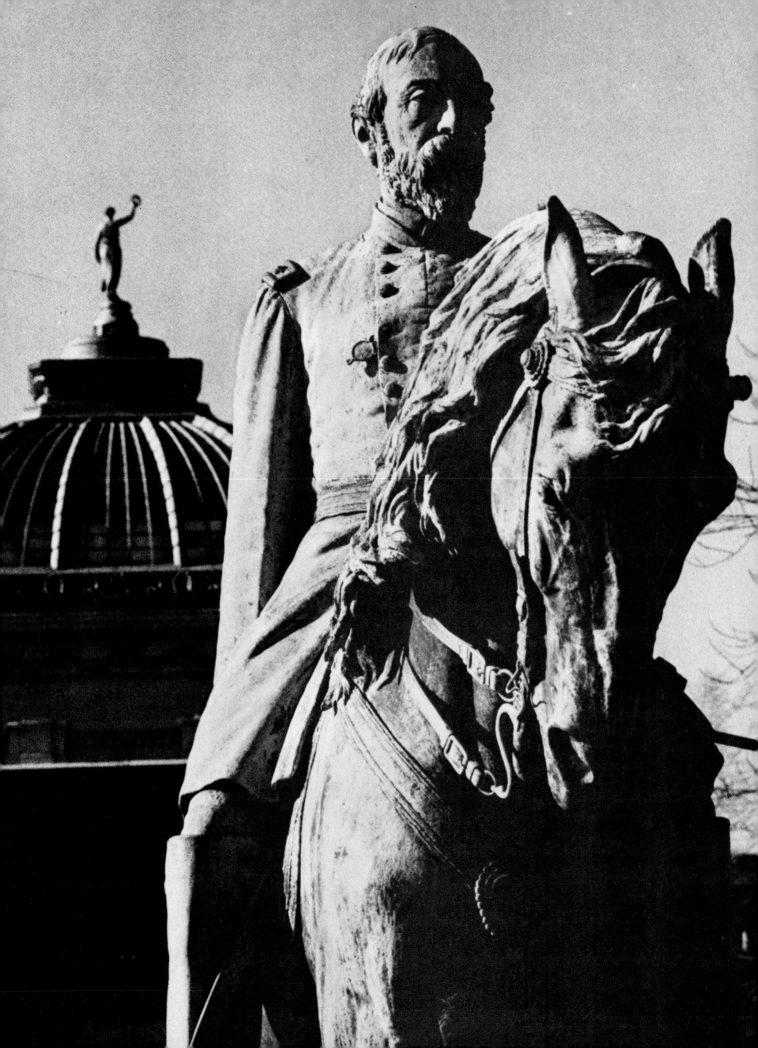

Major General George Gordon Meade 1887
by Alexander Milne Calder (1846–1923)
Bronze, height 138″ (granite base 144″)
West Fairmount Park
Lansdowne Drive, north of Memorial Hall

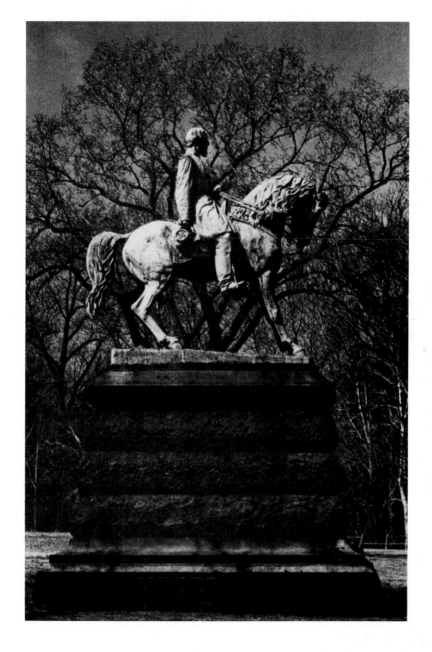

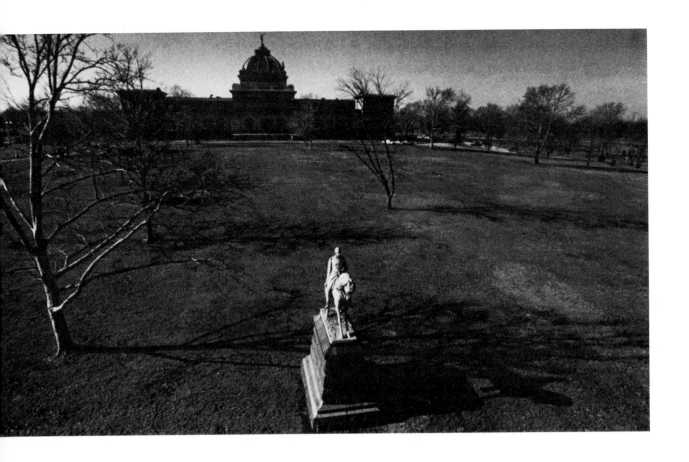

This majestic equestrian statue is a fitting tribute to the Union general whose military genius at Gettysburg secured Philadelphia by turning back the Confederate forces. Meade was a thorough soldier and a cultured gentleman—dedicated and disciplined. Alexander Milne Calder had known the general, so in creating the work he relied upon memory as well as photographs for guidance. Calder had studied anatomy, human and equine, under the great Thomas Eakins, so it is not surprising that the general's horse is rendered with great accuracy. In accord with the wishes of General Meade's family and friends, the statue was placed in Fairmount Park—the most appropriate location since Meade was a commissioner of the park from its origin until the day he died.

TOP: A view of Calder's equestrian statue, with Memorial Hall in the background.

OPPOSITE PAGE

TOP: The Meade statue dramatically silhouetted against the sky.

BOTTOM: Detail of the horse's head showing the fine modeling of anatomical details.

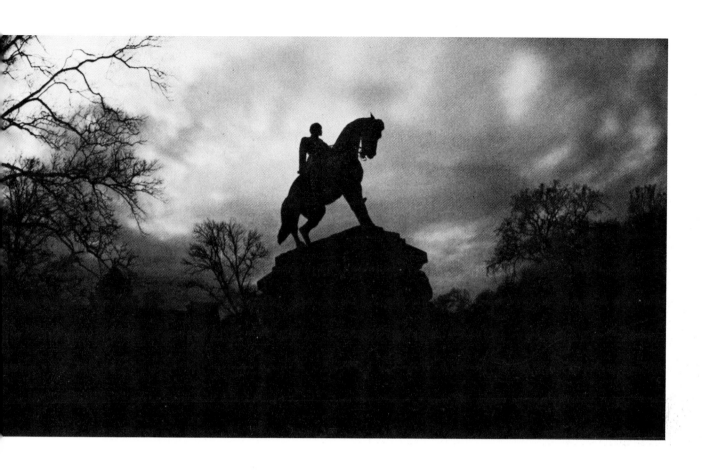

Major General George Gordon Meade
by Alexander Milne Calder

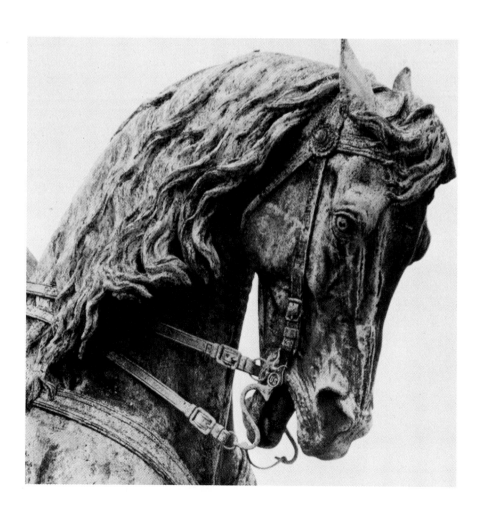

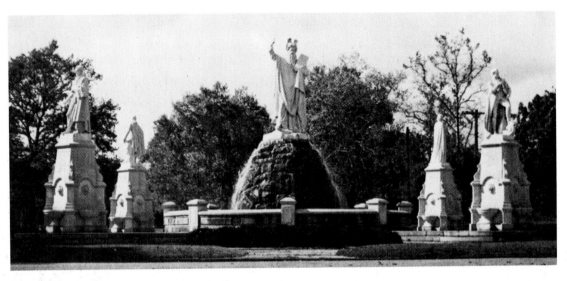

Catholic Total Abstinence Union Fountain 1876
by Herman Kirn (?–after 1911)
Marble, 40′ diameter (granite base)
West Fairmount Park

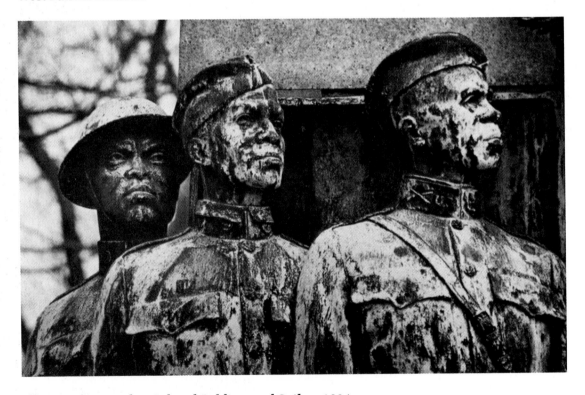

All Wars Memorial to Colored Soldiers and Sailors 1934
by J. Otto Schweizer (1863–1955)
Bronze, overall height 258″ (granite base)
Lansdowne Drive, West Fairmount Park (near Memorial Hall)

Columbus Monument 1876
Sculptor unknown
Marble, height 120″ (base 144″)
West Fairmount Park

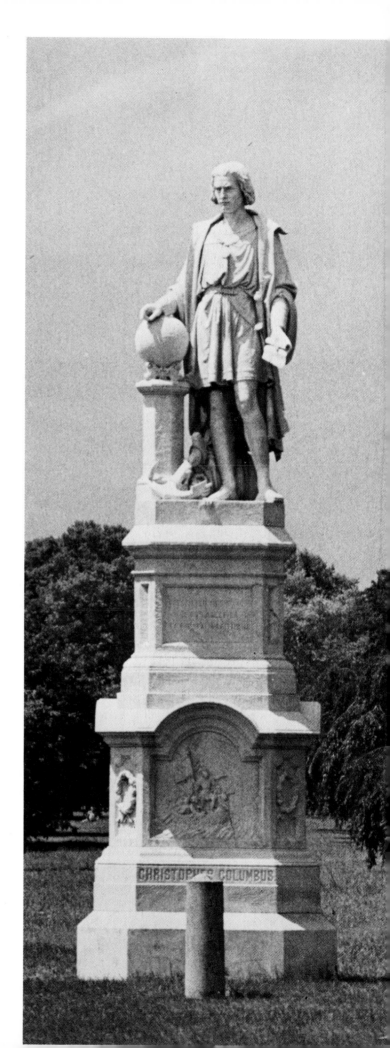

ABOVE: A statue of the Scottish-American Presbyterian clergyman who signed the Declaration of Independence.

RIGHT: Columbus stands atop a pedestal decorated with reliefs depicting the sighting of the coast, the first landing, and the seals of Italy and the United States.

OPPOSITE PAGE

TOP: The growing movement in America in favor of temperance resulted in the erection of this fountain to mark the union's participation in the 1876 Centennial.

BOTTOM: This memorial commemorates the service of black soldiers during the various wars in which the United States has been engaged.

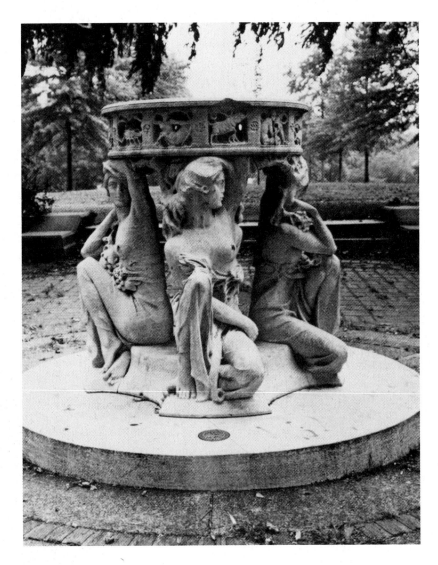

Sundial 1903
by Alexander Stirling Calder (1890–1945)
Marble, height 49″ (marble base 6″)
Horticultural Hall site, West Fairmount Park

A graceful group of four young women support the circular table which held the sundial. The figures represent the seasons. Spring holds a rose; Summer is carrying poppies; Autumn wears grapes in her hair; and Winter has a branch of pine across her figure. The apple bough that each figure holds suggests opulence, and signs of the zodiac embellish the outer edge of the table.

Night 1872
by Edward Stauch (1830–?)
Bronze, height 68″
(granite base 60″)
George's Hill,
West Fairmount Park

Night by Edward Stauch was the first official acquisition of the Fairmount Park Art Association. This bronze allegorical statue depicts a nude female form gathering a shroudlike garment about her in an apparent metaphor of descending night.

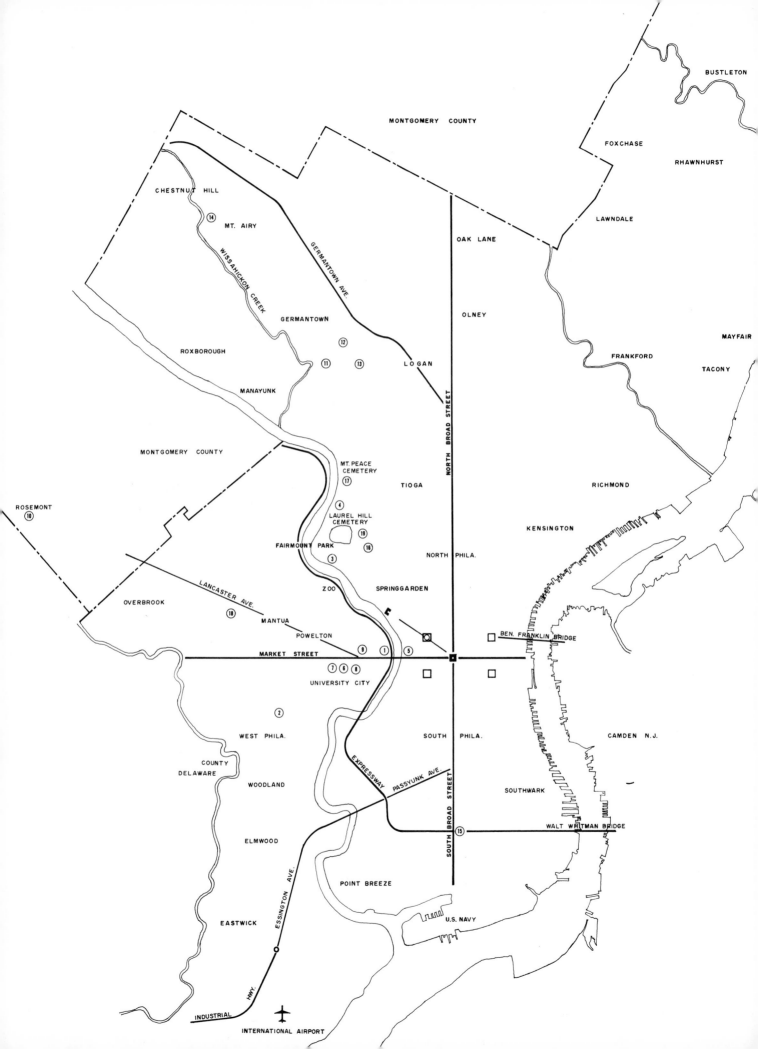

SCATTERED TREASURES

The city of Philadelphia is larger than most visitors realize. There are proud neighborhoods preserving a special quality—Germantown, founded by religious refugees; Southwark; and West Philadelphia, particularly University City. The western sector developed after 1810 and incorporated into the city in 1854. The University of Pennsylvania moved from the old city in 1872 and literally became a city in itself along with adjacent Drexel University. Here are an excellent group of sculptures commemorating statesmen and educators silently watching courtyards and classrooms.

The main roads hold occasional surprises: Walt Whitman strides beside the bridge named for him in South Philadelphia; an automobile showroom contains a remnant of the Centennial on South Broad Street.

Upper Fairmount gives way to the Wissahickon Valley on the north—a wild woodland to Philadelphia children. Perched on a rock is Tedyuscung, a majestic Delaware chief, frozen in stone, surveying his lands.

Of great historic importance is Laurel Hill Cemetery—Philadelphia's oldest and largest garden cemetery. Its funereal monuments are remarkable in their diversity of style and subject. Always a popular place to visit, Laurel Hill was frequented by such large numbers of people in the nineteenth century that tickets of admission had to be issued to control the crowds. It is still, justifiably, one of Philadelphia's most interesting attractions.

- ③ **Brownstone Gate**
- ⑦ **Construction #66**
- ⑱ **Decline and Rise**
- ⑦ **Dewey, John**
- ② **Dickens and Little Nell**
- ⑨ **Drexel, Anthony J.**
- ⑤ **Eagle**
- ⑥ **Fountain Sculpture**
- ⑦ **Franklin, Benjamin**
- ⑦ **Franklin, Benjamin, and His Whistle**
- ⑬ **Helical Form**
- ⑩ **Honor Arresting the Triumph of Death**
- ⑪ **Houston, H. H.**

- ④ **Laurel Hill Cemetery**
- ⑲ **Medicine Man**
- ⑰ **Nicholson, James Bartram**
- ⑯ **Orestes and Pylades Fountain**
- ⑫ **Pastorius Monument**
- ① **Pennsylvania Railroad War Memorial**
- ⑧ **Pepper, William**
- ⑭ **Tedyuscung**
- ⑦ **The Voyager**
- ⑦ **Whitefield, Rev. George**
- ⑮ **Whitman, Walt**
- ⑦ **Young Franklin**
- ⑨ **Young Vine Grower**

BELOW, LEFT: This heroic bronze statue depicts the Archangel Michael, Angel of the Resurrection, with a figure of an uplifted soldier in his arms. Michael stands on a black granite base on which are inscribed the 1,307 names of the railroad employees who lost their lives in World War II. American poet Robert Frost admired this memorial when he visited Philadelphia.

BELOW, RIGHT: This is the only likeness in sculpture of the famous English novelist Charles Dickens and perhaps the most famous statue of his popular heroine, Little Nell. American readers became involved in the fate of Little Nell as they read each successive installment of *The Old Curiosity Shop* in 1841.

Pennsylvania Railroad War Memorial 1950
by Walker Hancock (1901–)
Bronze, height 468″ (black granite base)
30th Street Station, Penn Central
Transportation Company

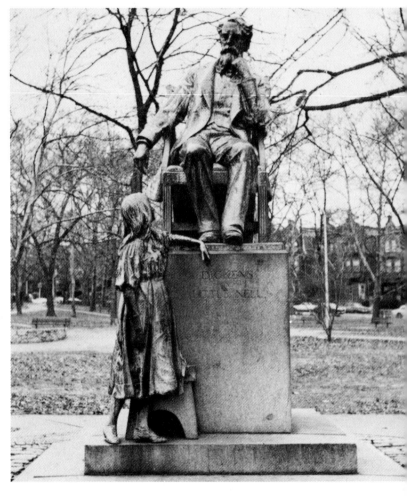

Dickens and Little Nell 1890
by Frank Edwin Elwell (1858–1922)
Bronze, *Little Nell*, height 64″;
Dickens, height 80½″
(granite base approximately 65″)
Clark Park, 43rd and Chester Avenues

Brownstone Gate to a Footpath 1876
Attributed to Frank Furness (1839–1912)
Brown sandstone, height 150″
East River Drive, below Laurel Hill

This detail of the floral ornament on a hundred-year-old brownstone gate shows an imaginative combination of natural forms and geometric patterns characteristic of the work of the great American architect Frank Furness. The gate was part of an exhibit at the 1876 Centennial.

Entrance Gate, Laurel Hill Cemetery
Cemetery, including gate, designed by John Notman (1810–65)
3822 Ridge Avenue,
Overlooking Schuykill River

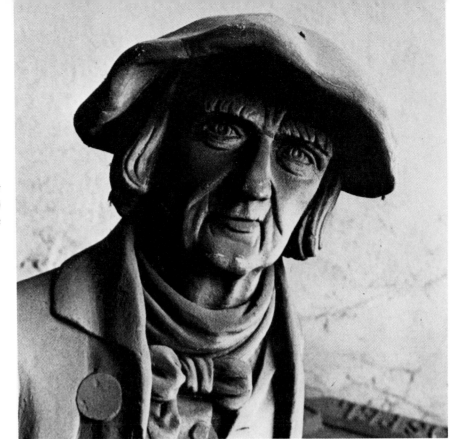

Old Mortality
by James Thom (1802–1850)
Laurel Hill Cemetery Entrance

OPPOSITE PAGE: This impressive Roman Doric gate is the entrance to
Philadelphia's oldest and largest garden cemetery. Because the cemetery
was also considered a public garden, it was embellished with sculpture.

BELOW: James Thom's rural tableau of the author Sir Walter Scott meeting an
aged gravestone-cutter, "Old Mortality."

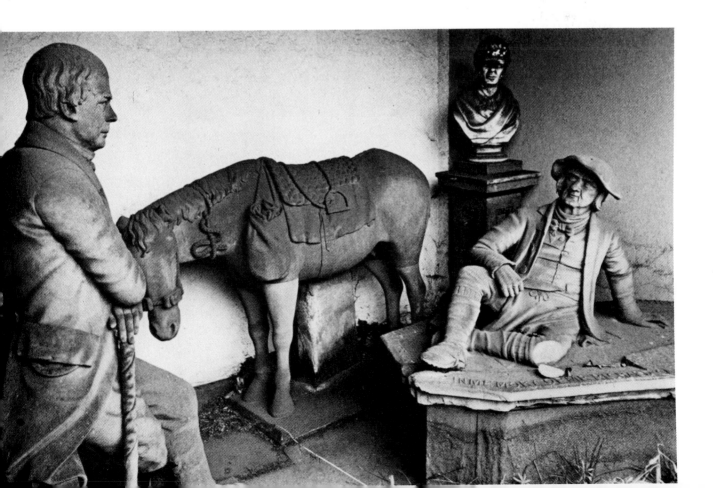

BELOW and OPPOSITE PAGE
Henry Charles Lea Monument 1911
by Alexander Stirling Calder (1870–1945)
(Zantzinger and Borie, architectural frame)
Bronze
Laurel Hill Cemetery

The custom of erecting public funereal monuments in a garden setting ended, for the most part, with the 19th century. However, a few exceptions allowed Philadelphia to continue the great tradition into the 20th century. One of the most impressive is the monument to Henry Charles Lea by the sculptor Alexander Stirling Calder. Calder's magnificent portrayal of Cleo, the muse of history, is enhanced by a classic architectural frame.

William Warner Tomb 1889
by Alexander Milne Calder (1846–1923)
Granite, height 92″, width 64″
(granite base)
Laurel Hill Cemetery

When crowded 18th-century churchyards gave way to more open landscaping, sculptors began to create imposing sepulchral tombs to fill the space and to satisfy wealthy patrons. The Warner tomb presents a striking allegory of the soul escaping in a stone cloud from a half-open sarcophagus.

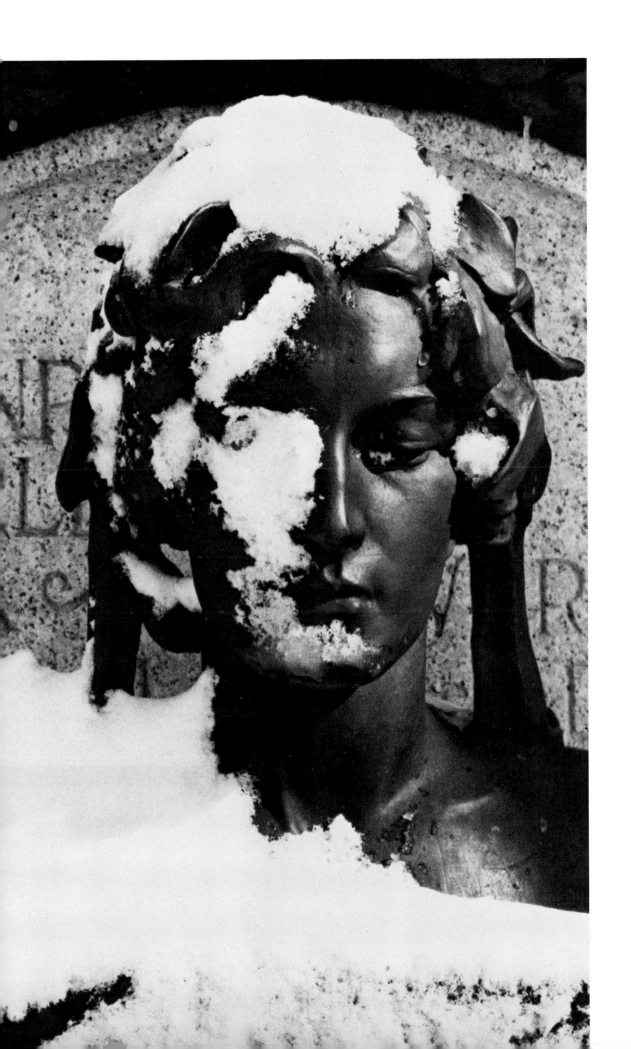

Funereal monuments in Laurel Hill Cemetery were executed in a great variety of styles, materials, and forms, reflecting the increasing complexity and vitality of the last century. For a time obelisks, which can be seen in the background of the photograph below, were popular and appeared in seemingly endless profusion. Sometimes architectural motifs were combined with sculpted figures. For example, angels capped the shafts of the William Clothier and Thomas Kirkpatrick monuments (below).

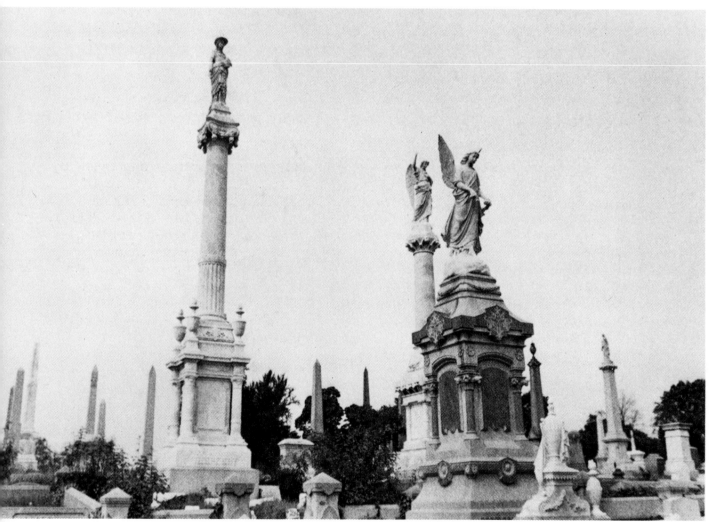

Clothier, Kirkpatrick and Winpenny tombs–Laurel Hill Cemetery.

Laurel Hill Cemetery

Remarkable diversity of style and subject is evident in the photographs on this and the next page of some Laurel Hill funereal monuments.

TOP: The great lion by J. Lacmer for the General Robert Patterson monument rests on a granite plinth with one paw grasping symbols of the general's profession—a sword, cannon, and the flag the general defended.

MIDDLE: This extraordinary monument to another military figure—General Francis E. Patterson—was done by the Philadelphia sculptor Joseph A. Bailly (1825–83). The figure of a weeping woman on a monument symbolized grief or familial devotion, and for monuments of a more public nature a draped nude was sometimes used. In Bailly's handsome work, the sensuous form of a nude woman sits holding an urn, which presumably contains the ashes of the hero.

BOTTOM: Eminent Philadelphia architect William Strickland (1788–1854) designed the intriguing Isaac Hull tomb, and the firm of John Struthers executed it. Using the ancient form of a classical couch (Scipio's tomb), the architect has added a contemporary American flag.

Laurel Hill Cemetery

LEFT: The unusual cairn serving as Robert Stewart's tomb has long carved-stone tendrils of ivy and a broken urn to denote violent death.

BOTTOM LEFT: The William Cresson tomb by Joseph A. Bailly is one of the best of the type of biographical monument as a portrait statue.

BOTTOM RIGHT: The spectacular monument to William Mullen, the "prisoner's friend," by E. Kornbau.

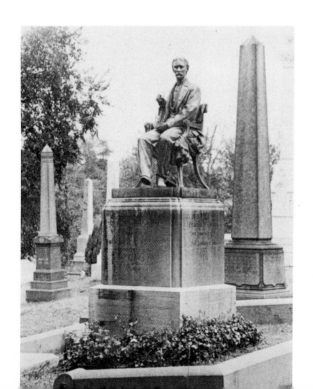

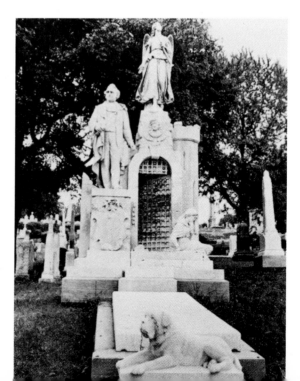

Eagle 1903
by Adolph Alexander Weinman (1870–1952)
Granite, height 60″, width 72″
Market Street Bridge over the
Schuylkill River

This impressive eagle is one of four that adorn the Market Street Bridge. They were originally ornamentations on the roof of Pennsylvania Station in New York. After the station was demolished in 1963, the eagles were given by the railroad to the Fairmount Park Art Association. Magnificent fragments of a once great building, these 5,500-pound sculptures were hauled by truck to Philadelphia and placed on the bridge in 1967.

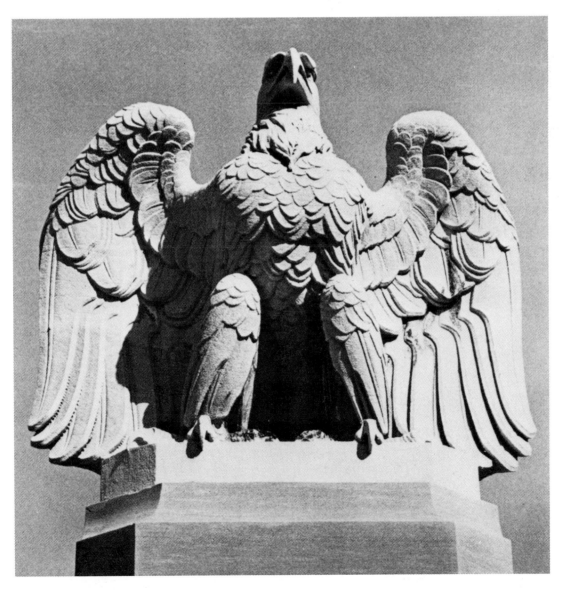

Fountain Sculpture 1967
by Harry Bertoia (1915–)
Copper tubes, bronze welded
Height about 144″, width 168″, depth 216″
Civic Center Plaza

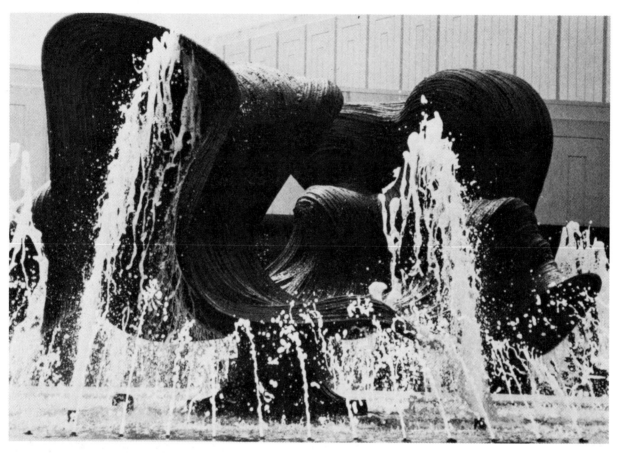

The city of Philadelphia commissioned this fountain sculpture. Its surging forms are a powerful echo of the water's movement, and the sweep of concave and convex curves create dramatic and surprising contrasts. Born in Italy, Harry Bertoia immigrated to the United States at the age of 15. His work was among the fine art chosen to represent this country at the Brussels World's Fair in 1957. His sculptures are never signed and rarely named.

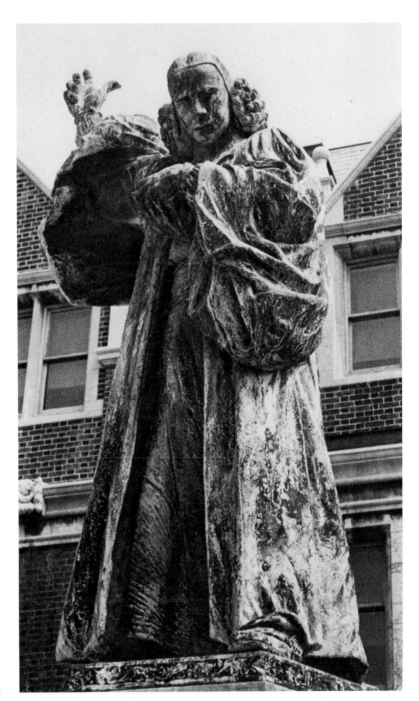

The Rev. George Whitefield 1918
by R. Tait McKenzie (1867–1938)
Bronze, height 96″
(limestone base)
University of Pennsylvania
Men's Dormitory Quadrangle

A work of unusual dramatic force, R. Tait
Mackenzie's sculpture of Rev. George
Whitefield, the celebrated Methodist
evangelist (1714–1770), conveys the intensity
of Whitefield's religious convictions and his
commanding personality. Showing the
evangelist delivering a sermon, with uplifted
arm, serious facial expression, and full sleeves
and flowing clerical robe, McKenzie created a
forceful dramatic work.

Benjamin Franklin 1899
by John J. Boyle (1851–1917)
Bronze, height 81″ (granite base 132″)
University of Pennsylvania, College Hall

This remarkable likeness of Benjamin Franklin was created by John J. Boyle, one of Philadelphia's finest sculptors. He based his portrait on the famous Houdon bust. Although he made Franklin a younger man, he retained the pinched muscles on one side of the face. The clothing is derived from the Duplessis protrait, showing the heavy fur-trimmed surtout covering the plain clothes of the period. The statue is appropriately located on the grounds of the University of Pennsylvania, which Franklin had helped to found.

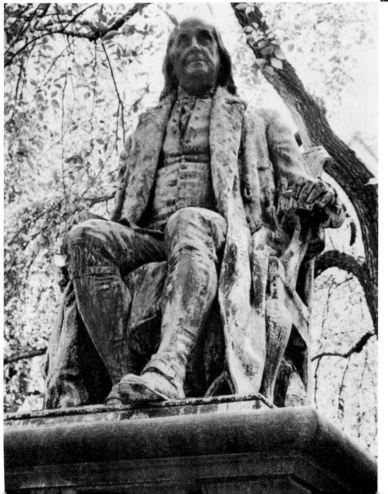

Young Franklin 1914
by R. Tait McKenzie (1867–1938)
Bronze, height 96″
(limestone and granite base 71″)
University of Pennsylvania,
33rd Street between Spruce and Walnut

In R. Tait McKenzie's commemorative
sculpture, young Benjamin Franklin
is shown as he might have looked dur-
ing his journey from New York to
Philadelphia in 1723. Though he made
it more youthful, McKenzie based the
head on the bone structure of Houdon's
bust of Franklin. He modeled the figure
directly from life, using a nude model,
in order to convincingly capture the
rhythm of walking. Also located at the
University of Pennsylvania, this fine
statue was intended to be an inspira-
tion "to many generations of the sons of
Pennsylvania."

Benjamin Franklin and His Whistle 1876
by Pasquale Romanelli (1856–1928)
Marble
University of Pennsylvania
and the Union League

This idealized portrayal of Benjamin Franklin as a
child shows him with whistle in hand, sitting on a
tree stump. Pasquale Romanelli executed this work
for the 1876 Centennial in Philadelphia.

BELOW: *The Voyager* is a striking example of Seymour Lipton's novel use of metal in sculpture. It successfully realizes the sculptor's goal of making abstract forms as mysterious as life itself.

RIGHT: James House, Jr.'s *John Dewey* is a powerful protrayal of the great American philosopher and educator.

John Dewey 1952–53
by James House, Jr. (1902–)
White oak, height 25″
(white oak base)
University of Pennsylvania
Penniman Library

The Voyager 1964
by Seymour Lipton (1903–)
Nickel silver on monel metal
height 31″
(limestone base 82″)
University of Pennsylvania,
Annenberg Center for
Communications Arts and Sciences

LEFT: Like many of his other works, *Construction #66* by Jose de Rivera is an elegant polished form. The sculptor wrote that for him the most important function of his work "is the total experience of the production The content, beauty and source of excitement is inherent in the interdependence and relationships of the space, material, and light"

BELOW: Karl Bitter's sensitive statue of Dr. William Pepper (1843–98), the distinguished scholar and brilliant diagnostician, is admired by all as an excellent likeness. He is shown seated, his head tilted, his legs and arms conveying controlled energy. The widely respected Dr. Pepper was Provost of the University of Pennsylvania during the years of great expansion (1881–94).

Construction #66 1959
by Jose de Rivera (1904–)
Chrome nickel steel-welded sheet,
43″ x 52″ x 44″ (travertine base 49″)
University of Pennsylvania,
Annenberg School of Communications,
3620 Walnut Street

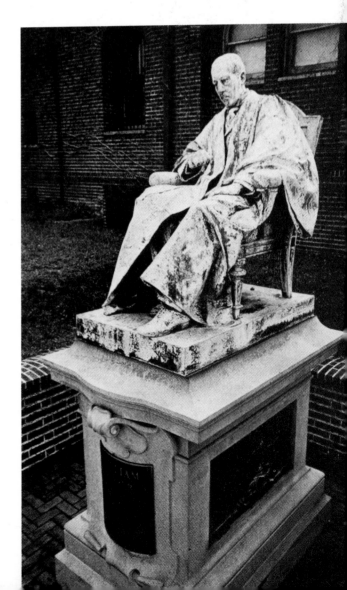

William Pepper 1895
by Karl Bitter (1867–1915)
Bronze, height 65″ (marble base 64″)
University Museum, 33rd Street side

Young Vine Grower 1876
by Auguste Bartholdi (1834–1904)
Bronze
Drexel University,
33rd and Market Streets

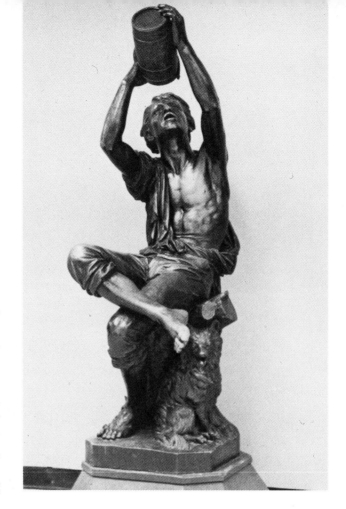

TOP: Auguste Bartholdi, sculptor of the famous *Statue of Liberty*, executed this graceful work for the 1876 Centennial. The strapping youth drinks from a wine keg. The statue was designed as a fountain in which the water would run from the keg's bunghole directly into the open mouth of the boy.

BOTTOM: This imposing statue of Anthony J. Drexel (1826–93) was executed by one of the leading sculptors of the time. Ezekiel had made several portrait busts of Drexel, so that this large seated bronze was easily realized. Fittingly, this memorial is placed near the library of Drexel University. The city's most powerful financial figure, Anthony J. Drexel was president of the Fairmount Park Association during its first 21 years.

Anthony J. Drexel 1904
by Sir Moses Jacob Ezekiel
(1844–1917) Bronze, height 100″
(marble base 116″)
Drexel University,
33rd and Market Streets

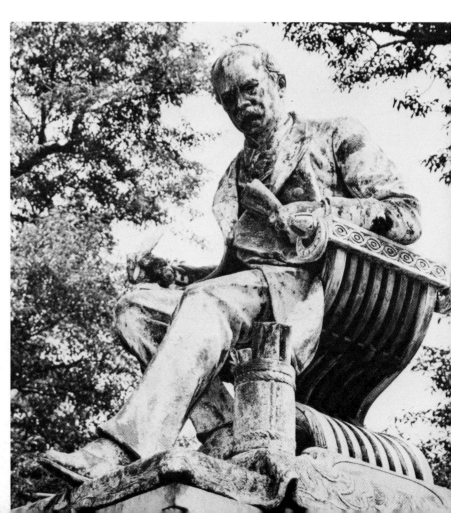

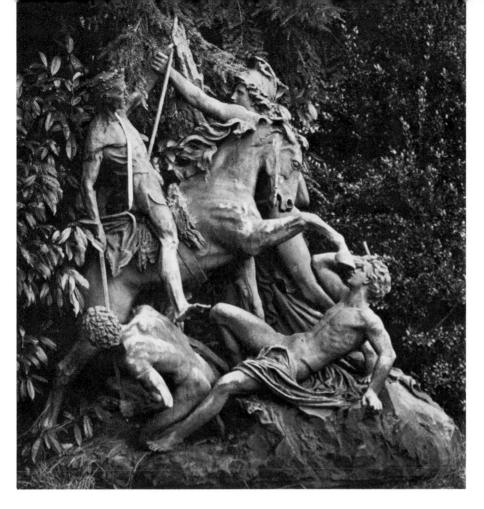

**Honor Arresting the
Triumph of Death** 1869
by Pierce Francis Connelly
(1841–after 1902)
Bronze, height 60″,
width 59″
Rosemont College

When it was exhibited at the
1876 Centennial in Philadelphia,
*Honor Arresting the Triumph of
Death* created a sensation. "One
scarcely knows which to admire
more, the audacity of the
scheme or the skill with which
it has been handled," wrote
Lorado Taft, an eminent art
critic and sculptor, at the time.
In this "ideal" work, Death
rides roughshod over Courage,
Perseverance, and Strength,
but is stopped short by Honor.

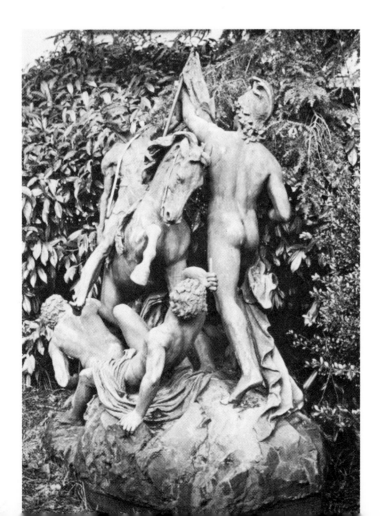

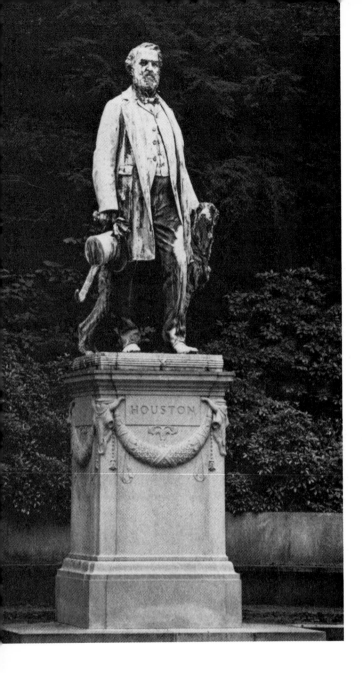

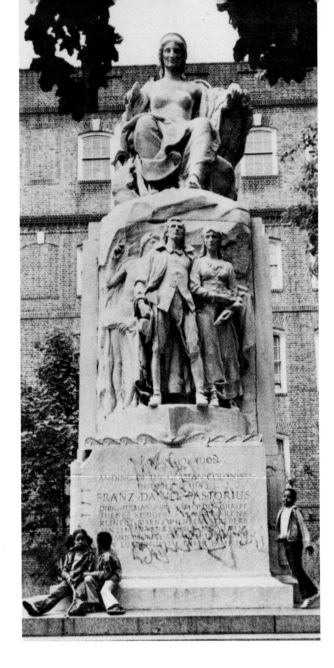

Henry Howard Houston 1900
by John Massey Rhind (1860–1936)
Bronze, height 114″ (granite base 86½″)
Lincoln Drive and Harvey Street

Pastorius Monument 1917
by Albert Jaegers (1868–1925)
Marble, height 324″
(marble and granite base)
Vernon Park, Germantown

LEFT: Henry H. Houston, a prominent Philadelphian of the 19th century, donated Wissahickon Heights to Fairmount Park. The Commissioners of the Park chose Rhind to execute this statue to his memory. He is seen walking his favorite hound.

RIGHT: This statue, a familiar Germantown landmark, commemorates the founding of the village in 1683 by 13 German families led by Franz Daniel Pastorius.

BELOW: William P. Daley describes his work *Helical Form* as a "symbol of continuousness. The form is related to a Mobius strip and a double helix. Its perpendicular terminus on one end is level with the world. Its platelike roundness gives it qualities of one location in a continuous set of locations I believe a good school is a place where beginnings and endings are illusions. Schools and meetinghouses are places where one seeks what is beyond The history of Germantown Friends School is testimony of such a quest."

RIGHT: This majestic Indian has long been a familiar Wissahickon landmark. Tedyuscung (c.1700–63) was a Delaware Indian chief who presented the grievances of his people at conferences with the white authorities. John Massey Rhind was commissioned to execute this work as a replacement for a wooden statue of an Indian that had begun to decay and is now preserved in the Germantown Historical Society.

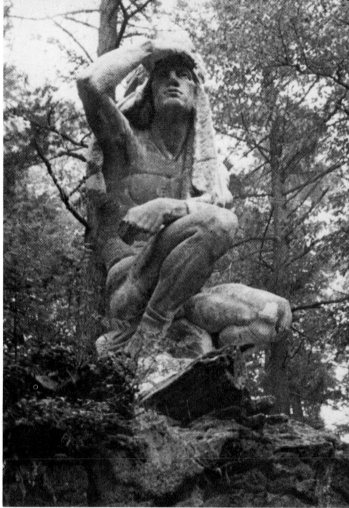

Tedyuscung 1902
by John Massey Rhind (1860–1936)
Limestone, height 144″ (natural rock base)
Indian Rock, Wissahickon Valley at Rex Avenue

Helical Form 1972
by William P. Daley (1925–)
Tomasil bronze, diameter 60″
(limestone base 30″)
Germantown Friends School,
Germantown Avenue and Coulter Street

Walt Whitman c.1939
by Jo Davidson (1883–1952)
Bronze, height 102″
(granite base 48″)
South Broad Street and Packer Avenue

An air of naturalness emanates from Jo Davidson's
sculpture of the great American poet. Whitman seems
to be striding joyously along in the open-hearted,
exhilarating manner that he celebrated. Of all the por-
trait studies he executed, this was one of the sculptor's
own favorites. This bronze cast of the original work was
made in 1957.

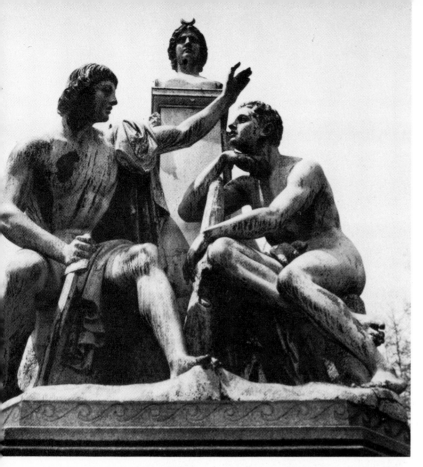

Orestes and Pylades Fountain 1884
by Carl Johann Steinhauser (1813–79)
Bronze, height 96″ (granite base 72″)
Columbia Avenue at 33rd Street,
East Fairmount Park

TOP: Ideal friendship is commemorated in this fountain, which shows the two seated figures of Orestes and Pylades with a bust of Diana on a plinth behind them. The friendship of the two young men from Greek legend is as famous as that of the Bible's David and Jonathan. The original work is in the palace park in Karlsruhe, Germany; a bronze cast was made by the Fairmount Park Art Association in 1884.

BOTTOM: This bronze memorial is undoubtedly one of J. Otto Schweizer's finest statues. It was erected as a tribute to James Bartram Nicholson (1820–89) by the Pennsylvania Grand Lodge of the Odd Fellows. Nicholson was well-known as the author of *A Manual of the Art of Bookbinding*.

James Bartram Nicholson Tomb 1913
J. Otto Schweizer (1863–1955)
Bronze, height 102″ (granite base 100″)
Mount Peace Cemetery,
31st Street and Lehigh Avenue

Decline and Rise 1969
by Harold Kimmelman (1923–)
Stainless steel, height 53″
West Mill Greenway, 51st and Reno Streets

The Medicine Man 1899
by Cyrus E. Dallin (1861–1944)
Bronze, height 96″ (granite base 102″)
East Fairmount Park, Dauphin Street Entrance

ABOVE: This one-ton columnar play sculpture for children is especially striking in the sunlight—the falling pieces are dull stainless steel, the rising pieces are mirror-polished stainless steel. To make it safe for children, the sculptor rounded the corners and edges.

RIGHT: Inspired by Buffalo Bill's Wild West Show, Cyrus E. Dallin turned to Indian subjects, seeking to portray the dignity and integrity of the red man. This statue is one of his finest works. The medicine man is shown nude, representing the total helplessness of man contrasted with the Great Spirit, whose power is denoted by the horns on the priest's head.

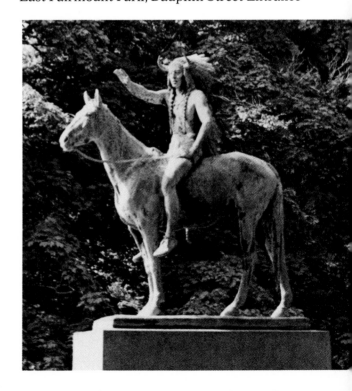

ACKNOWLEDGMENTS

Philadelphia's Treasures in Bronze and Stone is an adaptation of *Sculpture of a City*, by the Fairmount Park Art Association. Grateful acknowledgment is made to the following people and organizations for their contributions in creating this book: Samuel Maitin, designer; Wilson Gathings, editor; Susan Rappaport and Estelle Silbermann, assistant editors; Carolyn Pitts, archivist; Hugh McCauley, cartographer.

Robert W. Crawford, President, Fairmount Park Commission; Robert C. McConnell, Director, Fairmount Park Commission; the Commissioners of Fairmount Park; Richard Nicolai, Information Officer, Fairmount Park; Charles Greer, Fairmount Park Arborist.

The Redevelopment Authority of Philadelphia and Mary A. Kilroy, Coordinator, Fine Arts, Advisory Board of Design of the Redevelopment Authority of Philadelphia.

PHOTOGRAPHERS: Bernie Cleff, Edward Gallob, Tana Hoban, George Krause, Seymour Mednick, Dennis W. Weeks, Murray Weiss.

ESSAYISTS *(Sculpture of a City):* Glenn F. Benge, Wayne Craven, Anne d'Harnoncourt, Victoria Donohoe, John Dryfhout, George Gurney, R. Sturgis Ingersoll, Michael Richman, Charles Coleman Sellers, David Sellin, Lewis Sharp, John Tancock, George Thomas.

INDEX

188

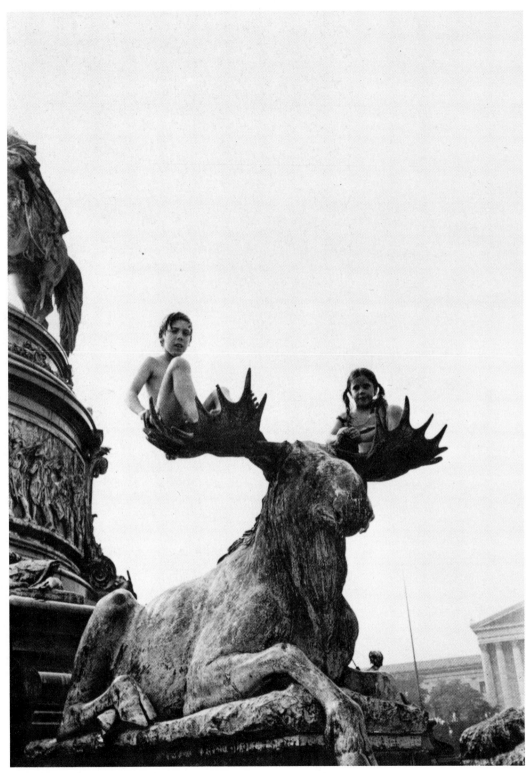

View of the Washington Monument *by Rudolf Siemering.*